Volume 13, Issue 2 June 2009

African Fashion/ African Style
Special Issue
Edited by Victoria L. Rovine

Fashion Theory
The Journal of Dress, Body & Culture

Aims and Scope
The importance of studying the body as a site for the deployment of discourses is well-established in a number of disciplines. By contrast, the study of fashion has, until recently, suffered from a lack of critical analysis. Increasingly, however, scholars have recognized the cultural significance of self-fashioning, including not only clothing but also such body alterations as tattooing and piercing. *Fashion Theory* takes as its starting point a definition of "fashion" as the cultural construction of the embodied identity. It provides an interdisciplinary forum for the rigorous analysis of cultural phenomena ranging from footbinding to fashion advertising.

Anyone wishing to submit an article, interview, or a book, film or exhibition review for possible publication in this journal should contact Valerie Steele (at the address listed to the right) or the Editorial Department at Berg Publishers, 1st Floor, Angel Court, 81 St Clements Street, Oxford, OX4 1AW, UK; e-mail: icritchley@bergpublishers.com.

© 2009 Berg. All rights reserved.

No part of this publication may be reproduced or utilized in any form or by any means, electronic or mechanical, including photocopying and recording, or by any information storage or retrieval system, without permission in writing from the Publisher.

ISSN (print): 1362-704X
ISSN (online): 1751-7419

www.bergpublishers.com

Ordering Information
Four issues per volume. One volume per annum. 2009: Volume 13

By mail:
Customer Services
Turpin Distribution
Stratton Business Park
Pegasus Drive
Biggleswade
SG18 8TQ
UK

By fax: +44 (0) 1767 601640
By telephone: +44 (0) 1767 604951
By e-mail: custserv@turpin-distribution.com

Subscription Rates
Institutional (print and online): (1 year) £290, US$566; (2 year) £464, US$905
Institutional (online only): (1 year) £247, US$482; (2 year) £395, US$771
Individuals (print only): (1 year) £46, US$79; (2 year) £74, US$126
Institutional subscriptions include two issues of *Fashion Practice*.

Full color images available online.
Access your electronic subscription through www.ingentaconnect.com

Inquiries
Editorial and Production: Ian Critchley, Managing Editor,
e-mail: icritchley@bergpublishers.com
Advertising and subscriptions: Corina Kapinos,
e-mail: ckapinos@bergpublishers.com

Reprints of Individual Articles
Copies of individual articles may be obtained from the Publishers at the appropriate fees.
Write to:
Berg Publishers,
1st Floor, Angel Court,
81 St Clements Street,
Oxford,
OX4 1AW,
UK.

Printed in the United Kingdom.

JUNE 2009

Fashion Theory is indexed by the following abstracting/indexing services: Abstracts in Anthropology; AIO Anthropological Index Online; ARTbibliographies Modern; British Humanities Index; DAAI Design and Applied Arts Index; IBR International Bibliography of Book Reviews of Scholarly Literature in the Humanities and Social Sciences; IBSS International Bibliography of the Social Sciences; IBZ International Bibliography of Periodical Literature on the Humanities and Social Sciences; ISI Arts and Humanities Citation Index; Scopus; Sociological Abstracts

Editor-in-Chief
Dr. Valerie Steele
Director
The Museum at the Fashion Institute of Technology, E304
Seventh Avenue at 27th Street
New York, NY 10001-5992, USA
Fax: +1 212 924 3958
e-mail: valerie_steele@fitnyc.edu

Exhibitions Reviews Editor
Dr. Alexandra Palmer
Royal Ontario Museum
100 Queen's Park, Toronto
Ontario M5S 2C6, Canada
Fax: +1 416 586 5877
e-mail: alexp@rom.on.ca

Book Reviews Editor
Peter McNeil
Professor of Design History
Faculty of Design, Architecture and Building
University of Technology, Sydney
P.O. Box 123
Broadway, NSW 2007
Australia
e-mail: peter.mcneil@uts.edu.au

Please send all books for review to the Book Reviews Editor

Editorial Board
Christopher Breward
Victoria and Albert Museum, UK

Patrizia Calefato
University of Bari, Italy

Joanne B. Eicher
University of Minnesota, USA

Caroline Evans
Central Saint Martins College of Art and Design, UK

Akiko Fukai
Kyoto Costume Institute, Japan

Pamela Golbin
Musée de la Mode et du Textile, France

Anne Hollander
New York Institute for the Humanities, USA

Susan Kaiser
University of California at Davis, USA

Yuniya Kawamura
Fashion Institute of Technology, USA

Dorothy Ko
Barnard College, Columbia University, USA

Harold Koda
The Metropolitan Museum of Art, USA

John S. Major
The China Institute, USA

Peter McNeil
University of Stockholm, Sweden

Patricia Mears
The Fashion Institute of Technology, USA

Alexandra Palmer
Royal Ontario Museum, Canada

Nicole Pellegrin
Institut d'Histoire Moderne et Contemporaine, CNRS, France

Philippe Perrot
École des Hautes Études, France

Simona Segre Reinach
IULM University, Milan, Italy

Lou Taylor
University of Brighton, UK

Efrat Tseëlon
University of Leeds, UK

Olga Vainshtein
Russian State University for the Humanities, Russia

Barbara Vinken
Hamburg University, Germany

Claire Wilcox
Victoria and Albert Museum, UK

Elizabeth Wilson
London College of Fashion, UK

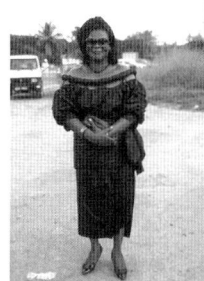
Page 141

Page 177

Page 215

Page 243

Contents

133 **Viewing Africa through Fashion**
Victoria L. Rovine

141 **Asante *Hightimers* and the Fashionable Display of Women's Wealth in Contemporary Ghana**
Suzanne Gott

177 **Conceptions of Identity and Tradition in Highland Malagasy Clothing**
Rebecca L. Green

215 **Making Fashion in the City: A Case Study of Tailors and Designers in Dakar, Senegal**
Joanna Grabski

243 **The Idea of Africa in European High Fashion: Global Dialogues**
Kristyne Loughran

AVAILABLE ONLINE FROM 2010

BergFashionLibrary.com

A unique and unrivalled source of interdisciplinary information on all aspects of dress and fashion worldwide – from prehistory to the present day

..........................

Cross search an expanding range of book and journal collections, all underpinned by a specially-created taxonomy

..........................

The full text of the 10-volume *Berg Encyclopedia of World Dress and Fashion* – including over 2,000 images – and an e-book collection of over 70 titles will be the first resources to be launched within the **Berg Fashion Library**

Find out more at BergFashionLibrary.com

Sign up to the **Berg Fashion Library** Newsletter today to ensure you keep up to date with the latest developments!

Berg Fashion Library.com

Viewing Africa through Fashion

Victoria L. Rovine

Victoria Rovine is an assistant professor at the University of Florida, in the School of Art and Art History and the Center for African Studies. Her book *Bogolan: Shaping Culture through Cloth in Contemporary Mali* was republished in 2008 (Indiana University Press). Her current research focuses on African fashion designers in global markets.
vrovine@africa.ufl.edu

The articles gathered here explore the garments that are produced at the intersection of two subjects that have only recently been addressed together: Africa and fashion. The authors address multiple aspects of Africa's production of and engagement with fashion, documenting local markets and transnational influences, encompassing garments designed by Africans as well as African styles created by non-Africans. Taken as a whole, these articles offer rich insights into local identities and global markets, creativity and tradition, the movement of styles, and the re-shaping of meanings.

A small but growing literature is beginning to address the work of Africa's *haute couture* fashion designers, including van der Plas and

Willemsen (1998), *Revue Noire* (1997–8), Mendy-Ongoundou (2002), Mustafa (2002), Geoffroy-Schneiter (2005), and Rovine (2004). Other recent work has explored specific local markets for clothing design in Africa, revealing the degree to which these practices reflect creative change over time—the hallmark of fashion. This analysis of local design practices is exemplified by Rabine (2002), Bastian (1996), Gondola (1999), Hansen (2000), Picton (1995), Renne (1995), Rovine (2008), and Perani and Wolf (1999), and several pieces in the edited volume Allman (2004). All demonstrate the complexity of local fashion production, many explore the diverse aesthetic, economic, social, and political forces at work in the production and marketing of changing styles.

African fashion appears in the global, Western-dominated realm of *haute couture* as well as in indigenous fashion economies, where designers may draw from international styles yet remain distinctly local. Fashion is difficult to define in a global context, requiring a negotiation of the slippery territory between practices classified as "African" and categories associated with the Western cultures. Fashion is usually associated with a particular market for modern, Western garments, beginning in mid-nineteenth-century Paris and since then centered in that city, in Milan, and in New York. Africa, and other non-Western sites, has no place in this conception of fashion, except as an occasional source of inspiration. As Niessen has asserted, a reassessment of this conception of fashion is long overdue: "A great divide between the studies of Western fashion/clothing processes and the universal phenomenon of dress/adornment still obtains. As a result, global dress events of profound implication for fashion theory are kept either hidden or barred from scrutiny" (Niessen 2003: 250).

Temporality is central in this division between Western and non-Western dress practices, epitomized by the all too prevalent discussion of non-Western dress in terms of an "ethnographic present" as opposed to the "perpetual future" associated with Western fashion's continual rush to the next season. In but one example of this tendency, a reporter for the *New York Times* breezily noted the absence of changing dress styles in one rural Kenyan community, where British scouts for a modeling agency were looking for likely prospects: "Orma girls grow up wearing flip-flops, not heels. Their fashion is the same every season: colorful robes that billow with the breeze and shield virtually every bit of flesh" (Lacey 2003: 2). By declaring their dress to be unchanging, this reporter implicitly excludes Orma attire from the realm of fashion. Yet Joanne Eicher, whose research on African dress practices has been in the forefront of non-Western fashion studies, notes: "Fashion is, after all, about change, and change happens in every culture because human beings are creative and flexible" (Eicher 2001: 17). Recognizing the histories and networks out of which change emerges is key to the analyses presented here, placing these garments within the contexts that transform them from clothing into fashion.

That African dress has changed over time is clearly evident, even if those changes have never been explored in terms of fashion. The Western influence on African clothing has been well documented, and often characterized as a "loss" of Africa's traditional cultures in the face of overpowering Westernization or Globalization (the two terms are often used interchangeably). A clear example of this rhetoric of loss can be found in Angela Fisher's immensely popular and lavishly illustrated book, *Africa Adorned*. Over the course of her many visits to Africa, she noted the disappearance of "some outstanding styles of jewelry and dress," and she found that groups whose "cultural and moral framework is still strong" were able to resist transformation from traditional to Western dress (Fisher 1984: 9–10).[1] While certainly the drive to colonize and convert Africans led to coerced or forced adoption of Western clothing, it is important to recognize that the presence of Western styles in Africa today often constitutes a creative adaptation rather than a capitulation.

By exploring the movement of clothing forms between African and Western cultures—exchanges that flow in both directions—the articles in this special issue demonstrate the inadequacy of the "change as loss" model. Many of the styles of clothing that are produced in Africa's highly internationalized urban centers draw from diverse sources, enriching rather than impoverishing their distinctly African styles. As is the case everywhere, African designers and consumers draw forms and styles from outside their immediate orbit, making these forms their own. As Hendrickson notes, the identities associated with clothing may shift as garments and styles travel: "When we see Africans using *our* products to create *their* identities—and vice versa—we learn that the meaning of body or commodity is not inherent but is in fact symbolically created and contested by both producers and consumers" (Hendrickson 1986: 1–16).

African Fashion/Africa as Fashion

Our examination of Africa's role in fashion production is particularly timely, for with the new millennium the continent is remarkably prominent in the realms of fashion design and marketing. As I write this introduction, Suzy Menkes—arguably fashion's most widely read journalist—has published a piece in the *New York Times Style Magazine* entitled "Next Stop, Africa." In it, she predicts that global fashion markets are on the verge of creating "a fashion first: a popular movement that sees the beauty and craft in sub-Saharan Africa" (Menkes 2005: 60). Since 2002, the year of the conference in Iowa City that inspired this special issue,[2] references to Africa have appeared in *haute couture* collections on major European and North American runways. Africa seems to be the muse *du jour* for a wide array of designers, including Jean Paul Gaultier, Donna Karan, Kenzo, and Dolce and Gabbana.

While Africa's profile in international fashion circles has been heightened by its appearance as a source of inspiration for Western designers, the many African designers who are themselves engaged in innovative transformations of African style receive little attention in the international fashion press. Their work emerges out of a long history of fashion in Africa, a continent whose styles of dress provide insights into both ancient cultures and the latest global fashion trends. Many African designers today create garments that make reference to or borrow from local clothing practices, often melding these forms with international influences. Their work spans diverse markets, from the seasonal runways of international *haute couture* to local markets, where garments reflect swiftly changing local styles.

Three of the articles presented here are focused on local fashion practices, yet all reveal the degree to which local and international fashion systems are intertwined, so that while designations such as "African" and "Western" can provide insights into the intentions of designers and marketers, they often obscure rich histories of exchange. Gott analyzes the dramatic fashions of an Ashanti women's subculture, placing their swiftly changing styles in the context of a long history of competitive displays of wealth. In her exploration of Dakar's fashion scene, Grabski describes how this cosmopolitan city provides fuel for the work of designers in diverse markets. Green's work in Madagascar documents the surprising intersection of fashion and funerary practice in a culture that accords cloth great spiritual power. In addition, Loughran provides a survey of Africa's long history as a source of inspiration for Western fashion design, and an overview of the work of one African designer whose career straddles Africa and Europe. Taken as a whole, these articles describe the complexity of African dress practices, which draw from both deep local roots and from contemporary, international trends, shifting constantly to absorb new influences and adapt changing elements of indigenous garments.

Fashion: Indigenous Everywhere

As numerous past articles in this journal have demonstrated, the study of non-Western fashion as fashion, not as garb, costume, or dress, is a growing field of inquiry (see, for example: Sun 1997, El Guindi 1999, Dogbe 2003, and Nagrath 2003). In her 2004 survey of current anthropological analysis of dress, Karen Hansen noted that recent scholarship in a variety of academic venues "demonstrates that fashion no longer is an exclusive property of the West" (Hansen 2004: 370). Much of the attention to non-Western fashion in academic circles has been centered on Asia, which has been a source of "exotic" inspiration for Westerners (much like Africa) as well as a producer of internationally renowned fashion designers (unlike Africa). As Lisa Skov notes, Japan

in particular was the first non-Western player in the rarified realm of *haute couture*: "... the 1980s was the first period when non-Western fashion designers came to influence mainstream fashion, when Issey Miyake, Yohji Yamamoto, and Rei Kawakubo, along with a series of other Japanese designers, proved themselves to be the leading fashion innovators of the world" (Skov 2003: 216).

Two publications that provided rich insights into the intersections of traditional and contemporary impulses in Asian fashion cultures are important precedents, and sources of inspiration, for the analyses of non-Western fashion presented here. *China Chic: East Meets West* (Steele and Major 1999) focused on multiple dimensions of Chinese fashion—historical styles, the absorption of new influences, revivals of historical styles, and the internationalization of those styles. *Re-Orienting Fashion: The Globalization of Asian Dress* (Niessen *et al.* 2003) explores contemporary Asian garments as symbols of local identities, diaspora communities, and international chic. While African and Asian fashion systems have in common only their mutual "otherness" for the Western-dominated international fashion industry, our hope is that this special issue will continue to demonstrate that fashion is not "indigenous" only to Western cultures.

Acknowledgments

For their support of my research, I thank the Rockefeller Foundation's Bellagio Study Center, the Getty Foundation's Curatorial Research Grant program, and the University of Iowa (Arts and Humanities Initiative and International Programs). Many thanks as well to my former colleagues at the University of Iowa Museum of Art. I am also grateful to Lamine Kouyaté, Carlo Gibson, Ziemek Pater, Ly Dumas, Anna Getaneh, Marianne Fassler, and the many other designers in Africa and Europe who have shared their time with me, and to Stephan Houy-Towner of the Costume Institute Library at the Metropolitan Museum of Art. Many thanks, as always, to Florence Babb.

Notes

1. The same tendency is evident in Fisher's work with her collaborator Carol Beckwith. Fisher and Beckwith have produced several lush publications, featuring their photographic work in Africa. These include *African Ark* (Fisher *et al.* 1990), *Nomads of Niger* (Fisher and Beckwith 1983), and the two-volume *African Ceremonies* (Fisher and Beckwith 1999).
2. The conference, which I co-organized along with Dr Sarah Adams, was entitled "The Cultured Body: African Fashion and Body Arts." It was held at the University of Iowa Museum of Art on October 17–20,

and received significant support from the Obermann Center for Advanced Studies, International Programs, and the Project for the Advanced Study of Art and Life in Africa, all based at the University of Iowa. The articles collected here were selected from two of the conference's five panels.

References

Allman, Jean (ed.). 2004. *Fashioning Africa: Power and the Politics of Dress* Bloomington, IN: Indiana University Press.

Bastian, Misty L. 1996. "Female 'Alhajis' and Entrepreneurial Fashions: Flexible Identities in Southeastern Nigerian Clothing Practice." In Hildi Hendrickson (ed.) *Clothing and Difference: Embodied Identities in Colonial and Post-colonial Africa*, pp. 97–132. Durham, NC: Duke University Press.

Dogbe, Esi. 2003. "Unraveled Yarns: Dress, Consumption, and Women's Bodies in Ghanaian Culture." *Fashion Theory* 7(3/4): 377–96.

Eicher, J. B. 2001. "Fashion of Dress." In C. Newman (ed.) *National Geographic Fashion*, pp. 16–23. Washington, DC: National Geography Society.

El Guindi, Fadwa. 1999. "Veiling Resistance." *Fashion Theory* 3(1): 51–80.

Fisher, Angela. 1984. *Africa Adorned*. New York: Harry N. Abrams.

Fisher, Angela and Carol Beckwith. 1983. *Nomads of Niger*. New York: Harry N. Abrams.

Fisher, Angela and Carol Beckwith. 1999. *African Ceremonies*, 2 Vols. New York: Harry N. Abrams.

Fisher, Angela, Carol Beckwith and Graham Hancock. 1990. *African Ark: People and Ancient Cultures of Ethiopia and the Horn of Africa*. New York: Harry N. Abrams.

Geoffroy-Schneiter, Bérénice. 2005. *L'Afrique est à la Mode*. Paris: Éditions Assouline.

Gondola, Ch. Didier. 1999. "Dream and Drama: The Search for Elegance among Congolese Youth" *African Studies Review* 42(1): 23–48.

Hansen, Karen Tranberg. 2000. *Salaula: The World of Secondhand Clothing and Zambia*. Chicago, IL: University of Chicago Press.

Hansen, Karen Tranberg. 2004. "The World in Dress: Anthropological Perspectives on Clothing, Fashion, and Culture." *Annual Review of Anthropology* 33: 369–92.

Hendrickson, Hildi. 1986. "Introduction." In Hildi Hendrickson (ed.) *Clothing and Difference: Embodied Identities in Colonial and Post-colonial Africa*, pp. 1–16. Durham, NC: Duke University Press.

Lacey, Marc. 2003. "In Remotest Kenya, a Supermodel Is Hard to Find." *New York Times* April 22: 2.

Mendy-Ongoundou, Renée. 2002. *Elégances Africaines: Tissus Traditionnels et Mode Contemporaine*. Paris: Éditions Alternatives.

Menkes, Suzy. 2005. "Next Stop, Africa." *The New York Times Style Magazine* Spring: 60.

Mustafa, Hudita Nura. 2002. "Oumou Sy: The African Place, Dakar, Senegal." *Nka* 15 (Fall/Winter): 44–6.

Nagrath, Sumati. 2003. "(En)countering Orientalism in High Fashion: A Review of Indian Fashion Week 2002." *Fashion Theory* 7(3/4): 361–76.

Niessen, Sandra, Ann Marie Leshkowich, and Carla Jones (eds). 2003. *Re-Orienting Fashion: The Globalization of Asian Dress*. New York: Berg.

Niessen, Sandra. 2003. "Afterword: Re-Orienting Fashion Theory." In S. Niessen, Ann Marie Leshkowich and Carla Jones (eds) *Re-Orienting Fashion: The Globalization of Asian Dress*, pp. 243–66. New York: Berg.

Perani, Judith and Norma H. Wolff. 1999. *Cloth, Dress and Art Patronage in Africa*. New York: Berg.

Picton, John. 1995. *The Art of African Textiles: Technology, Tradition and Lurex*. London: Barbican Art Gallery.

Rabine, Leslie W. 2002. *The Global Circulation of African Fashion*. New York: Berg.

Renne, Elisha P. 1995. *Cloth That Does Not Die: The Meaning of Cloth in Bunu Social Life*. Seattle, WA: University of Washington Press.

Revue Noire. 1997–8. *Revue Noire* (Special Issue) 27.

Rovine, Victoria L. 2008[2001]. *Bogolan: Shaping Culture through Cloth in Contemporary Mali*. Bloomington, IN: Indiana University Press.

Rovine, Victoria L. 2004. "Working the Edge: XULY. Bët's Recycled Clothing." In Alexandra Palmer and Hazel Clark (eds) *Old Clothes, New Looks: Second-hand Fashion*, pp. 215–28. Oxford: Berg.

Skov, Lisa. 2003. "Fashion-Nation: A Japanese Globalization Experience and a Hong Kong Dilemma." In Sandra Niessen, Ann Marie Leshkowich and Carla Jones (eds) *Re-Orienting Fashion: The Globalization of Asian Dress*, pp. 215–42. New York: Berg.

Steele, Valerie and John S. Major. 1999. *China Chic: East Meets West*. New Haven, CT: Yale University Press.

Sun, Lung-kee. 1997. "The Politics of Hair and the Bob in Modern China" *Fashion Theory* 1(4): 353–65.

Van der Plas, Els and Marlous Willemsen (eds). 1998. *The Art of African Fashion*. Trenton, NJ, and The Hague: Africa World Press and Prince Claus Fund.

The Men's Fashion Reader
Edited by Peter McNeil and Vicki Karaminas

January 2009
544pp • 50 bw illus • 244 x 189 mm
PB: 978 1 84520 787 8 £22.99 • $44.95
HB: 978 1 84520 786 1 £60.00 • $119.95

"Men's interest in fashion and the role of fashion in constructing masculine identity have so far not been investigated in depth. The Men's Fashion Reader is an important work exploring all aspects of men and fashion - from design to production, communication and consumption. At last an ideal resource is available to scholars, students and professionals."
Simona Segre Reinach, Iuav University, Venice

The Men's Fashion Reader brings together key writings in the history, culture and identity of men's fashion. The readings provide a balanced range of important methodological approaches, primary research and significant case studies. The book is organized into thematic sections covering topics such as history, theory, subculture, iconic items of clothing, consumption and the media.

Each section is introduced and concludes with an annotated guide to further reading. With exciting illustrations of men's dress from a range of historical periods, and including readings from key scholars and new writers across a wide range of fields, *The Men's Fashion Reader* is the essential introduction to the subject.

Order now at www.bergpublishers.com

BERG

Asante *Hightimers* and the Fashionable Display of Women's Wealth in Contemporary Ghana

Suzanne Gott

Suzanne Gott is an art historian in the University of British Columbia-Okanagan's Department of Critical Studies. Her research focuses on gender, the aesthetics of display and performance, and the fashion system of Ghana's Ashanti Region. She is currently investigating performative display, oratory, and aesthetic agency in Asante women's funerary presentations.
suzanne.gott@ubc.ca

Abstract

In Ghana's Ashanti Region, there is a certain category of woman commonly called *preman* (pl. *premanfoo̱*), a word that is the local version of the English *play-man* or *playboy*. Despite this word's seemingly male cast, *preman* is a term applied primarily to women, particularly wealthy market traders. This article explores the relationship between the flamboyantly fashionable behavior of the *preman* and the long-established Asante cultural practice of *poatwa* ("challenge"), involving both visual and verbal assertions of superior status. During the twentieth century, fashionable dress developed into a particularly female mode of

high-status display that provided visible proof of a woman's success in accumulating the prestigious textiles that became an increasingly important form of female wealth. The most extreme form of such displays are the extravagant, highly visible, and sometimes scandalous fashions of the Asante *preman*, which may be best understood as a distinctively female mode of contemporary Asante *poatwa* behavior.

KEYWORDS: fashion, women, textiles, wealth, status, Ghana, Africa, Asante

In southern Ghana's Ashanti Region, there is a certain category of woman that the Asante people commonly call *preman* (pl. *premanfoɔ*), using a word that is the local version of the English *play-man* or *play-boy*. Despite this word's seemingly male cast, *preman* is a term applied primarily to women, particularly wealthy market traders. A *preman*, people say, is a "very expensive" type of woman, a *hightimer*, who always wants to be seen at every social occasion dressed "gorgeously" in the latest, most fashionable and "fanciful" styles (Figure 1).[1]

This article explores the relationship between the flamboyantly fashionable behavior of the *preman* and the long-established Asante cultural

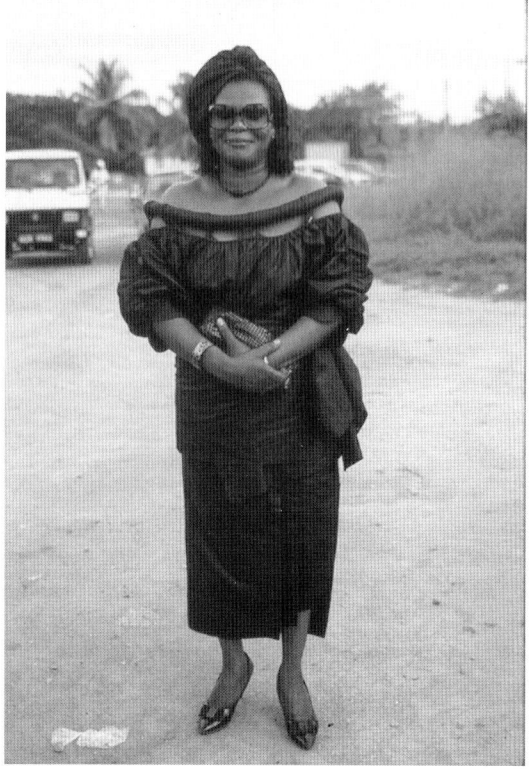

Figure 1
Cries of "*Ɔye preman!*" ("She is a *preman!*") greeted the photograph of this Asante woman attending a Kumasi funeral wearing a particularly fanciful and costly *kaba* ensemble, 1990. Photograph: Suzanne Gott.

practice of *poatwa*,[2] a term meaning "challenge" that references both visual and verbal assertions of superior status (Christaller 1933: 397). In the past, *poatwa* displays of costly textiles and golden regalia provided a major means of proclaiming the wealth and power of the Asante state's ruling elite.[3] In the Ashanti Region over the course of the twentieth century, fashionable dress developed into a particularly female mode of high-status display that provided visible proof of a woman's success in accumulating the prestigious textiles that became an increasingly important form of female wealth. The most extreme form of such displays are the extravagant, highly visible, and sometimes scandalous fashions of the Asante *preman*, which I argue may be best understood as a distinctively female mode of contemporary Asante *poatwa* behavior.

This study, based on research in Ghana during 1990, 1999, 2003, and 2005, examines the intersection of cultural ideals, historical developments, and gendered socioeconomic realities that have fueled Asante women's strong interest in cloth acquisition and fashionable display.

Hightimers and Asante Competitive Display

Within Ghana's Ashanti Region, funerals are at the center of Asante social life. On Fridays and Saturdays, the days dedicated to the observance of customary funeral rites, the streets of the capital Kumasi and towns and villages throughout the Ashanti Region are filled with throngs of women and men dressed in mourning ensembles of red, black, and brown textiles. Men abandon their everyday clothing of shirts and trousers for Akan men's customary dress, a stately eight- to ten-yard toga-like wrapped ensemble. Women, depending on their relationship to the deceased and bereaved family members, dress in either wrapped *dansinkran* or sewn *kaba* ensembles (Figure 2).

Asante funerals constitute what might be termed *totalizing events* that touch on almost every dimension of social life.[4] Funeral observances bring together great numbers of extended family, friends, and colleagues from throughout Ghana, and sometimes from abroad, to honor and attest to the social standing of the deceased and their matrilineage. In addition to being occasions for honoring the deceased, funerals in the Ashanti Region are important, high-visibility social occasions. Kumasi funerals, especially the widely attended commemorative funeral rites (*ayie*) held on Saturday afternoons following burial, are considered to be fashion showcases where one will see prestigious textiles sewn into the latest, most fashionable *kaba* ensemble styles (Figure 3).

It is at these large Kumasi funerals where one finds the greatest concentration of Asante *hightimers*, or *premanfoo*, dressed in the latest fashions of the costliest funeral *cloth* (see Figures 1 and 4). Such high-visibility status-seeking behavior is, in fact, considered to be the hallmark of the Asante *preman*:

Figure 2
Mrs Elizabeth Longdon, a Kumasi dressmaker (fourth from left), with members of her workshop and other sympathizers with a bereaved colleague (center, wearing white head-cloth) at the commemorative funeral rites for her father, 1990. Photograph: Suzanne Gott.

If you are a *preman*, more properly a *preman baa* ('*preman* woman') everything you wear is 'high cost': superior dressing, superior shoes, superior *cloth*. Food, drinks, everything is costly ... [they like] to live ostentatiously, to show off. *Premanfoɔ* have to show themselves. At any celebration—funerals, festivals—they will be there. They have to show themselves off."[5]

It is said that *premanfoɔ* will even attend grand funerals of perfect strangers in order to have the largest possible audience for assertions of wealth and social prominence by means of their costly and flamboyant styles of fashionable dress.

From the late-seventeenth-century beginnings of the Asante state until British colonial rule in the early twentieth century, public expressions of wealth and superior status were restricted according to a regulated ranking system based on political power and authority. On public occasions, members of this ruling elite dressed in ensembles of costly textiles and displayed golden regalia as a means of proclaiming the political power and wealth of the Asante state (Bowdich 1966[1819]; Garrard 1989; Kyerematen 1964; Ross 1977, 1998, 2002). The political monopoly

Figure 3
Emelia Damptey (left) and Evelyn Damptey dressed in the latest styles to attend a Kumasi funeral, 1990. Photograph: Suzanne Gott.

on such displays was maintained by strict sumptuary controls (Arhin 1990: 531–3).

"Wealth, like power," Arhin observes, was also closely controlled (1990: 525). Asante officials maintained a rigorous system of death duties and inheritance taxes that effectively transferred most subjects' accumulated wealth to the Asante state, thus preventing the transfer of accumulated individual and familial wealth to future generations. However, those individuals who accumulated substantial wealth during their lifetime were honored for the magnificence of this monetary contribution to the state by the bestowal of the rank of <u>o</u>biremp<u>o</u>n (pl., <u>a</u>biremp<u>o</u>n), a term derived from the pairing of the word <u>o</u>barima ("valiant man") with p<u>o</u>n ("great, powerful"). An individual's attainment of this exalted rank was publically proclaimed and celebrated by a ceremonial procession of royal proportions in which they were honored as magnanimous benefactors of the state (Wilks 1979).[6]

Given the inextricable linkage between gold, wealth, and power in Asante, great quantities of gold ornaments figured prominently in these regal, status-asserting performances. One such <u>o</u>biremp<u>o</u>n display was witnessed in 1817 by William Hutchison, Acting British Consul

Figure 4
An Asante *preman*, scandalously dressed in a flamboyant funeral ensemble of imported black and gold wax-print *cloth*, 1990. Photograph: Suzanne Gott.

in Kumasi. The main preparation for this <u>obirempon</u> procession, he found, consisted of fashioning "their gold into various articles of dress for show." Hutchison described the variety of gold regalia that this important court official, Gyaasewahene Opoku Fr<u>e</u>fr<u>e</u>, had commissioned for this once-in-a-lifetime ceremonial exhibition of his riches:

> Apokoo ... shewed [*sic*] me his varieties, weighing upwards of 800 bendas [£7,200 currency] of the finest gold; among the articles, was a girdle two inches broad. Gold chains for the neck, arms, legs, &c. ornaments for the ancles of all descriptions, consisting of manacles, with keys, bells, chairs, and padlocks. For his numerous family of wives, children, and captains, were armlets and various ornaments ... New umbrellas made in fantastical shapes, gold swords and figures of animals, birds, beasts, and fishes of the same metal (Bowdich 1966[1819]: 395).

While all known accounts of <u>obirempon</u> displays have been those of wealthy men, Akyeampong has observed that "scattered historical evidence stretching back to the seventeenth century" reveals a similar, yet

often overlooked "ethic of accumulation" among Gold Coast women. Such evidence, he argues, indicates that there "were 'big women' [female *abirempon*], just as there were 'big men'" (2000: 223–5).[7] In eighteenth- and nineteenth-century Asante, the influential moneyed elite known as *asikafoo* (from *sika*, "gold") included wealthy female entrepreneurs who, like their male counterparts, engaged in conspicuous displays of wealth, including generous gifts to the community and Asante state (Wilks 1975: 693–5).

Among the coastal Akan, the accumulation of wealth and sumptuary display had gradually become freed from the customary system of state regulation. Nineteenth-century accounts of life in the trading port of Elmina describe the manner in which women of this independent coastal elite orchestrated eye-catching public performances showcasing their wealth and superior status:

> If a woman wore gold ornaments, so did her "maids"; thus one might see a wealthy woman going through the streets of Elmina followed by ten of her slave women, all finely dressed and wearing gold ornaments. A woman of high status might spend hours dressing her female slaves and arranging their hair (Jones 1995: 106).

Away from the more fluid social milieu of the coast, Asante authorities were able to maintain state controls of wealth and high-status display for a significantly longer period of time. However, by the late nineteenth and early twentieth centuries, state regulatory powers had become seriously eroded, first as a result of internal instability, and then, by the imposition of British colonial rule (Arhin 1990: 525–8; McCaskie 1983: 39).

The weakening of state power permitted, for the first time, the development of an independent Asante entrepreneurial elite. Yet, although this new business class was now free of the customary system of state-regulated wealth accumulation, death duties, and sumptuary display, it soon became evident that "they were still enmeshed—as their descendants are—in the received (if modified) cultural imagery of behaving like a 'big man,' an *obirempon*" (McCaskie 1986: 8). Such behavior, Arhin observes, continues to flourish in contemporary Asante:

> Much of the well-known present-day Asante competitive acquisition, *poatwa*, of the biggest buildings, the latest and largest car models and extremely expensive funeral rites is calculated self-assertion: it is a message that one may not be an indigenous ruler but one is in certain material respects equal to or even above such a ruler (1990: 533).[8]

Over the course of the twentieth century, increasing numbers of the Asante population have found ways of engaging in the once strictly regulated practice of *poatwa*, or competitive sumptuary display. Asante

funeral rites have served as particularly popular high-visibility display frames for such status-seeking behavior, with the staging of prestigious funerals greatly facilitated by the development of rental businesses specializing in funerary display goods and regalia (De Witte 2003; Gott 2003). The social prominence accorded such high-status displays, both genuine and spurious, demonstrates the continuing salience of the Asante *obirempon* ethos.

During the twentieth century, with the development of women's sewn clothing styles, fashionable dress embodying Asante customary values and aesthetic sensibilities emerged as a new, ever-changing resource for women's *poatwa* displays. Within this dynamic Asante fashion system, the costly, flamboyantly fashionable dress of the "hightiming" *premanfoo*, who "have to show themselves" at all high-visibility social events, especially Asante funerals, may be best understood as a contemporary, and distinctively female, mode of Asante *obirempon* display.

The Importance of Dressing Well in Asante

Within contemporary Ghana, the Asante are characterized as being especially concerned with dressing well as a means of gaining social prestige. Residents of Kumasi, the Ashanti Region's capital city, often contrast dress behavior in their city with that of Accra, the nation's coastal capital. In Accra, they say, people are free to dress as they choose, but in Kumasi, people "gossip too much," with that gossip frequently focusing on the quality of an individual's dress.

Although it is Ghana's second largest city, Kumasi is, in the words of one local woman, more "like a big village," with an ongoing sense of social accountability maintained by regular face-to-face interaction. Kumasi residents move in interconnecting social networks of kinship, marriage, church membership, occupation, residence, and personal ties, such as those developed during school days. Both Asante and non-Asante report strong social pressure to dress well and often beyond their means, with particular scrutiny directed toward the dress behavior of women.

In Kumasi, women dress with an awareness that their clothing and appearance are subject to critical appraisal on trips to town and the market, while attending church events and funerals, and at important life transition points. All women, except for the most elderly, are considered to take great pride in their fashionable dress and sense of style.

The popular term for fashion or fashionable dressing is *life* (*laif* in Twi-English), from *highlife*, a name coined in early-twentieth-century Ghana for the cosmopolitan lifestyle and dance-orchestra music of the mission-educated urban elite. "*O pe laif*" ("she likes *life*") is a commonly used compliment for a woman who dresses fashionably. The opposite of such a positive evaluation, explained long-time Kumasi resident and

cultural studies teacher Mr M. H. Frempong, is "o ye atetekwaa," a pejorative assessment that most Kumasi women endeavor to avoid:

> The Ashanti coined this word, *tete*, meaning ancient dressing all the time. In the olden days, this was an old-fashioned way of dressing, of not putting on fine clothes ... Other women look down on such a woman, saying, "O ye atetekwaa." This means the woman doesn't like to dress well all the time. This is a terrible thing to call somebody, they will be very much angered ... If you visit friends in faded cloth, they will say out of your hearing, "O ye atetekwaa." The Gas [a coastal people] will never do that, but the Ashantis will do that—they want to be dressing beautifully all the time. If you don't do what they do, they say "*atetekwaa*."

A related term, he continued, is *pepee*, used to describe a person who doesn't dress well because of extreme frugality or "miserliness,"—a quality conventionally attributed to men, rather than women:

> A woman could never be *pepee*. Because for a woman, if she has the means, she will buy things to go out and better appear neatly [well-dressed]. She will never be *pepee* if she has the means, even if she is not married.[9]

The Special Significance of African-print Cloth

Within Ghana's Ashanti Region, women of different economic levels, educational backgrounds, ethnic identities, and religious beliefs all participate in a unified system of value in respect to ensemble fabric and style.

Women's ensemble fabrics are grouped into two basic categories: *ntoma* ("cloth")[10] and *material*. *Ntoma*, as well as the English word *cloth*,[11] serve as umbrella terms for the first category, which is comprised of three highly-valued textiles. Two of these prestigious textiles are products of local industry: hand-woven *kente*, a silk, rayon, or cotton strip-cloth textile historically associated with Akan rulership (Ross 1998); and *adinkra*, a cotton cloth stamped with symbolic designs, which is customarily associated with Asante funerals (Mato 1986). The third highly-esteemed textile is the distinctive factory-produced fabric known as *African-print cloth*, initially developed by late-nineteenth-century Europe manufacturers for the lucrative western and central African textile markets, with African manufacture beginning in the 1950s (Addae 1963[1956]; Bickford 1997; Littrell 1977; Nielsen 1974, 1979; Pedler 1974; Picton 1999; Rabine 2002; Spencer 1983; Steiner 1985). The borrowed English word, *material*, the term for the second category of ensemble fabrics, is used in referring to factory-made fabrics other than African-print cloth.

West African peoples first gained access to European textiles in the late fourteenth century, when Europe's interest in the West African market was spurred by European economic expansion and an ever-increasing demand for West African gold. Initially, European products were brought into West Africa by means of Muslim controlled trans-Saharan caravan routes. By the late fourteenth or early fifteenth centuries, Muslim merchants established trading settlements on the northern border of southern Ghana's forest zone (Posnansky 1987: 14–18; Wilks 1962). In the late fifteenth century, European merchant ships succeeded in gaining direct access to the area by establishing trading forts along the West African coast, including the region that came to be known as the Gold Coast (i.e. modern Ghana).

From their earliest contact, European merchants endeavored to discern and meet local consumer preferences, first by insinuating themselves into the established indigenous trade in highly esteemed north and West African textiles, and later by importing colorful East Indian cottons and Javanese batiks (Alpern 1995: 6–8, 10; Sundström 1974: 156–7). European manufacturers also modified their own textile products in order to appeal to African tastes and standards of quality. An early example of such efforts took place during a 1720–50 trade war between dealers in British Manchester cloth and those importing cottons from the East Indies. By the end of this thirty-year period, Manchester's coarse, dull-colored linen cloth had been significantly modified to suit West African consumers' preference for the lighter weight, brightly colored East Indian cottons (Nielsen 1979: 469). The eventual preeminence of European-manufactured cloth in the nineteenth-century African market was, in fact, only accomplished by the "large-scale imitation" of East Indian textiles by Europe's expanding cotton industry (Sundström 1974: 157).

The great popularity of the Javanese batiks, which were introduced into West Africa in the mid-nineteenth century, also prompted European textile producers to use recently developed technology to manufacture wax-print imitations of Javanese batiks for the African market (Nielsen 1979: 470–6; Pedler 1974: 242). To further ensure the commercial success of this new "African-print," European manufacturers also developed designs based on indigenous textiles, investigated the color and pattern preferences of different West African peoples, and employed a variety of marketing strategies, all aimed at furthering their efforts to meet local tastes (Addae 1963[1956]: 27; Cordwell 1979; Nielsen 1974: 25, 38; Steiner 1985: 97–106).

The designs of the African-print cloth produced for Gold Coast markets were given "names," in a manner similar to the named designs of indigenous *kente* and *adinkra* textiles, in order to meet Akan standards of cultural and aesthetic value (Warren and Andrews 1977: 14).[12] For the Asante, all highly valued forms of material culture must possess a name (McLeod 1976). Within Ghana, it is the endowment of African-print designs with culturally meaningful names, often by *cloth* traders

of the Ashanti Region (Boelman and van Holthoon 1973: 239) that distinguishes African-print cloth from all other manufactured textiles.

The names given to African-print designs may reference important events in Asante political history, as in the *cloth* named *Bonsu* ("Whale"), named for the early-nineteenth-century Asantehene Osei Tutu Kwame, who earned the title "Bonsu" after becoming the first Asante king to successfully lead a southern military campaign all the way to the sea (Buah 1998: 95). African-print names may have religious meanings, such as the *cloth* called *Yesu Mogya* ("The Blood of Jesus"), while other African-prints are named after common elements of everyday life, as in the *cloth* designs *Aya* ("Fern") and *Kwadusa* ("Bunch of Bananas").[13] New African-print designs have also been given the names of popular *highlife* songs (van der Geest and Asante-Darko 1982: 28–9).

The strong interrelationship between Akan verbal art and visual culture, which Cole and Ross have termed the "verbal-visual nexus" (1977: 9–12), finds expression in the particular value accorded those visual forms that are associated with "some more-or-less fixed verbal expression" (McLeod 1976: 88-9). The Akan refer to such verbal expressions as *ebe*—a speech genre conventionally translated as "proverb"—that includes not only proverbs but "moral-embedded extended metaphors, illustrative anecdotes, and parables" (Yankah 1989: 88–9). *Ebe* or *ebebuo* ("speaking" *ebe*). Yankah observes, may be expressed aurally in speech, song, or tonal drumming, and visually in sculptural form, textile design, dance gesture, or demeanor (1989: 98).

Asante *ebe* provide a major source of textile names, such as the popular African-print design *Akwadaa bo nwa* (Figure 5), which is an abridged version of the saying *Akwadaa bo nwa na ommo akyekyedee* ("A child can break the shell of a snail, but cannot break that of a tortoise," i.e. only attempt what is appropriate to your level of ability). Other *ebe*-derived names, such as the funerary African-print designs *Nsuo afa borodee hono* ("The stream carries away plantain peels," i.e. death carries people away) and *Owuo atwedee* ("The ladder of death," everybody climbs it) visually express philosophical commentaries on the transience of life and inevitability of death.

Marriage and motherhood are ever-popular subjects. The African-print *Nsubura* ("Wells"), whose concentric circular designs are likened to small natural wells, signifies the "stillness," or stability, and depth of an ideal marital relationship. On a more cautionary note, the *cloth* named *Barima nye sumye* ("Man is not a pillow," i.e. "you cannot rely on a man for security"), stresses the need for female self-reliance and financial autonomy, even within marriage. Asante maternal ideals of nurturance and protection find expression in African-print cloth with the well-known image, *Akokobaatan ne ne maa* ("Mother hen and her chicks").[14]

While a sophisticated knowledge of named African-print designs remains strongest among *cloth* traders and older women, the fact that African-print cloths are generally known to possess names continues

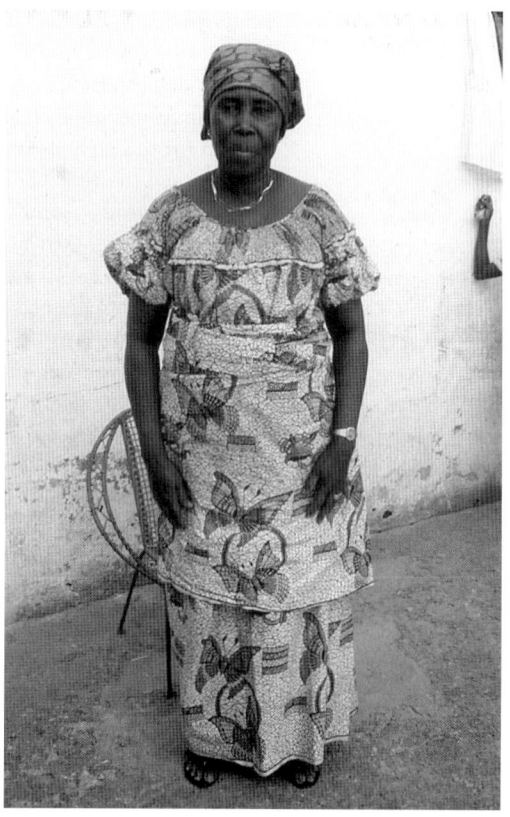

Figure 5
A Kumasi trader wearing the African-print design *Akwadaa bo̱ nwa na o̱mmo̱ akyekyedeẹ* ("A child can break the shell of a snail, but cannot break that of a tortoise"), 1990. Photograph: Suzanne Gott.

to endow these factory-produced textiles with a cultural and economic value recognized by women of all ages and from all walks of life. As Juliana Osei, a young schoolteacher in her twenties explained: "If you put on *cloth* with no name, it is not good *cloth*. It is important to show people that you have put on good *cloth*."[15]

The Relationship between Fabric and Ensemble

Distinctions of value between *ntoma*, or *cloth*, and *material* are also expressed in local conventions regarding the matching of fabric to ensemble style. Only *kente*, *adinkra*, and African-print cloth are used for women's prestigious *dansinkran* and *kaba* ensembles, while those fabrics called *material* are relegated to that category of Western-style ensemble called *ataadeẹ* ("dress" or "skirt and top"). A woman's selection from among these three categories depends on the occasion and on her stage of life.[16]

Ataadeɛ, the umbrella term for sewn dresses, skirts, and blouses, is the usual attire of girls and younger women. However, as a woman matures, three-piece *kaba* ensembles of African-print cloth become an increasingly important part of her wardrobe. Women who have reached their fifties rarely wear *ataadeɛ* ensembles in public because only *dansinkran* or *kaba* ensembles are considered appropriate to the "respectability," or dignity, of an older woman.

Asante women's customary two-piece *dansinkran* ensemble, consisting of a wrapped lower and upper cloth, is named for the distinctive Asante *dansinkran* hairstyle.[17] The *dansinkran* hairstyle and wrapped ensemble, which is worn by queen mothers, elderly women, and chief mourners at Asante funerals, is regarded as an especially beautiful expression of time-honored Asante custom (*ammamerɛ*) and cultural pride (Figure 6).

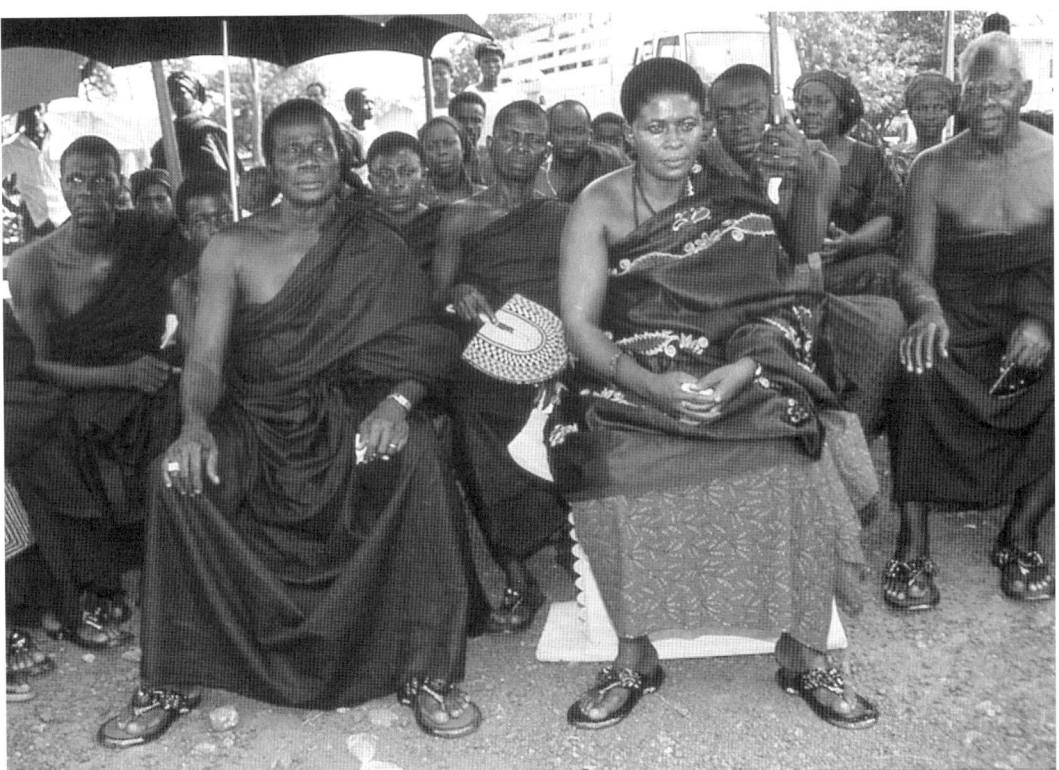

Figure 6
An Asante queen mother sitting in state, with the *dansinkran* hairstyle and two-piece wrapped *dansinkran* ensemble, 1990. Photograph: Suzanne Gott.

The *kaba*, a syncretic three-piece ensemble, consists of a sewn blouse (*kaba*), a wrapped or sewn skirt (*abo̱so̱o̱* or *slit*), and an unsewn cloth (*akataso̱o̱*, or *second cloth*) that can be worn as a second wrapper, or folded and tied into stylish headgear (Figure 7). The term *kaba*—a local adaptation of the English word "cover"—probably originated within the pidgin trade languages of Africa's western coast.[18] During the nineteenth century, *kaba* was the name given to three very different regional styles that incorporated elements of European dress: Ghana's three-piece *kaba* ensemble; the *kaba sloht* dress of Sierra Leone (Wass and Broderick 1979); and the smocked *kaba* dress style of Cameroon.[19]

The Ghanaian *kaba* ensemble was created by the addition of a European-inspired, sewn blouse to the one- or two-piece wrapped ensemble that was commonly worn by women in many West African societies. This syncretic ensemble first developed in coastal towns, which had trade relationships with European merchants dating to the late fifteenth century, and in those communities strongly influenced by nineteenth-century

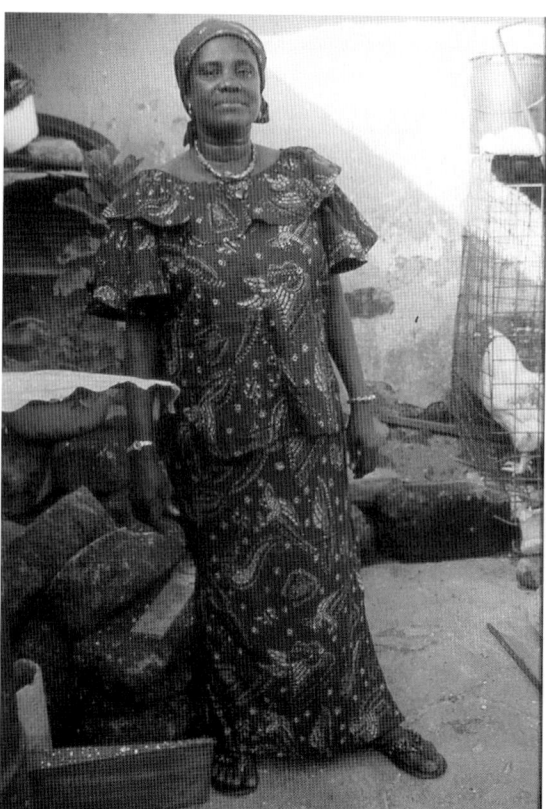

Figure 7
Mrs Mary Owusu-Ansah, dressed in a *kaba* ensemble of African-print cloth, 1990. Photograph: Suzanne Gott.

European missionary activity. However, the *kaba* did not become an established style in the Asante interior until the early twentieth century, after the imposition of British colonial rule in 1896 provided access to European missionaries and immigrants from the coast (Gott 2005).

Over the course of the nineteenth century, European-style clothing increasingly became the preferred attire of Ghana's mission-educated elite, while the *kaba* came to be regarded as the dress of women who had no formal schooling (Figure 8). However, during the decades preceding Ghana's 1957 independence from Great Britain, the *kaba* ensemble gained new popularity among educated women as a symbol of national pride. On the eve of Ghanaian independence, Beauchamp noted the widespread use of European-produced African wax-prints in Ghana "for making up into the noble national costume" (Beauchamp 1957: 209), and film footage of the 1957 Independence Ball, broadcast annually on government-sponsored television, shows women stylishly attired in *kaba* ensembles worn as evening dress, with the *second cloth*, or *akataso̱o̱*, folded and draped around their shoulders as an elegant matching stole.[20]

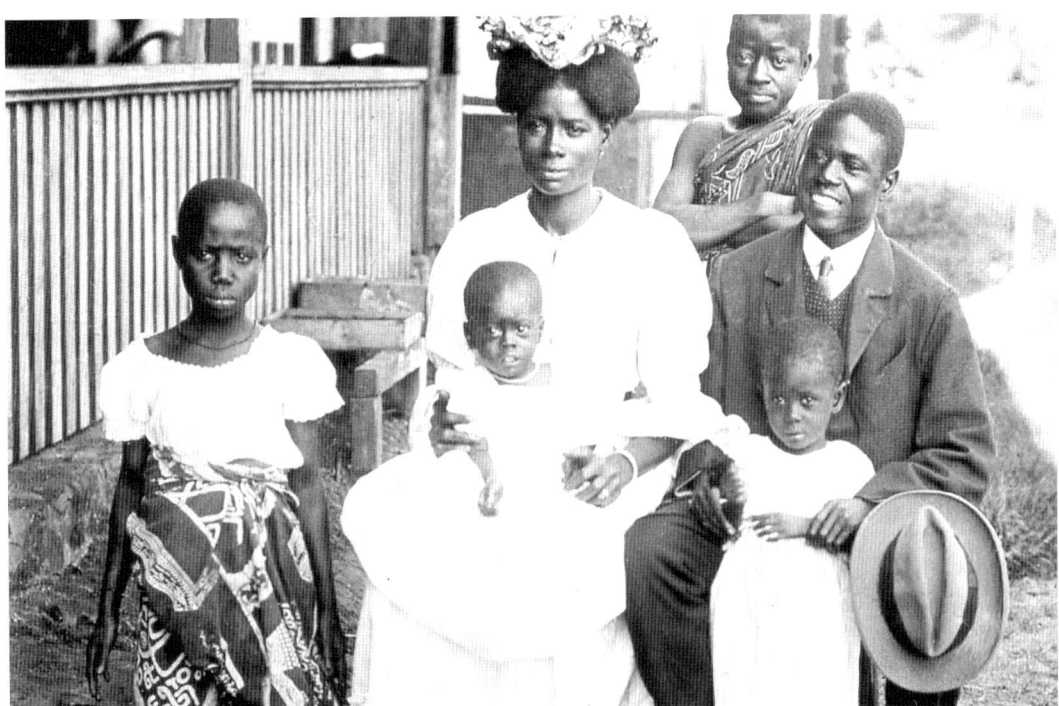

Figure 8
Abetifi seminary: the housemaster, catechist Ofori, with his family. 1896–1912. Photograph: probably Mr. Karl Wieber. Archives mission 21 / Basel Mission Archive, D-30.14.035.

In present-day Ghana, fashionable *kaba* ensembles of African-print cloth are worn either daily or for special occasions by women from all walks of life. This practice is especially apparent within the Ashanti Region, where African-print *kaba* ensembles have a particularly strong association with female maturity and women's wealth.

African-print Cloth as Women's Wealth

In Asante, the accumulation and wearing of prestigious African-print cloth is considered emblematic of respectable female maturity and financial well-being. The particular significance of *cloth* accumulation and display for the women of contemporary Asante is based in textiles' historical value as a widely circulated commodity and currency form throughout western and central Africa (Johnson 1980; Martin 1986). In Ghana's Ashanti Region, textiles have also been regarded as a distinctively female form of wealth since at least the mid-eighteenth century (Mikell 1989: 16).

Momentous social and economic changes followed the 1896 imposition of British colonial rule, some of which proved particularly detrimental to the financial security and well-being of Asante women. Women responded to these challenges with new strategies for financial autonomy in which textiles, with their historic status as female wealth, proved to be an important resource.

During the early decades of the twentieth century, Ghanaian agriculture, under colonial influence, made a major shift from customary food-crop production to a cocoa-based cash-crop agricultural economy largely controlled by male farmers. As a result, a wife's work on her husband's land ceased to produce crops that would feed their family, because labor on a husband's cocoa farm only yielded monetary profits. Rural wives therefore became dependent on a husband's willingness to contribute a portion of his cocoa profits to the subsistence needs of his wife, or wives, and their children (Allman 2001: 139–40; Roberts 1987: 54).

The concerted efforts of Christian missionaries and colonial institutions to replace Asante's matrilineal kinship system with the Western nuclear model simultaneously succeeded in weakening matrilineal loyalty and "the moral imperative of blood kinship" that customarily ensured support from a woman's brothers and other matrilineal kin. During the course of the twentieth century, Asante women became increasingly dependent on what is generally considered to be the more tenuous marital bond and on financial support contingent on a husband's "continued loyalty and prosperity" (Clark 1999b: 71–2).

Then, in the early 1960s, a sudden drop in the value of cocoa on the international market initiated a chronic state of economic crises that has substantially reduced the real income of most Ghanaians. In subsequent decades, the substantial decline in Ghanaians' real incomes brought about "a dramatic shift in the balance of contributions between husband and

wife" that made it even more difficult for wives to obtain the food money and children's school fees customarily expected of husbands and fathers (Clark 1999b: 67, 73–6). The steadily deteriorating economy has led Asante women to regard financial self-reliance as a fundamental requirement for female maturity and motherhood, by providing a mother with the capacity to feed and educate her children if her husband is unable to fulfill his customary paternal obligations (Dinan 1983: 351–2; Manuh 1993: 179).

Good-quality African-print cloth, an asset that only increases in value, provides Asante women with a ready source of cash when funds are needed to pay for children's school fees or to weather times of financial crisis. One such crisis can be the death of a husband.

Within the Asante matrilineal inheritance system, a husband's death may result in members of his extended matrilineage not only laying claim to the husband's property but to jointly acquired marital assets as well.[21] However, on such occasions the widow's cloth and clothing usually remain untouched because of textiles' customary status as relatively sacrosanct forms of female wealth. Conversely, in the event of a wife's death, strong social sanctions will usually prevent her husband from acquiring the wife's clothing and textiles in order to sell them, or present them to another wife or girlfriend. The relatively inviolable wealth embodied in a woman's cloth and clothing thus provides Asante wives with a valuable means of safeguarding financial assets, as well as a strategic means of securing an inheritance for their children.

In the Ashanti Region, women of widely differing financial means are united by their strong interest in acquiring and accumulating good-quality African-print cloth. This distinctive textile has been at the center of Asante women's *cloth* accumulation strategies since the early twentieth century, a period marked by a substantial increase in the importation and sale of African-print cloth.[22] At that time, women also began moving into the previously male-dominated market trade in such prestigious imported goods, which men were abandoning in favor of more lucrative cocoa farming and wage work. Increasing numbers of women began trading in imported cloth, liquor, and tobacco (Clark 1994: 316–18). Soon, cloth trading came to be regarded as not only a distinctly female enterprise, but a profession with the potential for achieving the status of a wealthy woman.

During the 1990s, assessments of female prosperity were, in fact, frequently expressed in terms of the number of African-print cloths a woman owned, as in Mrs Selina Aggrey's description of her wealthy landlady:

> She is rich! She has a large wardrobe filled with *cloth* ... She has so much that you would think she is selling it ... Any new *cloth* that comes, she wants to be the first person to buy it.[23]

This landlady's daughter, she added, was "just like her," with a substantial bank account that was equaled by the cash value of the daughter's own stockpile of over 150 pieces of high-quality African-print cloth.

Women's *Cloth* Wealth and the Asante Display Imperative

Given the long-established nature of Asante culture's emphasis on high-status display, it is not surprising that women are expected to demonstrate their capacity to acquire and accumulate good-quality African-print cloth. A woman's dress receives particular scrutiny after she reaches adulthood, marries, and bears children. It is generally said that a woman who fails to wear a sufficient number of good-quality African-print ensembles or who wears only the cheaper grades of African-print cloth will be "laughed at," or ridiculed.

Kaba ensembles of African-print cloth are endowed with particular significance because of their capacity to communicate unequivocally their economic worth (Boelman and van Holthoon 1973: 247; Gott 1994: 59–67). When Kumasi women comment on an African-print *kaba* ensemble they see worn at a social event or by a woman they pass on the street, their evaluation characteristically begins with an astute appraisal of the ensemble's monetary value. Such assessments are facilitated by two important characteristics of African-print ensembles, one being the standard six-yard unit in which African-print cloth is sold and worn. The second characteristic is the well-established ranking system, based on quality and price, for different kinds of African-print cloth.[24]

Most women keep well informed as to the current market value of the varieties of African-print cloth. The simple statement, "*eye Holland*" ("it is *Holland*," i.e. a Dutch wax-print), is an appreciative evaluation of the highest order because imported Dutch wax-print *cloth* has long been regarded as the most prestigious African-print cloth in Ghana, with the required six yards costing 400,000 to 500,000 cedis (US$48 to US$60 in 2003, in an economy where the average annual income is equivalent to US$350). A woman who wears only cheaper grades of locally produced African-print cloth, costing 60,000 to 70,000 cedis (US$7 to US$8 in 2003) is subject to ridicule, and for this reason, all but the very poorest women endeavor to have at least one ensemble of Dutch wax-print *cloth*. Women are considered to spend a significant percentage of their income on *cloth* and clothing. In the words of one Kumasi woman, "after chop [food] money, the dressing is next."[25]

Husbands are expected to provide gifts of *cloth* and clothing, or the money to purchase these items, particularly upon marriage and childbirth, and as a customary gift at Christmas. Married men, who may have more than one wife in this polygynous society, report feeling considerable pressure to provide their wives with African-print cloth, citing such demands as a common source of marital stress for financially strapped husbands. Yet, as one sympathetic husband observed, Asante women, especially those living within the urban sophistication of Kumasi, feel keenly aware of social imperatives to dress well and

perhaps above their means. A good husband, he explained, must try to help his wife acquire good-quality African-print cloth.[26]

However, most Asante women find men's gifts insufficient in meeting social demands for dressing fashionably and well. Women instead rely more heavily on their own financial initiative for acquiring a respectable quantity of good-quality African-print cloth. During adolescence, girls also begin receiving assistance in this endeavor by occasional gifts of *cloth* from their mother or other family members.[27] And, although younger, unmarried women generally wear *ataadeɛ* ("dress") ensembles of less prestigious *material*, they work to acquire African-print cloth to wear after marriage, and particularly after giving birth.

In the Ashanti Region, a woman's attainment of motherhood has long been an occasion for distinctive personal display. In the past, new mothers would paint their bodies with *hyerɛ* (a local white clay) in order to express their "victory" and "joy" in successfully giving birth (Figure 9).[28] In present-day Asante, new mothers wear fashionable *kaba*

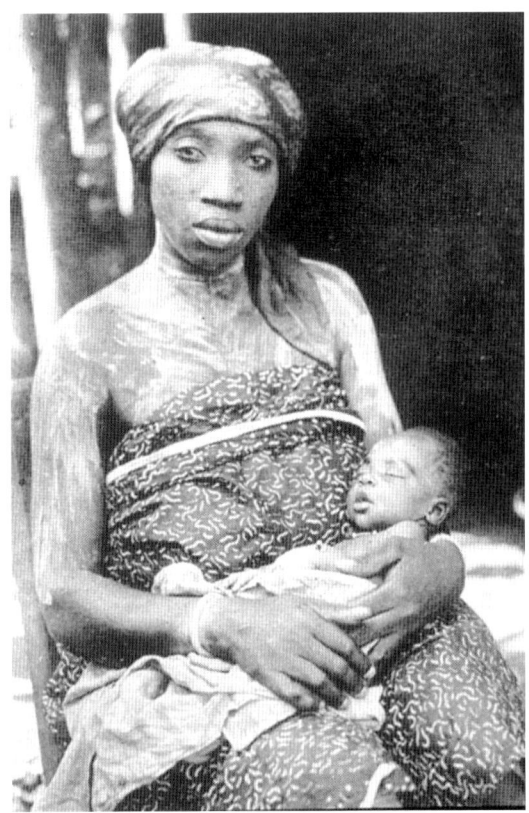

Figure 9
An Asante mother, "dressed in her best attire, with shoulders, breasts, and arms smeared over with white clay," holding her newborn infant during the "outdooring" rites customarily held eight days following childbirth. Photograph: Robert Sutherland Rattray, c.1921–1932.
PRM 1998.312.452.1, Pitt Rivers Museum, University of Oxford.

ensembles of white (*fufuo*) African-print cloth (i.e. white with indigo patterning) to convey their victory and success (Figure 10).[29] A new mother is, in fact, expected to wear a substantial number of new *kaba* ensembles of good-quality wax-print *cloth*, particularly following the birth of her first child.

One friend in her mid-twenties described how she began buying and saving wax-print *cloth* during her adolescence in order to fulfill the African-print cloth display imperative that accompanies marriage and motherhood. "If you are a young woman who gives birth and are not rich enough to buy *cloth*," Julie explained, "then people will laugh at you, saying that you are not of an age to give birth."[30] In 1990, Mrs Bea Asare, a new mother, described the social consequences of failing to meet social demands for wearing a sufficient quantity of new *kaba* ensembles of higher quality African-print cloth:

> When a woman is pregnant, she will find every avenue to get *cloth* so people won't talk against her ... Especially in Kumasi

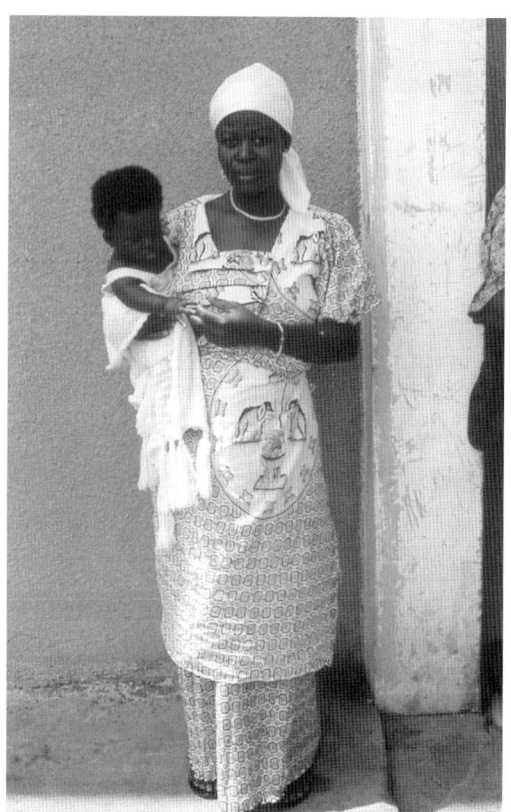

Figure 10
A new mother dressed in "victory white" attending the postnatal clinic at Kumasi Central Hospital, 1990.
Photograph: Suzanne Gott.

when you give birth, they will start counting the *Holland* [Dutch wax-print *cloth*] you wear, because they know that *Holland* is the most expensive *cloth*. If you don't wear many, they will say, "Oh, when she brought forth, she only put on two *Holland* cloths!"[31]

Fashion as Status-seeking Display

Fashion, with its changeability and aesthetic appeal, has become an important component in women's display of African-print cloth. Within Asante, the desire to appear fashionably attired in prestigious *cloth* is generally regarded as a distinctly female characteristic. In the words of an oft-repeated phrase, "while a man will be content to wear the same shirt and trousers for two years, a woman will always be wanting the newest *cloth* and the newest styles."

Fashionable new styles develop and spread rapidly throughout Kumasi's bustling urban environment in a grassroots fashion system that is facilitated by individuals commissioning most of their clothing from local seamstresses or tailors. Male tailors, considered to excel in sewing Western-styled garments because of training in sewing men's tailored styles, are often sought after by younger women desiring dresses or skirt and top (*ataadee*) ensembles. However, female seamstresses are considered to possess greater expertise in designing and sewing the *kaba* ensembles that become an increasingly important part of a woman's wardrobe as she matures, marries, and bears children. As a friend, Mrs Angelina Bilson, explained:

> While a young woman may spend all her money sewing new dress styles with a tailor, no mature woman is going to spend her money sewing dresses of *material*. If she has the money, she will buy *cloth* and take it to her seamstress to sew *kaba*.[32]

Women distinguish between two categories of *kaba* ensembles: *simple* styles and *fanciful*, or *complicated*, styles. Simple styles are said to be more modest and "ladylike." Most women tend to have their better quality, imported wax-print *cloth* sewn in simple *kaba* styles that will remain in fashion for two or three years (Figure 11). Fanciful, or complicated, styles are more distinctive and intricate (Figure 12). Most women only use less expensive local wax-print or imitation wax-print *cloth* for these relatively short-lived styles. However, the Asante *hightimer*, or *preman*, is noted for wearing fanciful *kaba* styles of costly, imported wax-print *cloth*.

The fanciful styles favored by *premanfoo* are distinctive in several important ways. First, fanciful styles are more expensive to sew, both

Figure 11
Mrs Nora Kyei dressed in a three-piece *kaba* ensemble sewn into a *simple* style, 1990. Photograph: Suzanne Gott.

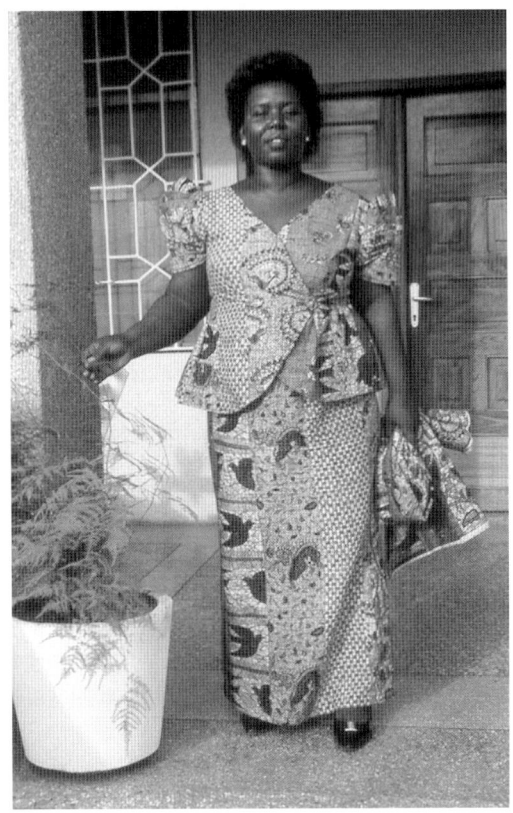

in terms of the higher labor costs of such intricate styles and because of the large quantity of expensive decorative materials that are often used, such as yards of satin ribbon, or gold braid and thread. Fanciful *kaba* styles are also emblematic of the wearer's wealth not only due to the expense in sewing a particular style, but because of the extravagance of sewing valuable *cloth* into a distinctive, fanciful style that will remain stylish for only a short period of time, compared to the lasting stylishness of simpler fashions. Finally, the fanciful *kaba* styles associated with *premanfoo* may be described as "extraordinary" because of more provocative and revealing features, such as a low-cut neckline or short *slit* skirt (see Figures 1 and 4). In Ghana, excessive exposure of the female body is considered improper and is said to be the behavior of "prostitutes," of women who want to attract the attention and patronage of men.

Yet despite such negative associations, the fanciful styles associated with the *preman* may, in fact, become popular fashions worn by numer-

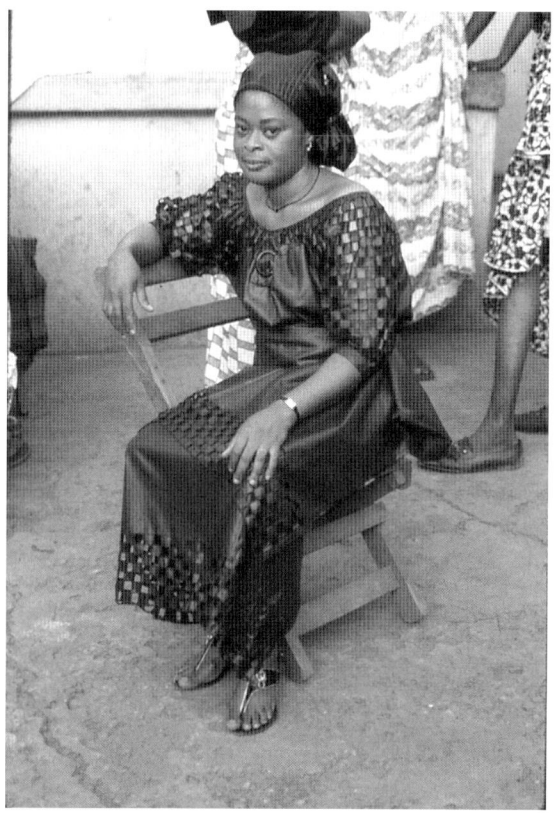

Figure 12
A Kumasi woman attending a funeral dressed in a *kaba* ensemble sewn into a *complicated,* or *fanciful* style, 1990. Photograph: Suzanne Gott

ous women at important social events in Kumasi, albeit in a somewhat modified form (Figure 13; compare with Figure 1). In the 1990s, Abidjan, capital of neighboring Côte d'Ivoire, was reputed to be the source of many of the more fanciful, flamboyant styles favored by the *preman*. Wealthy Asante market women on business trips to Abidjan might commission new *kaba* styles there, and upon returning home, these new styles would be seen and reproduced, often with certain modifications, by Kumasi seamstresses.

Certain popular fashions, such as the low-cut *show-your-shoulders* neckline and the stiffened *big sleeve* of the 1990s, have served to accentuate the physical "greatness" or "majesty" (*kesee*) that is the Asante ideal. The term *kesee*, often appearing in Akan proverbs referring to all-powerful entities, such as *Onyame ye kesee* ("God is great," i.e. all-powerful), or in proverbial allusions to individuals of high position, such as *Aboa kesee na ne nwoma so* ("A large animal's skin is also large"), expresses Asante conceptual linkages between social and physical greatness.

Figure 13
A new mother dressed in a modest version of a fanciful and revealing *preman* style, 1990. Photograph: Suzanne Gott.

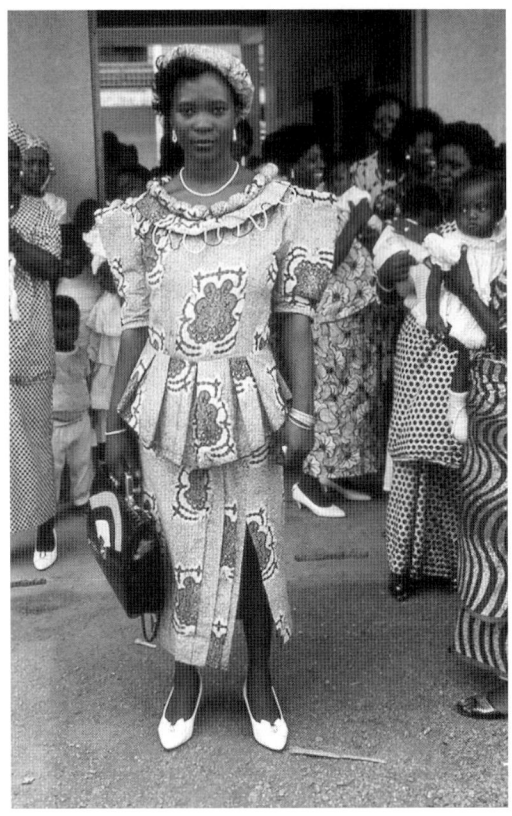

In terms of the Asante *preman*, Madame Akua Abrafi, a Kumasi trader, describes *premanfoɔ* as women who "make everything *kesee* … they make everything about their appearance higher than others … big sleeves, big earrings."[33] During the 1990s, when fashionable *kaba* blouses featured an enlarged *big sleeve* stiffened with interfacing, the *kaba* styles favored by *premanfoɔ* exhibited the most extreme versions of the *big sleeve*, resulting in "*kesee*" *kaba* styles that served not only as a means of augmenting the physical presence of the *preman*, but of asserting the superior social standing of the *preman*, as well.

An additional, associated meaning of *kesee* is "stoutness," or "fatness" (as it is often spoken of in English), a term used in describing the ideal body shape for the mature Asante woman. Greeting a woman with the complimentary statement, "*woayɛ kese paa*" ("you have grown nicely fat"), is a way of telling a woman that she is "looking very attractive." A plump, rounded appearance is considered visible evidence of a woman's inner state, indicating wealth, a good marriage, and a contented, peaceful state of mind. Because of the importance accorded

Figure 14
Mrs Gladys Prempeh (right) with her close friend, wearing the popular *show-your-shoulders* neckline, 1990. Photograph: Suzanne Gott.

plumpness as a visible sign of a woman's personal well-being and success, some Kumasi women have reportedly taken steroids in order to retain water and achieve the appearance of "fatness."[34] *Kaba* styles revealing such ideal plumpness, such as the *show-your-shoulders kaba* blouse style, are understandably popular (Figure 14).

Fashionable Display and the Controversial *Preman*

For those women committed to Asante custom and cultural values, who find *cloth* accumulation a valuable strategy for financial security, the wearing of costly, prestigious dress is regarded as emblematic of the hard work and determination of an ideal Asante woman. Such a sentiment was expressed by one prosperous market trader in 1990: "Dressing is expensive! You can't pay 25,000 cedis for a shoe [roughly US$72 at the time] unless you work hard. So when people see you wearing this expensive shoe, they will say, 'that woman works hard!'"[35]

However, not all women in the Ashanti Region participate wholeheartedly in this local display system with its emphasis on expensive dress, especially those Asante and non-Asante civil servants and teachers whose education, as well as limited incomes often place them at odds with Asante customary status-seeking behaviors. These women tend to regard all contemporary *poatwa* displays, especially the extravagant dress and behavior of the *preman*, as highly visible instances of the "wastefulness" and "backwardness" of Asante excess and ostentation. For such women, the display imperative associated with the Ashanti Region's fashion system is an unnecessary burden, not a status-seeking opportunity.

In fact, pejorative comments concerning *preman* dress and behavior reflect an ongoing critical commentary within Asante society concerning the illusory nature of elite prestige displays. Thus, although the "gorgeous dress" of a *preman* may elicit an admiring appraisal that the wearer is "a very rich woman," her costly dress may also evoke the wry observation that *premanfoo* are only able to dress so beautifully by borrowing or "hiring" [renting] the clothing of other women. Such skepticism concerning the substantiality of conspicuously displayed wealth is not new in Asante culture, being articulated by such popular proverbs as "Empty barrels make the most noise" (*Ankore a hwee nnim no na ekasa dodo*), and the proverb, "You say you have become fat, but you are full of water" (*Wose waye kese, nso woahye nsuo*).

Such criticisms of *premanfoo* have implications beyond questions of dress as an element of *poatwa* displays of wealth. Many women are also highly critical of the deviance of *preman* behaviors from the social expectations for a modest Asante woman. For one well-educated Kumasi woman, the *preman* constitutes a particularly scandalous type of person, known "by the way she dresses and the way she moves around." She characterized *premanfoo* as being:

> ... those women who want these fanciful styles [and who] move about spending a lot of money on drinks and so forth, having fun by themselves. They like moving with men, [they] can't stay at one place, you meet them at any funeral, any social gathering.[36]

She also described the fanciful styles she associated with the *preman* as being "extraordinary" (i.e. highly visible and even scandalous), with low-cut, revealing necklines and *slit* skirts cut scandalously high. The wearing of such revealing styles causes some women and men to say that *premanfoo* behave "like prostitutes" by dressing in a provocative manner in order to attract male attention and financial favors.[37]

The concept of the flamboyantly wealthy *preman* as being "like a prostitute" has some illuminating parallels in early-twentieth-century

Ghana. At that time, when colonialism and the new cocoa-based agricultural economy placed married women at a distinct disadvantage, Allman found that Asante women who chose to remain unmarried in order to pursue their own financial autonomy were frequently accused of being prostitutes. Their efforts to remain independent from male control and authority caused great unease among many local chiefs, who actually imprisoned women until they consented to marry (2001: 130–3). During the early colonial period, Ghanaian women who migrated into towns in order to pursue wealth and autonomy outside the confines of marriage and patriarchal village life were criticized for their acquisitiveness and promiscuity, as in the 1930s *highlife* song quoted by Akyeampong, "Wo pe tam wo npe ba" ("You like *cloth* but you don't want children") (2000: 228).

In contemporary Asante, the independence of *premanfoo* from the control of husbands, as well as male and female elders, is a major factor in *preman* impropriety. Although Asante is a matrilineal society, in which inheritance passes through the maternal line, senior men have customarily exercised significant control over the women of their matrilineage. The twentieth-century introduction of Christianity, with its emphasis on the Euro-American model of a nuclear family under the authority of the husband and father, has provided a new, even more restrictive ideology that inhibits female autonomy. Mrs Mary Owusu-Ansah, a retired civil servant, expressed the association of *preman* dress with social marginality:

> When they call a woman a *preman*, it means she has been a hooligan before. It is not good. They are those women who do not respect themselves, married women who are free to be approached by men with their dressing … If you are a married woman, you can't dress like that … Some women, as soon as you see them, you know that they are not under anyone, a husband or family member. The average woman can't go out in such a manner. A woman who respects her husband can't go out that way. If girls come from good homes, they don't dress in such a manner … *Preman* people are always the people who wear gorgeous things everywhere. They will go to a funeral not wearing funeral costume … They won't abide by what others say.

However, when questioned further, Mrs Owusu-Ansah made a marked distinction between the propriety required of married women, daughters, or nieces, and the greater latitude acceptable for an unmarried, financially independent woman. When asked if an unmarried woman could be a *preman*, she responded:

> Yes, a woman can if she is not married, is well-to-do and controls herself. If she is a wealthy woman who can do what she likes. If

she's the breadwinner of her family; if she is wealthy, sometimes has her own building. She is an all-around woman. You see her with necklaces, bangles, high heels, gorgeously dressed. She can talk as she likes.[38]

Conclusion

Asante *premanfoo* flaunt their wealth and independence by wearing fanciful *kaba* styles of prestigious African wax-print cloth. Such fashionable, high-visibility displays of *cloth* wealth and superior status constitute a distinctly female mode of Asante *poatwa* display, which is based in the special status of African-print cloth and clothing as a major form of female wealth. Yet, the revealing styles favored by the flamboyant *preman* also represent a freedom from customary restraints on female behavior and sexuality that has provoked the notoriety associated with the Asante *preman*.

Most women do not engage in such extreme displays of financial well-being and autonomy. However, virtually all women living in Ghana's Ashanti Region actively pursue the accumulation and fashionable display of good-quality African-print cloth. Some, such as the Asante *premanfoo*, are enthusiastic participants in this endeavor. Other women may, in fact, voice displeasure at the social pressure to acquire and wear expensive *cloth*, as in the following conversation in 1990 among three school teachers—Angelina, Bea, and Nora.[39] Bea, an Asante woman who had recently returned from teaching near the coastal capital of Accra, complained that:

> In Accra, people don't care what you put on, but when you come to Kumasi, people are very particular about dressing ... Illiteracy is the reason. For people in the Ashanti Region, education came late. In Accra, people don't care, but in Kumasi there is a special *cloth* and everyone would want it, and even styles, everyone would want to sew that style with even one in that particular *cloth*.

Yet, even within the context of this sometimes heated discussion about the burdensome pressures for women to dress fashionably and well, Bea concluded by drawing attention to the particularly fashionable character of her friend and fellow schoolteacher Angelina, exclaiming "*Angie pe laif paa*!" ("Angie likes *life*, i.e. dressing fashionably, very much!"); and Bea commented on the special interest in fashionable dress that she observed in her own four-year-old daughter, Amma Seiwaa, who regularly expressed special admiration for Angelina's stylishness:

Amma Seiwaa is always talking about money and dressing ... Angie is her idol. Amma Seiwaa used to come to school and when we came back home, all she would talk about is Angie and her dressing, saying "Angie *pe laif!*" ... When we are going out, every person Amma Seiwaa sees, she will comment on their dressing—their hairdo, shoes, dresses.

"She's like Abigail [Nora's six-year-old daughter]!" Angelina interjected, as Bea continued:

I tell Amma Seiwaa, "You like dressing too much," but my husband says, "She's just like you. *O pe laif na nso wo pe laif*" ("She likes fashionable dress because you also like fashion") ... When going to church on Sunday, Amma Seiwaa will select her own dress on Saturday ... I'm embarrassed, she's too young. But my mother says I was like that, too.

Thus, in a discussion critical of the dress display imperatives for women in the Ashanti Region and of the extravagant, flamboyant fashions of the Asante *preman*, these three schoolteachers also admitted their own special interests in dressing well, as well as their daughters' precocious preoccupation with *life*—the fashionable stylishness considered to be a fundamental feature of contemporary Asante womanhood.

Epilogue

During the late 1980s and early 1990s, women invested significant percentages of their income in costly Dutch wax-print textiles and more affordable West African factory prints. By the late 1990s, Ghana's worsening economy began limiting women's acquisition of African-print cloth; although money or *cloth* sent by family members living abroad provided one means of continuing to dress well. By 2007, new, cheaper versions of African-print cloth manufactured in China had become increasingly popular, enabling women to continue wearing fashionable African-print *kaba* ensembles. At the same time, world fashions, especially imported second-hand clothing, have become increasingly popular not only with Ghanaian men and youth, but with a growing percentage of middle-aged women who now largely reserve their African-print ensembles for church, funerals, and special occasions.

Notes

1. Use of the term, *hightimer,* for those engaged in an extravagant, elite lifestyle, is conceptually linked to *highlife,* the name given to

the elite cosmopolitan lifestyle and syncretic Ghanaian-European dance-orchestra music that developed among Ghana's early-twentieth-century educated urban elite (Collins 1976: 62–3).
2. The Asante constitute the largest subgroup of the linguistically and culturally related Akan peoples of southern Ghana. Their language is Asante Twi, the most widely spoken dialect of the Akan language.
3. See the following selected works on Asante leadership regalia: Cole and Ross (1977), Garrard (1989), Kyerematen (1964), and Ross (1977, 1998, 2002).
4. Similar characterizations of Asante funerals are made by Arhin (1994: 307) and by Manuh (1995: 188).
5. Interview with Mr M. H. Frempong, Kumasi, June 1990.
6. This practice had historical precedents among the Akan peoples living on the coast. A 1602 account by Dutch merchant Pieter de Marees describes and illustrates a "triumphal ceremony" held to celebrate a man's rise to the status of "Brenipono," or "Nobleman" (1987[1602]: 167). French prefect Fr Godefroy Loyer's 1714 account of his visit to a different coastal region records one male trader's prayer for "Brembi," or *obirempon* status (1935[1714]: 213), indicating that similar ennoblement ceremonies may have taken place among various coastal peoples.
7. In present-day Asante, the honorific title of *obirempon* ("valiant, powerful man") has a female corollary in the term, *obaa barima* ("valiant, manly woman"), that is used for market women who achieve "the level of financial success and economic independence considered essential for men" (Clark 1999a: 722).
8. In Asante, the assumption of "royal" prerogatives by members of the moneyed, rather than royal, elite remains a point of contention that continues to the present day, as in the restrictions concerning the wearing of *ahenemma mpaboa* ("royal children's sandals") by non-royals at ceremonial and ritual gatherings.
9. Interview with Mr M. H. Frempong, Kumasi, May 1990.
10. For the Fante, a coastal Akan people, the term for cloth is *ntama*.
11. In this article, the word *cloth* will be italicized when referring to African-print cloth, in keeping with the Asante linguistic convention of using the term *ntoma*, or the English *cloth,* to distinguish African-print cloth from other factory-produced textiles.
12. The Akan practice of assigning names to textile designs has been well documented in respect to the three most valued forms of cloth: locally produced hand-woven *kente* and hand-stamped *adinkra,* as well as imported and, more recently, local factory produced African-print cloth (Boelman and van Holthoon 1973; Bowdich 1966[1819]; Domowitz 1992; Gott 1994; Mato 1986; Rattray 1927; Ross 1998; Warren and Andrews 1977).
13. The deeper levels of meaning that may be associated with seemingly mundane names is exemplified by the *cloth Aya* ("Fern"), an

African-print whose fern-like designs and name are reminiscent of an earlier *adinkra* pattern. In Rattray's discussion of the *adinkra* design *Aya*, he observed that in addition to "fern," the Asante word *aya* "also means 'I am not afraid of you,' 'I am independent of you,' and the wearer may imply this" by wearing this design (1927: 265). Certain women also find deeper meaning in the *cloth* name *Kwadusa*, as a metaphorical allusion to matrilineal unity and support.

14. See Gott (1994: 71–106) for an extended discussion of African-print cloth naming practices and Gott (2003) for a discussion of the particular salience of maternal imagery in matrilineal Asante.
15. Interview with Juliana Osei, Kumasi, January 1990.
16. See LeBlanc (2000) for a study of the relationship between dress and Muslim women's life course in Bouaké, Côte d'Ivoire.
17. Asante women's *dansinkran* hairstyle consists of closely cropped and darkened hair, with a shaved, recessed hairline outlined with a mixture of soot and shea butter in order to create a high, clearly delineated forehead.
18. Personal communication, Dr Kofi Agyekum, Department of Linguistics, University of Ghana, Legon, July 1999.
19. Personal communication, Dr Virginia DeLancey, African Studies Program, Northwestern University, Evanston, Illinois, September 1995.
20. Personal communication, Mrs Angelina Bilson, Kumasi, March 1990. See Wass (1979), and LeBlanc (2000), for investigations into the impact of historical change and political identity on dress in Lagos, Nigeria, and in Bouaké, Côte d'Ivoire.
21. In 1985, the national government passed the Intestate Succession Law to ensure that the widow and a man's children receive a portion of his estate. In actual practice, however, the law has had limited effect on customary inheritance practices (De Witte 2001: 173–9).
22. See Boelman and van Holthoon (1973) for more information.
23. Interview with Mrs Selina Aggrey, Kumasi, June 1990.
24. *African-print cloth* is an umbrella term for three closely related fabrics—*African wax-prints*, *Java prints*, and *fancy prints*—all with designs created to suit consumers' tastes in different regions of western and central Africa: *African wax-prints* are machine-made batiks manufactured in a process that imitates the Javanese handmade batik method. Designs are applied in hot wax or resin to both sides of plain cotton cloth using mechanized rollers. This printing process has been carefully developed to create the imperfections that are distinctive to handmade batiks, such as crackling of the wax or drip spots of wax. The fabric is then dyed indigo, leaving a blue pattern on a white background after the wax or resin is removed. Additional colors may then be added by hand blocking or by a special printing run. *Java prints* are high-grade imitations of wax-prints produced by direct roller printing, preceded and/or followed by special dyeing or chemical processing. *Fancy prints* are lower quality wax-print imitations produced

by direct roller printing with no additional dyeing or chemical procedures (Bickford 1997; Nielsen 1974, 1979; Picton 1999).
25. Interview with Mrs Bea Asare, Kumasi, July 1990.
26. Interview with Mr Maxwell Gyamfi, Kumasi, March 1990.
27. See Manuh concerning the increasingly important role of Ghanaian emigrants' financial contributions and gifts of European-manufactured African-print cloth in keeping "close family members well clothed and able to maintain a semblance of well-being" (1998: 14).
28. See Rattray's documentation of Asante body-painting practices for new mothers (1927: 62) and Hagan's discussion of Akan color symbolism for *fufuo* ("white") (1970: 11–13).
29. Women often compare childbirth with "going off to battle," and describe labor as a perilous event in which the woman or baby may not survive—a fear borne out by the continuing threat of maternal and infant mortality in West Africa. A new mother therefore wears white to signify her victory over death, as well as her joy and success in giving birth.
30. Interview with Juliana Osei, Kumasi, June 1990.
31. Interview with Mrs Bea Asare, Kumasi, July 1990.
32. Interview with Mrs Angelina Bilson, Kumasi, September 1990.
33. Interview with Madame Akua Abrafi, Kumasi, September 1990.
34. Personal communication, Dr John Bilson, Kumasi, July 1990.
35. Interview with Mrs Gladys Prempeh, Kumasi, November 1990. At that time, 300 to 350 cedis (US$0.85 to US$1) was considered to be the average worker's daily income.
36. Anonymous interview, Kumasi, June 1990.
37. Certain cultural factors, however, complicate assigning the label of prostitute to all women seeking financial favors from men: As Dinan observes, there is a long-established sense of reciprocity associated with customary courtship and marriage, in which men are expected to provide gifts and maintenance in exchange for sexual access (1983: 353). Akyeampong also notes that, given "the traditional context of gender relations among the peoples of southern Ghana, it is not surprising that sexuality became a key resource in women's endeavor to acquire wealth in towns" (2000: 228).
38. Interview with Mrs Mary Owusu-Ansah, Kumasi, September 1990.
39. Interview with Mrs Angelina Bilson, Mrs Bea Asare, and Mrs Nora Boakye, Kumasi, July 1990.

References

Addae, Gloria. 1963[1956]. "The Retailing of Imported Textiles in the Accra Market." Ibadan, Nigeria: Nigerian Institute of Social and Economic Research.

Akyeampong, Emmanuel. 2000. "'*Wo pe tam won pe ba*' ('You like cloth but you don't want children'): Urbanization, Individualism, and Gender Relations in Colonial Ghana, *c*. 1900–39." In David M. Anderson and Richard Rathbone (eds) *Africa's Urban Past*, pp. 222–34. Oxford: James Currey.

Allman, Jean. 2001. "Rounding Up Spinsters: Gender Chaos and Unmarried Women in Colonial Asante." In Dorothy L. Hodgson and Sheryl A. McCurdy (eds) *"Wicked" Women and the Reconfiguration of Gender in Africa*, pp. 130–48. Portsmouth, NH: Heinemann.

Alpern, Stanley. 1995. "What the Africans Got for Their Slaves: A Master List of European Trade Goods." *History in Africa* 22: 5–43.

Arhin, Kwame. 1990. "Trade, Accumulation, and the State in Asante in the Nineteenth Century." *Africa* 60(4): 524–37.

Arhin, Kwame. 1994. "The Economic Implications of Transformations in Akan Funeral Rites." *Africa* 64(3): 307–22.

Beauchamp, P. C. 1957. "A Gay Garb for Ghana." *West Africa* March 2, 41(2081): 209.

Bickford, Kathleen E. 1997. *Everyday Patterns: Factory-printed Cloth of Africa*. Kansas City, MO: University of Missouri-Kansas City.

Boelman, V. J. and F. L. van Holthoon. 1973. "African Dress in Ghana." *Kroniek Van Afrika* (Leiden) 3: 236–58.

Bowdich, T. Edward. 1966[1819]. *Mission from Cape Coast to Ashantee*. London: Frank Cass & Co.

Buah, F. K. 1998. *A History of Ghana*. London: MacMillan Education.

Christaller, J. G. 1933. *Dictionary of the Asante and Fante Language called Tshi (Twi)*, 2nd edn, revised and enlarged. Basel: Basel Evangelical Missionary Society.

Clark, Gracia. 1994. *Onions are My Husband: Survival and Accumulation by West African Market Women*. Chicago, IL: University of Chicago Press.

Clark, Gracia. 1999a. "Mothering, Work, and Gender in Urban Asante Ideology and Practice." *American Anthropologist* 101(4): 717–29.

Clark, Gracia. 1999b. "Negotiating Asante Family Survival in Kumasi, Ghana." *Africa* 69(1): 66–86.

Cole, Herbert M. and Doran H. Ross. 1977. *The Arts of Ghana*. Museum of Cultural History. Los Angeles, CA: University of California.

Collins, E. J. 1976. "Ghanaian Highlife." *African Arts* 10(1): 62–8, 100.

Cordwell, Justine M. 1979. "Appendix: The Use of Printed Batiks by Africans." In Justine M. Cordwell and Ronald A. Schwartz (eds) *The Fabrics of Culture*, pp. 495–6. The Hague: Mouton.

De Marees, Pieter. 1987[1602]. *Description and Historical Account of the Gold Kingdom of Guinea*. Trans. and edited by Albert van Dantzig and Adam Jones. The British Academy, London: Oxford University Press.

De Witte, Marleen. 2001. *Long Live the Dead! Changing Funeral Celebrations in Asante, Ghana*. Amsterdam: Aksant Academic Publishers.

De Witte, Marleen. 2003. "Money and Death: Funeral Business in Asante, Ghana." *Africa* 73(4): 531–59.

Dinan, Carmel. 1983. "Sugar Daddies and Gold-Diggers: The White-collar Single Women in Accra." In Christine Oppong (ed.) *Female and Male in West Africa*, pp. 344–66. London: George Allen and Unwin.

Domowitz, Susan. 1992. "Wearing Proverbs: Anyi Names for Printed Factory Cloth." *African Arts* 25(3): 82–7, 104.

Garrard, Timothy F. 1989. *Gold of Africa: Jewellery and Ornaments from Ghana, Côte d'Ivoire, Mali, and Senegal*. Barbier-Mueller Museum. Munich: Prestel-Verlag.

Gott, Suzanne. 1994. "In Celebration of the Female: Dress, Aesthetics, Performance, and Identity in Contemporary Asante." PhD dissertation, Indiana University, Bloomington.

Gott, Suzanne. 2003. "Golden Emblems of Maternal Benevolence: Transformations of Form and Meaning in Akan Regalia." *African Arts* 36(1): 66–81, 93–6.

Gott, Suzanne. 2005. "The Dynamics of Stylistic Innovation and Cultural Continuity in Ghanaian Women's Fashions." In Ilsemargret Luttman (ed.) *Mode in Afrika*, pp. 61–70, 79. Hamburg: Museum für Völkerkunde.

Hagan, George P. 1970. "A Note on Akan Colour Symbolism." *Research Review* (Ghana, University College Legon. Institute of African Studies) 7(1): 8–14.

Johnson, Marion. 1980. "Cloth as Money: The Cloth Strip Currencies of Africa." In Dale Idiens and K. G. Ponting (eds) *Textiles of Africa*, pp. 193–202. Bath: Pasold Research Fund.

Jones, Adam. 1995. "Female Slave-owners on the Gold Coast: Just a Matter of Money?" In Stephan Palmié (ed.) *Slave Cultures and the Cultures of Slavery*, pp. 100–11. Knoxville, TN: University of Tennessee Press.

Kyerematen, A. A. Y. 1964. *Panoply of Ghana: Ornamental Art in Ghanaian Tradition and Culture*. New York: Praeger.

LeBlanc, Marie Nathalie. 2000. "Versioning Womanhood and Muslimhood: 'Fashion' and the Life Course in Contemporary Bouaké, Côte d'Ivoire." *Africa* 70(3): 442–81.

Littrell, Mary A. 1977. "Ghanaian Wax Print Textiles: Viewpoints of Designers, Distributors, Sellers, and Consumers." PhD dissertation, Purdue University, West Lafayette, Indiana.

Loyer, Godefroy. 1935[1714]. "Relation du voyage du Royaume d'Issyny." In Paul Roussier (ed.) *L'Etablissment d'Issiny 1687–1702*, pp. 109–235. Publications du Comité d'Études Historiques et Scientifiques de l'Afrique Occidentale Française, Série A, No. 3. Paris: Librairie Larose.

Manuh, Takyiwaa. 1993. "Women, the State and Society Under the PNDC." In W. Gyimah-Boadi (ed.) *Ghana under PNDC Rule*,

pp. 176–95. Chippenham: Council for the Development of Social Science Research in Africa.

Manuh, Takyiwaa. 1995. "Changes in Marriage and Funeral Exchanges among the Asante: A Case Study from Kona, Afigya-Kwabre." In Jane Guyer (ed.) *Money Matters: Instability, Values, and Social Payments in the Modern History of West African Communities*, pp. 188–201. London: James Currey.

Manuh, Takyiwaa. 1998. "Diasporas, Unities, and the Marketplace: Tracing Changes in Ghanaian Fashion." *Journal of African Studies* 16(1):13–19.

Martin, Phyllis M. 1986. "Power, Cloth, and Currency on the Loango Coast." *African Economic History* 15: 1-12.

Mato, Daniel. 1986. "Clothed in Symbol—The Art of Adinkra Among the Akan of Ghana." PhD dissertation, Indiana University, Bloomington.

McCaskie, T. C. 1983. "Accumulation, Wealth and Belief in Asante History, I. To the Close of the Nineteenth Century." *Africa* 53(1): 23–42.

McCaskie, T. C. 1986. "Accumulation: Wealth and Belief in Asante History: II The Twentieth Century." *Africa* 56(1): 3–23.

McLeod, M. D. 1976. "Verbal Elements in West African Art." *Quaderni Poro* 1: 85-102.

Mikell, Gwendolyn. 1989. *Cocoa and Chaos in Ghana*. New York: Paragon House.

Nielsen, Ruth T. 1974. "The History and Development of Wax-printed Textiles Intended for West Africa and Zaire." MA thesis, Michigan State University, East Lansing.

Nielsen, Ruth T. 1979. "The History and Development of Wax-printed Textiles Intended for West Africa and Zaire." In Justine M. Cordwell and Ronald A. Schwartz (eds) *The Fabrics of Culture*, pp. 467–98. The Hague: Mouton.

Pedler, Frederick. 1974. *The Lion and the Unicorn in Africa: A History of the Origins of the United Africa Company, 1787–1931*. London: Heinemann.

Picton, John. 1999. *The Art of African Textiles: Technology, Tradition, and Lurex*. London: Lund Humphries.

Posnansky, Merrick. 1987. "Prelude to Akan Civilization." *The Golden Stool: Studies of the Asante Center and Periphery, Anthropological Papers of the American Museum of Natural History* 65(1): 14–22.

Rabine, Leslie W. 2002. *The Global Circulation of African Fashion*. Oxford: Berg.

Rattray, Robert S. 1927. *Religion and Art in Ashanti*. Oxford: Clarendon Press.

Roberts, Penelope A. 1987. "The State and the Regulation of Marriage: Sefwi Wiawso (Ghana), 1900–40." In Haleh Afshar (ed.) *Women, State, and Ideology: Studies from Africa and Asia*, pp. 48–69. Binghamton, NY: State University of New York Press.

Ross, Doran H. 1977. "The Iconography of Asante Sword Ornaments." *African Arts* 9(1): 16–25, 90–1.

Ross, Doran H. 1998. *Wrapped in Pride: Ghanaian Kente and African American Identity*. UCLA Fowler Museum of Cultural History Textile Series, No. 2. Los Angeles, CA: UCLA Fowler Museum of Cultural History.

Ross, Doran H. 2002. *Akan Gold from the Glassell Collection*. Houston, TX: Museum of Fine Arts.

Spencer, Anne M. 1983. *In Praise of Heroes: Contemporary African Commemorative Cloth*. Newark, NJ: Newark Museum.

Steiner, Christopher B. 1985. "Another Image of Africa: Toward an Ethnohistory of European Cloth Marketed in West Africa, 1873-1960." *Ethnohistory* 32(2): 91–110.

Sundström, Lars. 1974. *The Exchange Economy of Pre-colonial Tropical Africa*. New York: St Martin's Press.

van der Geest, Sjaak and Nimrod K. Asante-Darko. 1982. "The Political Meaning of Highlife Songs in Ghana." *African Studies Review* 25(1): 27–35.

Warren, Dennis M. and J. Kweku Andrews. 1977. "An Ethno-scientific Approach to Akan Arts and Aesthetics." *Working Papers in the Traditional Arts,* No. 3: 1–42.

Wass, Betty M. 1979. "Yoruba Dress in Five Generations of a Lagos Family." In Justine M. Cordwell and Ronald A. Schwartz (eds) *The Fabrics of Culture*, pp. 331–48. The Hague: Mouton.

Wass, Betty M. and S. Modupe Broderick. 1979. "The Kaba Sloht." *African Arts* 12(3): 62–5, 96.

Wilks, Ivor. 1962. "A Medieval Trade-Route from the Niger to the Gulf of Guinea." *Journal of African History* 3(2): 337–41.

Wilks, Ivor. 1975. *Asante in the Nineteenth Century: The Structure and Evolution of a Political Order*. Cambridge: Cambridge University Press.

Wilks, Ivor. 1979. "The Golden Stool and the Elephant Tail: An Essay on Wealth in Asante." *Research in Economic Anthropology* 2: 1–36.

Yankah, Kwesi. 1989. *The Proverb in the Context of Akan Rhetoric: A Theory of Proverb Praxis*. New York: Peter Lang.

Conceptions of Identity and Tradition in Highland Malagasy Clothing

Rebecca L. Green

Rebecca L. Green, Associate Professor and Chair of Art History at Bowling Green State University, has been conducting research on Malagasy art and culture with funding from the Social Science Research Council (1990), Indiana University (1990), Fulbright-Hays (1992–3, 2003), the American Association of University Women (1995–6), and Fulbright (2004). rlgreen@bgnet.bgsu.edu

Abstract

For the Merina and Betsileo peoples of highland Madagascar, one of the most powerful expressions of self—one's humanness, Malagasiness, and Merina- or Betsileo-ness—is indigenous raw silk, *landibe* (*Borocera madagascariensis*). Arguably one of the symbols highland Malagasy link most intimately with identity due to its significant ancestral ties and to its corresponding use in extensive ancestral traditions (*fomba*) and associated taboos (*fady*), it is therefore also one of the most potentially dangerous and hence controversial symbols. Yet, *landibe* is now being intentionally selected and manipulated to express identity in two highly

disparate contexts—ancestral funerary ceremonies and national and international fashion runways—by two very distinct constituents—those who say they follow "tradition" and those who follow a global world view. The expression of identity is therefore complex, and based on personal and communal constructs of tradition, history, and memory that are all highly individualized yet intertwined.

KEYWORDS: Betsileo, Famadihana, *lambamena*, *landibe*, *landikely*, Madagascar, Merina, reburial, shrouds

> Just consider: *Ny maty hono hoe tsy avarina an-tany fa fonosin-dambamena.*
>
> *Ny velona tsy jerem-potsiny fa tsy maintsy human-bary.*
>
> You don't just throw your deceased loved ones in the ground, but you must wrap them in *lambamena* [burial shrouds]. And you don't just look at the living, but you must feed them rice."[1]

The Merina and Betsileo peoples living in Madagascar's central highland region consciously create and depict themselves, using actions, symbols, and art to make intentional statements about who they are in the world and what that means. Through actions and associations, they declare their humanness, their Malagasiness, and their Merina- or Betsileo-ness. Cloth and clothing in particular, as tangible yet manipulable extensions of self, are prominent factors in the creation and negotiation of highland Malagasy identity. At the center of this negotiation is a cloth now being used and manipulated in two highly disparate contexts—ancestral funerary ceremonies and national and international fashion runways—by two very distinct constituents, yet ultimately chosen to express similar statements, indicating just how complex this process remains.

Identity and Its Negotiation

How one establishes one's identity or one's self—how one thinks of, presents, or posits oneself—is contextualized and marked by relationships with others. Because this dialogue must navigate the complexities of distinct and layered relationships between oneself and a multitude of others, each of us is continually negotiating and renegotiating multiple identities, both serially and simultaneously. In highland Madagascar, one of the most powerful expressions of self revolves around textiles designated by highland Malagasy as "ancestral," and the manner in which they are used as "traditional" or "non-traditional." While indigenous raw silk, *landibe* (*Borocera madagascariensis*), is arguably one of the symbols highland Malagasy link most intimately with identity due to its significant ancestral ties and to its corresponding use in extensive

ancestral traditions (*fomba*) and associated taboos (*fady*), it is therefore also one of the most potentially dangerous and therefore controversial symbols (Figure 1).

The idea of "ancestral tradition" is central in highland Malagasy culture. Imerina, the historic land of the Merina, "is a place where people attach enormous importance to the memory of their ancestors and the lands on which their ancestors once lived. History, in Imerina, is largely a matter of placing the living in an historical landscape created by the dead" (Graeber 1999: 319). I would argue that this sense of history informs a highland understanding and conception of "tradition" shared by both Merina and Betsileo alike.

Highland individuals use the term *fomba* daily in discussing what is "traditional" and therefore what is "right" and what is "wrong," based on what one deems culturally and historically appropriate. If someone makes a social *faux pas*, witnesses will say that the person "does not follow [or understand, or know] tradition." I use this term throughout the text, therefore, as I experienced it being commonly used in highland Madagascar. Similar to the concept of "truth," however, "tradition," is not one monolithic or homogeneous concept. Rather, it is complex

Figure 1
Merina weaver, Bebe Razanamioly, holding her *lambam-bato* or "stone cloth," the burial shroud in which she will be buried, in indigenous *landibe* silk, 1993. Photograph: Rebecca L. Green.

and multifaceted and is based upon interpretation, whether that interpretation be individual or group-determined (as is made evident in a significant number of scholarly works, e.g. Middleton 1999). In fact, the reason I found the cultural practices under consideration in this article *are* contentious is precisely because while highland Malagasy recognize indigenous silk as a significant ancestral material essential to constructing identity, there is no common agreement as to what, exactly, the historical traditions or "factual" histories are surrounding this material. Personal and communal constructs of tradition, history, and memory are all highly individualized yet intertwined in varying combinations that can be sincerely adhered to or intentionally manipulated with ulterior motive, regardless of the actual "fact" of historical use. Therefore, in this article I focus primarily on the current *interpretation* or *understanding* of "tradition" rather than the "factual" past, for another person's conception of the actual historical past matters little to highland Malagasy who debate the issues under consideration and upon whose opinions current practices are based.

Highland Malagasy tend to fall into three distinct categories or groupings when interpreting "tradition." For those highland Malagasy who regard "traditional" practices according to a relatively conservative interpretation of history, tradition, and memory (individuals in this group tend to be older, often rural, and frequently poor), indigenous silk is inextricably linked to a "deep tradition" that should not be altered—it is reserved for the ancestors alone and no one else should consider wearing it on pain of severe repercussions and possibly death (if the ancestors are sufficiently angered nothing can stop their wrath nor their desire for revenge). For highland Malagasy who view "tradition" through a broader and more interpretive lens (a group that tends towards younger or middle-aged individuals who are upwardly mobile urban or semi-urbanites), "tradition" is less static and immutable than the first group assumes and is instead a malleable tool that remains culturally and socially germane—any Malagasy person who wears ancestral silk as tailored clothing in a respectfully appropriate setting is not only honoring the ancestors but is donning the ultimate expression of Malagasy identity. A third group (generally young people, who are less frequently immersed in ancestral practices and who consider issues surrounding ancestral practices as far removed from their own created realities, and who are often urbanites born into an increasingly global world of internet and music videos) associates "tradition" with elders; while the ancestral links may make the material nominally interesting, it remains old-fashioned and confining and therefore not relevant in today's contemporary and globally "hip" society. Their youthful search for new expressions of identity is often temporary, however, for,

> A certain number of young Malagasy aspire towards becoming foreigners. Some accomplish this and blend in with foreigners.

But years later, they return to being Malagasy again. Malagasy who become foreigners are unable to experience the various dimensions of life to which they are accustomed. Moreover, their souls/selves increasingly weaken and after a time, they feel isolated. They cannot sustain this situation, they experience a great unrest, and finally, they become Malagasy once again (Dubois 1999: 163; my translation from the French).[2]

All three groups, therefore, interpret the meanings and applicable intentions and implications of silk variously, yet all understand indigenous silk as an obvious visual expression of highland Malagasy ancestors, and therefore, identity.

In this article, I will look briefly at indigenous silk in relation to the profound ancestral foundation upon which highland Malagasy culture is based, and to the current trends through which it plays a central role in ancestral traditions, including the new (or not so new) uses that may (or may not) display a significant break with the past. However, as noted above, as with all significant symbols, indigenous *landibe* silk revolves around interpretation, understanding, and opinion, themselves dependent upon one's orientation, context, and agenda, all of which can be particularly volatile in regards to the incredibly powerful and therefore potentially dangerous ancestors.

The elaborate relationships between the living and their ancestors (*razana*), beings who live in a parallel spiritual world, comprise a fundamental component of Merina and Betsileo identity. As two of the island's largest ethnic groups and the two primary ethnicities residing in Madagascar's central highlands, the Merina and Betsileo are not only close geographically but share the closest cultural and linguistic connections[3] as compared with the other sixteen officially recognized ethnic groups. And the most important cultural components shared by both Merina and Betsileo center on the ancestors and on the performance of reburials (Figure 2), observed only in Madagascar's central highlands. Highland Malagasy trace all traditions and cultural practices on which life is based back to the ancestors; nothing of consequence can be accomplished without their help or with their hindrance, and ultimately the good (and bad) in life comes from them. Because ancestors are integral to Malagasy life and identity, all tangible or symbolic references to them or to activities and material goods associated with them—from funerals and periodic reburials, to tombs and burial shrouds—are important cultural elements forming the essence of one's highland Malagasiness, and are therefore objects with which one should never trifle.

The living and their ancestors interact constantly, although the most significant occurrences take place during funerary ceremonies to which both living and dead communities are invited and during which the living physically interact with their predecessors. Initial funerals, called *fandevenana*, and successive reburials, called *famadihana* ("to turn")

Figure 2
Betsileo Famadihana. 1997.
Photograph: Rebecca L. Green.

or *famonosan-drazana* (to wrap one's ancestors), ensure that one's ancestors are remembered, honored, and appropriately cared for by their descendants who provide for their most basic needs, such as being housed within the family tomb and clothed properly.

The quintessential ancestral clothing is the burial shroud, called *lambamena* (Figure 3). Although highland Malagasy, in response to current economic difficulties and to availability of goods, currently employ a variety of materials including cotton, nylon, and polyester, shrouds were historically made of one of two types of hand-woven silk. Indigenous, uncultivable, and therefore "wild" silk is called *landibe* (*Borocera madagascariensis*), or alternatively "Malagasy silk," "Betsileo silk," or *landy tapia* since the cocoons must be collected from local *tapy* or *tapia* trees. Mulberry silk, called *landikely* (*Bombyx mori*), is a later import (possibly in the nineteenth century) that is readily cultivable and whose alternative nickname is *landy vazaha* (foreign silk) (Figure 4). Due to indigenous silk's great physical strength—it is said to last up to thirty years wrapped around a decaying corpse—to its perceived antiquity and therefore "traditionality," and to its spiritual power (arising from

Figure 3
Lambamena for sale at the *zoma* market, Arivonimamo, 1993. Photograph: Rebecca L. Green.

its intimate ancestral associations), shrouds in this material are considered characteristically "Merina" and "Betsileo." Regardless of material used, however, to highland Malagasy, any ancestor wrapped in a shroud is by definition "highland Malagasy" and more specifically, Merina or Betsileo. Moreover, faced with selecting a global signifier to establish a recognizable international identity, Merina and Betsileo have seized upon the practice of performing periodic reburials and more importantly, upon the shrouds used within them, as visual symbols of what it means to be "Malagasy," regardless of the fact that this custom is limited to two distinct ethnicities within the relatively limited region of the island's central high plateau.

A shroud's significance lies in the fact that the honor and reputation of the deceased and his or her family and community are based on its existence, for a shroud distinguishes humans from animals, Malagasy from non-Malagasy, highland Malagasy from coastal Malagasy, and ancestors from the simply "dead." In fact, if a deceased's family cannot provide a shroud at the initial burial, the local community is expected to supply what it can. Without a shroud, an ancestor may not enter

Figure 4
Shroud of *landibe* (dark stripes) and *landikely* (light stripes), Ambositra, 1993. Photograph: Rebecca L. Green.

into the family tomb, a step critical to establishing one's familial, community, ethnic, and social identity. According to McGeorge, "persons prohibited burial in the ancestral tomb are persons who stand outside of the social structure" (1974: 33). In fact, the severest punishment a family can mete out, and the sentence reserved for only the most serious infractions, is to deny someone his or her rightful position in the family tomb.[4]

Participants who supply their ancestors with *lambamena* are therefore simultaneously clothing and honoring them, thereby providing the means whereby their deceased relatives can become ancestors, a transition that cannot be made if one is not enveloped within a shroud and placed within the tomb. If the living care for their deceased relatives properly—giving them appropriate clothing and interring them appropriately—the dead will transcend their physical remains to become ancestors. Most importantly, through a process of continual bodily disintegration punctuated by periodic reintegration within successive

layers of burial shrouds provided during reburials, the ancestors' physical remains become indivisibly mixed with the shrouds (literally as well as conceptually), which then become part of the ancestral remains and thus powerful components in and of themselves. To deny an ancestor her or his shroud(s) not only removes the tool through which he or she may progress from a living mortal to a known ancestor, but ultimately, transform into an all-powerful and unknowable Ancestor. For it is through the process of successive reburials that individually enshrouded ancestors (who continue to require the living to satisfy their mortal needs of food, warmth, and attention/interaction) are eventually incorporated into composite Ancestral bundles (all powerful, unknowable spiritual beings who no longer experience mortal needs) (Figure 5) that not only represent but create and express the ultimate in unified family identity. To refuse a deceased family member his or her rightful shroud, therefore, wrenches that deceased being from the natural ancestral process (living to dead to individual ancestor to omnipotent

Figure 5
A Merina Ancestral bundle comprised of a deceased couple who have received multiple reburials and were combined into one bundle during the previous reburial, and their recently deceased grandson being added to his grandparents bundle during his first reburial, 1993. Photograph: Rebecca L. Green.

Ancestor), and relegates him or her to the status of non-human, non-ancestor, and non-Malagasy.

To deny an ancestor his or her rightful shroud also denies his or her living relatives the medium through which to physically interact and communicate with their predecessor. By carefully manipulating shrouds, a person can transmit and receive requests and blessings to and from the dead since shrouds are tangible conduits through which communication may pass. For example, if a woman walking to the family tomb during a reburial wraps herself—and her womb—in shrouds intended for her ancestors, the shrouds can physically carry her request for and the responding benediction of fertility. Alternatively, reburial participants often discreetly remove small silk remnants or beads from a disintegrating shroud to keep as mementos and as repositories of ancestral power. Shrouds, then, and the indigenous silk in which they are traditionally made, are physical embodiments of ancestral benedictions and power, and to elect to use them otherwise is not an insignificant or haphazard decision.

Objects, in this case textiles, therefore, can be powerful vehicles of communication in that they physically embody and transmit essential information by way of requests, blessings, and general communiqués. Moreover, because shrouds are displayed and then critiqued publicly during a series of ceremonies (*lanonana*) that precede a reburial, they can embody information concerning the ethnic, moral, and social identities of the deceased, the host family, and the community. One's wealth, beliefs, and regional affiliations are manifest in the quality and choice of shroud and in the decorative features displayed. It is not, however, the shroud as an object that plays such an important role in establishing and expressing identity. The material in which it is made (especially if indigenous *landibe*) and the physical act of wrapping that occurs during burials and reburials are both significant elements of this ancestral practice, and therefore the foundation of the ancestrally based identity so important in highland Madagascar. Therefore, to misuse—or appear to misuse—this material or this practice could place in jeopardy the very traditions and identity one wishes to express.

Clothing the Living

"They say that the *landikely* and the *landibe* might cause some problem or they may scare people [if worn by the living]."[5]

Clothing worn by the living in highland Madagascar, particularly if worn in a culturally or traditionally sensitive context, has the potential of being ideologically and symbolically related to that of the dead in

the way the body is enveloped, in the material that is used, and in the tradition on which it is based. The article of clothing central to highland Madagascar is the *lamba*, a cloth worn around the shoulders by both men and women (Figure 6). Although *lamba* literally translates as any "cloth" or clothing," and although variations exist, "classic" men's *lamba* are generally large cotton wraps while women's have become thinner and are made of silk or cotton, and called *lamba fitafy*. The term *fitafy* indicates that it is a formal *lamba* worn in a particular way (draped around one's shoulders, with one fringed end visibly draping down in front of one shoulder, and the other end crossing one's chest and then flipped over the same shoulder to hang down one's back) that sends explicit messages regarding one's age, morality, and sense of tradition. It indicates that a person has reached an appropriately mature age and visually demonstrates that one is following Highland tradition, with the implication that one is "traditional" in all areas of one's life. Women who wear *lamba fitafy* also tend to wear their long black hair braided in two plaits and pulled back into the distinctive knotted hairstyle of the central highland region. As one woman explained, "Wearing the *lamba* is important to me. If I cut my hair short, or if I wore foreign clothes [without the *lamba*], I would be naked. I would not be a Malagasy woman."[6]

Worn by the wealthy and poor alike, *lamba* are social equalizers. While a wealthy person may wear a wrap rich in embroidery and fine thread, an extremely poor woman may drape a piece of white cloth around her shoulders and attend an ancestral ceremony with dignity, assured that she is dressed appropriately. The fact that highland Malagasy considered *lamba* dignified makes them an essential element of formal highland Malagasy attire. Moreover, many highland Malagasy conflate a specifically highland identity with an island-wide Malagasy identity and therefore view wearing *lamba* as symbolic of a national Malagasy identity.[7] Thus, Malagasy dignitaries sent abroad by the Merina royalty draped *lamba* over their formal European-style coats when visiting foreign courts in the nineteenth century (Anon. n.d.), as is evidenced by an oil painting by the British artist Henry Room depicting Queen Adelaide as she receives a group of Malagasy ambassadors in Windsor Castle in 1837. Merina royalty also bestowed silk *lamba* as political gifts to foreign powers (see Razi 1977: 38, among others). The United States government received textile gifts at least five times between 1837 and 1893. For example, Richard P. Waters, American consul to Zanzibar, stopped on Madagascar's coast in 1837 and was given, among other gifts, a "shawl" by Queen Ranavalona I. In 1869 Queen Ranavalona II included two *lamba* in gifts to President Andrew Johnson, and in 1886 she sent two silk *lamba* to President Grover Cleveland to commemorate his successful presidential election (Arnoldi 2002: 95–103).[8]

Figure 6
(Top) *Lamba* worn around shoulders of men and women during *famadihana* ceremony. (Bottom) *Lamba* worn by Betsileo women preparing for *zana-drazana* performance during *famadihana* ceremony, 1993. Photographs: Rebecca L. Green.

Silk *lamba* in their more elaborate incarnations were obviously deemed as gifts appropriate for sovereign nations and the ruling class, and as items appropriately symbolic of Madagascar and its central highlands. Therefore, when upper-class Malagasy began wearing European fashions in the nineteenth century, they still wore *lamba* shoulder wraps over their foreign garments on important occasions (see Decary 1951: 71, 73; Price 1989: 161; Kreamer and Fee 2002). With the influx of foreign influences over the past two hundred years, wearing *lamba* continues to be a symbol of national pride and cultural identity in highland Madagascar. In fact, some highland people have indicated that anyone who does not wear a *lamba* in formal situations is expressing her rejection of the culture (Bloch 1971: 10).

Today this conscious use of *lamba* to express identity continues in various manifestations. Musical troupes who perform *hira gasy*, the quintessential Malagasy folkloric theatrical/musical competitions (see Edkvist 1997), that are an important component of elaborate reburial ceremonies, wear distinctive traditional outfits: full-length nineteenth-century European-style dresses for women, and slacks with long, button-down "military" coats (usually red and/or blue) and flat-topped, brimmed, stiff basketry hats for men. Both, however, finish their ensembles with *lamba*—women with their long and thin *lamba fitafy*, the ends of which they use to punctuate their graceful hand gestures and inflections to emphasize points of their narrative songs, and men with their large rectangular cloths draped diagonally across their bodies or, at certain choreographed moments, tied around their waists—that quite deliberately posit the *hira gasy* tradition within a particularly highland Malagasy one.

It is significant, however, that highland Malagasy treat *hira gasy* in a manner linguistically similar to *lamba*. Springing from a highland Malagasy conception of identity, the term *hira gasy* translates as "Malagasy singing," even though the theatrical performance is a specifically highland tradition. Similarly, Graeber, an anthropologist studying Merina culture, noted that he "never heard anyone there spontaneously refer to themselves as such. They always spoke of themselves as 'Malagasy,' just as they spoke of 'Malagasy' customs, 'Malagasy' beliefs, and 'Malagasy' forms of knowledge" (Graeber 1997: 107), rather than labeling themselves or their actions as specifically Merina.

Lamba continue to play a significant role in pivotal life ceremonies as well. For example, some young couples are deliberately reviving the tradition of a *lamba*-wrapping ceremony within their weddings to visually demonstrate their union, as was recently illustrated in the Smithsonian's National Museum of African Art's 2002 exhibition *Gifts and Blessings: The Textile Arts of Madagascar* (Kreamer and Fee 2002: 85). Significantly, Malagasy living abroad who are searching for appropriate expressions of identity often look to *lamba*

as an important emotional and visible link "home," often wearing it on important occasions and commissioning formal clothing in it while visiting Madagascar. In late 2003, for example, I met a young Malagasy woman living in England who traveled to Antananarivo to visit Mme Nanou Ravelo, a fashion designer and pioneer of combining Malagasy silks and high fashion, to commission the dress in mulberry silk (*landikely*) that she would wear in her upcoming London wedding.[9]

The material in which cloth and clothing are made can have significant cultural implications. Mulberry silk has long been appreciated by highland Malagasy and recognized as a material highly valued by foreigners, and therefore useful for political gifts and exchanges. Yet, highland Malagasy wear clothing made in indigenous silk (*landibe*) to express a close affiliation with tradition, culture, and a distinctly Malagasy identity. Indigenous silk may have been tailored into European-styled suits and worn by high-status individuals as early as the "time of Andrianampoinimerina," a phrase referring to the king who established the powerful Merina monarchy before he died in 1810, but more commonly used to indicate the deep and therefore "legitimate" past. Combining indigenous silk and international fashion may, however, have its origins during the reign of Andrianampoinimerina's son, the young and fashion-conscious Radama I (r. 1810–28) who was the first Merina monarch to establish official relations with European powers and to wear European clothing (Figure 7). Suits cut to reflect European fashion probably ceased to be popular when an influx of inexpensive, imported cotton lowered the demand for silk (Gade 1985: 113–15), at which time it became ceremonial wear for such events as birth celebrations, marriages, and funerals (Raherisoanjato 1986: 6).

Many Betsileo and Merina elders with whom I have spoken remember wealthy Malagasy and foreigners alike wearing tailored indigenous silk suits on ceremonial occasions in the early years of the twentieth century. The late Betsileo weaver Celestine Rasoamody, for example, described how her grandfather "wore *landibe* ... He wore it often during the last ten years of his life [d. 1950 at 90 years of age], but it never wore out, it didn't change at all ... He wore it every time he went to a grand *fête*, whenever there was a *lanonana* [ancestral ceremony], or if there was a festival at church."[10] Memories of ancestral silk being worn cross generations, thereby establishing a firm oral foundation upon which current beliefs and trends rest. As the late Merina cloth vendor Mr Razafimahefa commented in 1993 (at approximately eighty-five years of age), his own father, grandfather, and great-grandfather wore indigenous silk clothing during their life times.[11] Some elders recounted not only their elders, but reported firsthand that they themselves had worn *landibe*, as did Mr Rakotondramasy, an elder Merina gentleman who wore a coat of indigenous silk as a young man in the 1920s.[12]

Figure 7
Merina King Radama I, ruled 1810–28.
Cited in Larson (2000).

The historical precedent for wearing indigenous silk may also have roots in the *Menalamba*, or "red cloth" rebellion, the 1895–8 uprising aimed at driving out the French invaders while protesting the perceived decline of traditional highland culture under the last Merina monarch, Queen Ranavalona III (r. 1885–96; see Covell 1995). A common popular belief in the highlands is that *Menalamba* rebels wore *lambamena* into battle because, having assumed they would be killed, they wanted to ensure they would have appropriate shrouds.

The *lamba*'s association with Malagasy culture is based not only on the shoulder wrap as a distinctly highland Malagasy object of clothing, but as a decorative surface on which to display Malagasy cultural symbols. Current designs on *lamba* are founded in a distinct Malagasy identity, from the oft-depicted images of zebu cattle, powerful repositories of traditional wealth and indicators of economic identity, to the more frequently incorporated floral imagery said to be poinsettia. The significance of poinsettia rests in its Malagasy vernacular—"Madagasikara."

Conscious identity constructs are evident not only in choices made from within a group's repertoire of potential symbolism but in those selectively borrowed or adapted from others. For example, although the southern Mahafaly are only one of Madagascar's eighteen officially recognized ethnic groups, their tall *aloalo* funerary sculptures (Figure 8) have come to represent a global Malagasy identity. As sculpture, Westerners easily recognize and appreciate *aloalo* as "art" (see Boulfroy 1976 and Camboué 1928, among others) based upon a Eurocentric assumption of what constitutes "art" that is informed by an aesthetic favoring three-dimensional wooden constructs. Moreover, the strong design element of *aloalo* readily translates into two-dimensional designs that can be incorporated easily into a variety of contexts and consequently are imprinted on everything from postcards, to clothing, table linens, books, pens, and cloth. As a result of this proliferation, foreigners continue to associate *aloalo* with the island and expect to see this familiar and "authentic" object when visiting, while highland Malagasy have come to embrace this image as an easily recognizable and malleable symbol of self, even though individuals in the high plateau are not Mahafaly and do not live in southern Madagascar.

Figure 8
Woman's *lamba* with float design depicting an *aloalo* funerary sculpture. Photograph: Rebecca L. Green.

The fact that various cultural traditions exist across the island while certain ethnicities readily adopt and adapt various components of others exemplifies Middleton's warnings of the "difficulties in making general pronouncements on the relative place of performance ('doing') over essentialism ('being') in 'ethnicity' in Madagascar ... In fact, far from being uniform or homogeneous, the ways in which ancestors enter into on-going processes of creating, sustaining and transforming identities (national, 'ethnic', regional, and local) in the various regions of Madagascar are diverse, complex, and often highly nuanced" (Middleton 1999: 20), even though Madagascar is touted as having one unified language, with an implication that it shares a unified cultural construct as well.

Visual Communication

Textiles then, particularly when worn as clothing, communicate to a larger general audience via their visual attributes, whether through their physical appearance or through how they are made, used, worn, or otherwise manipulated. Although Bogatyrev and many others stress that clothing can be read similarly to the way we read and understand language (Bogatyrev 1971[1937]: 83),[13] semiotic or visual language does not have a similarly linear construct. Through a complex and alinear layering of color, material, aesthetic, form, symbolism, style, context, and appropriateness, cloth and clothing have the potential to convey a great amount of information, including the wearer's age, gender, occupation, social position, group affiliations, emotional state, and morality, as well as the contexts, cultures, and communities with which the wearer identifies. Moreover, "textiles offer important insights into how people identify themselves at particular times and how they define and symbolize notions of personhood, gender, and power through objects" (Kreamer 2002: 18).

Yet one's attire can be read in a variety of ways because the communicative effect depends on whether individuals reading and interpreting it enjoy a shared vocabulary based on a collective body of knowledge. In fact, miscommunication can occur if one's visual vocabulary is not clearly indicated or mutually understood. For example, in rural highland areas, shirts (other than T-shirts) that pull over one's head are normally considered appropriate wear for women while shirts that open or button down the front are considered suitable for men, including frilly shirts and knit or crocheted "hippie" vests that, from an American perspective, would "obviously" be categorized as women's clothing. While the Malagasy criteria is based on the shirt's cut and the American on a more ambiguous designation of "feminine" versus "masculine" aesthetic, both are founded in a culturally derived and appreciated visual vocabulary that is not automatically understood by outsiders.

Material objects *can* serve as effective communicative devices, however, within communities that share a visual language. Cloth in particular has "an almost limitless potential for communication" (Schneider and Weiner 1989: 1). Clothing and adornment specifically elucidate the wearer's conceived and projected identities and ideological values. It is through clothing and adornment that we posit ourselves within specific identities and particular life events. This visible indicator of identity is not lost on anyone reading the signals; it is not only exploited as a means of expressing one's own identity, but of attracting the attention of individuals who identify with particular groups. Thus, a political poster (Figure 9) depicts various ethnically and socially derived clothing and hat styles intended to communicate with a cross-section of the Malagasy population in the hopes of attracting a large and diverse voter turnout during the hotly contested 1992–3 presidential election. Similarly, a 2003 HIV/AIDS awareness flier (Figure 10) portrays a cross-section of highland Malagasy society to illustrate that the infection can affect anyone. In both instances, the variety of identities is depicted without additional explanation, through dress, hairstyle, and accessories.

Figure 9
A political poster encouraging all Malagasy, depicted through clothing, hat, and hairstyles, to vote in the upcoming presidential elections, 1993. Photograph: Rebecca L. Green.

Figure 10
HIV/Aids awareness flier, Antananarivo, 2003. Photograph: Rebecca L. Green.

The ability of cloth and clothing to convey non-verbal messages is also achieved through physical manipulation, as exemplified by an eighteenth-century highland king's quest for political domination. According to legend, the powerful Merina king Andrianampoinimerina sent a cloth with a hole cut in its center to his southern Betsileo neighbor, King Andriamanalina, who refused to submit his authority. Andriamanalina understood the hole to represent his small kingdom surrounded on all sides by other Betsileo kingdoms (the cloth) whose kings had already sworn their allegiance to Andrianampoinimerina. The visual reference was undeniable—the cloth easily and simply communicated his complete isolation (see Brown 1978: 127).

Textile messages can also be quite explicit. *Lamba hoany* are proverb cloths made in either Madagascar or India that include Malagasy text in the design. Worn by men and women alike, *lamba hoany* serve as scarves and head ties, are spiraled onto the crown of one's head to support and distribute the weight of a heavy load, and are used to secure a baby onto one's back, as slings to carry bundles,

and as wrappers to protect one from cold. As aprons they protect one's clothes while working, and allow a woman to cover modestly her legs when she is sitting on a low stool or in an otherwise compromising position. Rectangular in form, with an overall pattern or central motif surrounded by a lesser pattern and hemmed in by an outer border, *lamba hoany* incorporate proverbs, popular sayings, statements, or slogans in a rectangular box along the bottom length of the cloth. As a medium of communication, proverb cloths can be strategically worn or draped to send a message to a specific person or to the community at large, as when worn by multiple people, *lamba hoany* indicate group membership (Figure 11). Some recent popular examples include: "regret makes one sick," "no one has enough in life so blessed are those who help others," "I will not lose what I have in my hand," "it is not easy to find money," or finally, "you will not get sick if you sleep with what/who you love," a saying emblazoned on a cloth depicting a cowherd with his cattle (see Figure 12).[14]

Figure 11
Family members wear *lamba hoany* while performing the *zana-drazana*, a performance of familial solidarity by wearing matching cloth during a Betsileo Famadihana hosted by Ramarovavy. Photograph: Rebecca L. Green.

Figure 12
Lamba hoany with the proverb, "you will not get sick if you sleep with what/whom you love." Photograph: Rebecca L. Green.

Not all cloth that includes writing creates a distinct and linear message that is mutually understood—its context (where on the body or article of clothing is it displayed, how big or clear it is, and its associative imagery) as well as its intelligibility (its language, grammar, or writing style) greatly affect the communicative effect. A wearer's or viewer's visual and literary comprehension can drastically change the overall effect. T-shirts are considered appropriate wear for both men and women—as surfaces with foreign text they are linked with status. Therefore, proud and dignified elder matriarchs wear T-shirts with adorable animal imagery—kittens or bright red roosters, for example—frequently accompanied by English text. The fact of having writing is enough to make the T-shirt in question "appropriate" for a high-ranked individual while the underlying meaning of the text is theoretically insignificant. However, if the wearers or community were to understand that the texts use *double entendre* to create messages that are often quite raunchy,[15] it would cause a sensation.

The favorite T-shirt of a king from northern Madagascar in 1993 was bright green with large bold lettering in English splashed across the front. He considered himself sophisticated and worldly, and the shirt appropriately emblematic of these characteristics. Ironically—and luckily unbeknownst to him or to the community, especially in light of the fact that his authority was under scrutiny by elders who considered him an inappropriate successor to the previous ruler—the wording on his shirt was an excerpt of a popular Beatles song, "Help, I need somebody!" In this instance, the coloring and lettering gave the shirt a bright and bold look, and the fact of having a foreign language gave it a sophistication derived from its somewhat exotic yet worldly origins. The literal message itself was of secondary importance and only those foreigners in the community caught the irony of its message.

While a particular text may be chosen for its foreign exoticism, status, and implied sophistication, its generalized reference to literacy, or its ability to convey a life philosophy through a specific message to a rival, friend, or relative, *lamba hoany* and other cloth also play an important role in establishing group identity during ceremonial events, as when Merina and Betsileo families don specific, matching apparel (see Figure 11). Family members may wear special outfits throughout a ceremony, or may change into matching garb at a prearranged signal, to suddenly reappear while dancing, singing, or working together as a group to "perform" a cohesive or uniform identity. As a minimum, participants wrap brightly colored proverb cloths around their waists over their clothing; those who can afford it commission matching dresses or shirts. The most impressive and prestigious display, however, is for individuals to wear tailored suits during *zana-drazana* performances.

Zana-drazana, or "children of the ancestors," is the name for the family hosting a reburial as well as for the performance during which pairs or groups of these family members wear matching clothing and parade and dance together in the main performance arena to the accompaniment of *hira gasy* folkloric music. Ostensibly, a *zana-drazana* is held to collect monies from each family participant to enable the host elders to tip the *hira gasy* singing troupes, musicians, tomb builders, and diviner appropriately. The performance of a unified family solidarity is as important as raising money, however, particularly if one considers the substantial additional expense required when the entire extended family participates in this display. The ultimate *zana-drazana* outfit is the height of fashion—in a rural context this entails a tailored two-piece suit for women of a jacket and skirt, accessorized by a purse, heels, nylons, makeup, jewelry, and of course, the *lamba fitafy* shoulder wrap (see Figure 6, bottom), while the men's ensemble includes a three-piece suit, with jacket, vest, and slacks, accompanied by shined shoes, sunglasses, cuff links, and hat. The reburial context is noteworthy because such outfits must remain carefully pressed before the presentation, even though the journey to the event may take hours of walking while

carrying additional heavy loads of foods, gifts, and supplies. In a country as poor as Madagascar, the expense of such an outfit is significant.

Emerging Trends

The fashion consciousness suggested by the expense that highland Malagasy are willing to bear in order to "stand out" during an ancestral ceremony is indicative of the importance they place on dress to signify identity. Yet the underpinnings of understanding how fashion evolves is complex. "Fashion has influenced culture, in the same way that it has reflected cultural change" (Khan 2000: 115).

Because individuals continually negotiate their expressed and projected identities by manipulating the objects and symbols around them, culturally or socially charged objects play a key role in this negotiation. In highland Madagascar, objects imbued with the greatest meaning and therefore power, are those with a significant ancestral affiliation. *Lamba* of the living, therefore, are important due to their firm associations with ancestral *lambamena*, the later being instrumental in creating and maintaining one's ancestors, and thus one's very existence. The finest examples of both are made of silk, are wrapped around the body, and are perceived as being worn by highland Malagasy alone. In fact, *lamba* are continually spoken of as the "national" clothing of Madagascar, even though the shoulder wrap is worn primarily by Merina and Betsileo, only two of Madagscar's eighteen officially recognized ethnic groups.

The fact that highland Malagasy use *lamba* and *lambamena* to create an identity that is projected out to the rest of the world is evident from their proliferation in the tourist market and the high-fashion galleries and shops in the capital, Antananarivo. *Lamba* are often specifically chosen by highland Malagasy to symbolize a distinct Malagasy identity, even by individuals who do not normally wear them. For example, the popular and internationally known contemporary musical group *Tarika* is comprised of five young singer–musicians who do not yet wear *lamba*. In fact, the lead singer is known for her cutting-edge spiked hairstyle and fashion sense. Yet the liner notes of their 1994 cassette *Bibiango* incorporate a background design depicting twenty-four stick figures,[16] each wearing, holding, or dancing with a rectangular *lamba*—the one item chosen to represent the group's Malagasy identity (Figure 13).

Clues, therefore, are selectively layered upon the human body through actions, possessions, and accessories. The conscious manipulation of cloth and clothing in a way that posits highland Malagasy identity as separate from others' ("only *we* wear the *lamba* scarf and the *lambamena* shroud") fits well with the contention that as "an art form that allows people to individualize their bodies, clothing is often used to communicate information about the identity of the wearer" (Boram-Hays 2005:38), keeping in mind that "the identities of individuals and

out in the open to be fed or kept in a zoo somewhere in a strange land. Life in Madagascar is now a question of survival for both animals and human beings. So the song also applies to many Malagasy people who are real fighters but now have to submit to the rules of those who have the money. *Bibiango* was especially written with Tarika in mind.

Bibiango
Hey mister hungry beast
Do you sell your soul because you cannot find what to eat today?
Hey big beast, sweet animal, Bibiango.
Where do you come from?
What is your destination?
It's only here, nowhere else but here, it never changes.
Enraged by poverty, you want to devour.
You want to try hard but you can't.
So you keep silent and stay where you are.
Bibiango
Hey, mister hungry beast
You present yourself as a rare thing for these passing rich people?
Hey big beast, sweet animal, Bibiango.
Where do you come from?...
Hey, strong headed animal.
Hey, enraged animal.
Hey, unusual animal.
Hey, intelligent animal.
Bibiango
Hey, mister hungry beast.
I hate to tell you; you've escaped the primitive jungle, But now you are imprisoned by the rules of the developed world.
Hanitra: Lead Vocal, Tsipetrika/ Noro: Vocal/ Donné: Vocal, Marovany/ Ny Ony: Vocal, Acoustic Guitar, Bass Guitar/ Solo: Vocals, Djembe, Korintsana.

HAINTANY
Words: Noro/ Music: Hanitra
Haintany means "drought". It was written during the big drought in the Southern part of Madagascar in 1992 when a lot of people died. Hanitra and Noro heard about it while they were away on tour and were very sad. The inspiration came from the fact that despite the help from the government, a lot of people still died because they refused to be moved and fed somewhere else. That is the importance of belonging to the land of your ancestors in Madagascar.

Charred and burnt.
Our environment is burnt, burnt, and it's sad.
Fire, fire, big fire.
The forest is burnt.
Who doesn't know it?
The earth is dry.
The soil is dry because there is no water.
The soil is dry and it's sad.
Deserted, plain and hills.
Dry all year round, since it was eroded by the river
Children are dying.
Children are dying because the crops are dead.
Children are dying because there isn't enough food.
Hungry, hungry and pleading,
In pain and agony,
Hanitra: Vocal/ Noro: Lead Vocal/ Donné: Valiha/ Ny Ony: Acoustic Guitar/ Solo: Bass Guitar/ Guest – Ian Anderson: Slide Guitar.

KILALAO
Words: Hanitra/ Music: Tarika.
Kilalao means "games". The song is all about different games that children in Madagascar used to play, especially during the time that the members of Tarika were small. Hanitra wrote the words on the way back from a festival in Portugal, when they spent time talking about what they all used to do when they were young and how much they missed it. The song lists many games, some of which will be familiar to foreigners such as marbles, tiddlywinks, hide-and-seek, sliding, swinging, I-Spy, spinning tops and cooking on camp fires. Others are uniquely Malagasy including games with stones, board games, pretend cock-fights, many singing

Figure 13
Liner notes from the cassette *Bibiango*, by the musical group Tarika, depicting stick figures manipulating *lamba*. Photograph: Rebecca L. Green.

groups are not simple, static, innate definition; instead they, like the people they represent, are complex, multifarious, flexible, and not pre-determined. Rooted in biological and cultural conceptions, all human identities are fluid constructions formulated in relation to the identities of others" (Boram-Hays 2005; see also Schwarz 1979: 41). The projection of an identity, then, is contingent upon the audience to whom it is projected, not only because of the comparative element necessary to make a statement of individuality or group affiliation, but, as noted by Roach and Eicher, "all aesthetic acts are acts of speaking, through which an individual may speak as an individual, what is said having meaning only because of relationships with other people" (1979: 7). Thus, manipulation of particular ethnic symbols (such as the *lamba*) and the incorporation of design elements originating from other ethnicities (such as the Mahafaly *aloalo*) specifically manipulate the wearer's expressed identity while addressing and exploiting the perceived understanding of Malagasy identity by others.

Current trends in contemporary art and fashion demonstrate that outward-looking artists understand these principals as well. Noelisoa Ravelonjanahary, better known as Mme Nanou Ravelo, is a Merina designer living in the capital city who was arguably the first contemporary fashion designer to create (or reintroduce) high-end fashion using indigenous *landibe* silk (Figure 14). When I first interviewed her in 1992, she said that although this material had been used for years (centuries?) in its purest, unadorned form, her particular contribution was to incorporate additional embellishments (e.g. embroidery, piping, trimmings, etc.), and by that date, had already been using it in her designs for six or seven years. It was not an easy fashion trend to establish, however. Ravelo said she found it difficult to break into the local fashion industry using a controversial material that "clients wear only if they are not afraid of wearing a material reserved for the dead,"[17] and only if they do not believe they are risking serious repercussion. A young urban Merina woman living in the capital city in 1990 told me that while she would love to wear the expensive and expressive silk, she could not until her mother had passed away because this powerful matriarch had explicitly forbidden any family member from wearing this material in a way that

Figure 14
A two-piece woman's suit in *landikely* made by Nanou Ravelo in 1992. Photograph: Rebecca L. Green.

she perceived as untraditional as long as she remained alive.[18] It is difficult to defend oneself against the argument that someone, sometime, somewhere will die as a result of ancestral wrath initiated by any dangerous and irresponsible uses put to ancestral silk—for eventually someone will indeed die. Another elder Merina woman informed me that the only plausible explanation for daring to wear clothing in ancestral *landibe* silk is that someone is obviously a sorcerer, quite literally crazy, or already dead.[19]

Yet sentiments in the high fashion industry tend towards a more liberal interpretation of tradition. In 2001 when Mme Nanou first began participating in *Manja*, the major annual (biennial as of 2004) fashion show in Antananarivo, she immediately won a prize for Best Creator, and in 2002 won the award for Best Utilization of Material. Her expensive designs make a strong statement of identity and in the fashion industry at least, she is striking a positive cord and one that is now being increasingly copied.

Highland Madagascar does not have an overtly recognizable "Malagasy" dress, other than the *lamba* shawl worn over other clothing. Peoples of many non-Western nationalities and ethnicities often struggle with choices of dress and what those choices express while living, working, and interacting in a global world. Many must identify the correct environments and situations in which to wear "international" dress versus "traditional" dress (e.g. a West African *boubou*, a Muslim *shirvani* coat, or *burqa* veil). Yet for highland Malagasy, especially those who travel outside of the country, the opposite is often true; it can be difficult to establish a recognizable ethnic identity. For individuals searching for such an identity, indigenous silk and highland shawls can serve such a purpose. In the high-end fashion market, Nanou is actively trying to create a new Malagasy clothing tradition that establishes a recognizable, visual identity using indigenous *landibe* silk, a highly controversial issue when she first began in the mid-1980s and early 1990s. *Haute couture* is famous for pushing fashion's boundaries yet for clients who chose to purchase her designs, wearing *landibe* in a tailored outfit is a natural extension of a historical precedent, or of the highland Malagasy-based practice of wearing *zana-drazana* suits of the best quality and cut of cloth one can afford, and is not that far removed from wearing the best textile possible for the traditional *lamba fitafy* shoulder wrap. Luckily for Nanou, as the urban elite become economically viable with a simultaneous growing interest in competing on the global fashion "stage" while maintaining a distinctive Malagasy flair, the interest in wearing indigenous *landibe* silk is increasing as well. The process is slow, however, due to the high cost of the materials and the difficulty for some clients to overcome the controversy of ancestral tradition.

The reason controversy exists over the 'truth' behind the living wearing ancestral silk (did they or didn't they? was it an acceptable tradition or no?), is that the so-called "tradition" may have phased out due to an

apparent lack of materials. As the late Razafimahefa noted in 1992, it had been fifteen or twenty years since he had seen anyone wear *landibe* clothing. "It stopped being worn because of its price ... moreover, there was less and less *landibe* available ..."[20] Even today, indigenous silk is not commonly used for ancestral burial shrouds, nor worn by individuals unless they are significantly wealthy because it is both expensive and rare due to decreasing forestland for this uncultivable silkworm (which is dependent upon the *tapia* tree for its shelter and nourishment), and to an accompanying elusiveness of the *Borocera madagascariensis* silkworm itself. The "controversy" of wearing this material remained largely in the conceptual discourse for many decades, therefore, rather than on the streets due to unattainable costs. Yet because of its rarity and expense, combined with a strong sense of uniqueness, this material is now becoming a luxury item closely tied to Malagasy identity that is ideal for high-end fashion and a powerful signifier of wealth and status.

Currently, Mme Nanou is not the only designer using indigenous silk in her designs. Although creating couture in this pricey and increasingly rare material and finding sufficient clients who can afford to purchase the finished product is difficult, this trend is slowly proving itself both fashionable and marketable. The transition is not a quick one, however. When designer Suzanne Ramananantoandro[21] wore a silk cloak in 1997, people told her "*ianao mahasahy*" (you are bold!), even though she is an elder from a prominent Merina family. "I had to constantly talk to people and convince them it was okay to wear *landibe*, that nothing would happen [as a result]," that no one would not die. Finally, after seeing that she survived both disaster and death after wearing it, and recognizing that it must, therefore, be safe, others began to wear *lamba* shawls of indigenous silk. According to Ramananantoandro, individuals now wearing "ancestral silk" include foreigners (*vazaha*) and Malagasy, nobles and non-nobles, young and old. Not everyone, however, has been easily swayed. Ramananantoandro notes that young people are not really partial to indigenous *landibe* since it reminds them of death (and perhaps because its colors tend to be more somber and therefore not buoyantly stylish), while many elders still don't like the idea of wearing *landibe* because its ancestral associations serve to remind them their own mortality. However, Ramananantoandro, whose primary items for sale are silk scarves and shawls (Figure 15), has a solution. If the problem is with clothing made entirely of indigenous *landibe* silk, then she would create a new luxury item by mixing the two primary silks (*landibe* and *landikely*). In the Fall of 2004 this material had become quite popular with young and old alike; "everyone wears it," she says, noting that she currently has many high-level commissions from Malagasy and foreign clients desiring both clothing and shawls.

Still, change comes slowly. A daughter of Ramananantoandro's friend and colleague wanted to wear Malagasy silk for her wedding dress. The

Figure 15
Dress by Suzanne Ramananantoandro, Mpanjakalandy, 2004. Photograph: Rebecca L. Green.

young woman's mother (a member of Mpanjakalandy, an association of individuals reviving silk traditions) said absolutely no, because as neither a widow nor a divorcée, it was unacceptable for the daughter to wear it. The argument raged and they could not agree. Ultimately, the daughter wore a beautiful dress of indigenous silk made by Ramananantoandro. The young woman's mother said she would never forgive her daughter for wearing Malagasy silk, nor Ramananantoandro for making it. It would not have been an issue had the silk in question been imported from China and therefore without the same cultural associations (and repercussions) of Malagasy silk, which many highland Malagasy believe should be worn solely by those of noble ancestry and only those with white hair (e.g. if they were of an appropriately advanced age) and thus able to withstand the material's power. Yet, wearing foreign silk would not answer the desire to wear something "Malagasy," and as Ramananantoandro ironically notes, nowadays people commonly dye their hair black, making obsolete this manner of designation.

Now that *landibe* is slowly yet determinedly making a comeback in fashion, and now that weavers and designers see its popularity, it is beginning to appear in many arenas, even if it remains expensive and thus elusive to the majority of the population. Vendors therefore focus on wealthy local and foreign clientele, and items in this material are therefore primarily, although not exclusively, sold in the capital city of Antananarivo (in the heart of Imerina) and a few other large urban centers. Two well-established silk vendors are Vatosoa Boutique run by Mr and Mme Georges Randrianatody, and Rakotomalala et fils of Jocelyn Aimé and Bakolitiana Rakotomalala, both located in Antananarivo and run by rival branches of the same family (both shops trace their entrepreneurial lineages back to the same founding grandparents of the current owners) (Figure 16). Both sell high quality burial shrouds, yet over the past thirteen years have begun to sell clothing and accessories, including shoes, purses, and ties (Figure 17). Both stores are doing well with a steady flow of clients (significant considering the foundering economy) and in fact, in 2004 the later was featured in an educational "spot" on national television as an example of a successful and significant business.

It is also becoming increasingly common to find indigenous silk transformed not only into clothing trends, but also into fashion accessories and household items. A number of boutiques and shops in the capital now sell pillows, bedspreads, and accessories of indigenous silk alongside clothing items. In fact, the strong tendency in Madagascar for individual artists or entrepreneurs to copy any trend, artistic or otherwise, once it has proven itself economically viable has actually increased the relative availability of indigenous silk items. Once one artist or designer successfully launches a new product, the competition tends to immediately snatch it up and produce the same items multifold, often much

Figure 16
Rakotomalala et Fils Boutique, Antananarivo, 2003. Photograph: Rebecca L. Green.

to the chagrin of the artist or designer who took the initial artistic and economic risk.

Traditional cloth and clothing have received a great deal of national attention recently. In 2003 the annual national fair, called *Dialogue des Cultures*, had the theme "*Ny lamba sy ny firenena, ny zo maha-olona*" (Cloth/Clothing and the nation, the rights of the people), located in the Palais des Sports, in the capital city. Delegates from across the island and representatives of numerous foreign embassies contributed to the *Dialogue* by setting up booths and displays, giving demonstrations and speeches, and participating in an opening parade to highlight the clothing and fabrics from the various locales. The Betsileo- and Merina-sponsored booths (Figure 18) highlighted indigenous silk in burial shrouds and as shoulder wraps, but did not display the more cutting-edge and expensive high-end fashion.

While remaining primarily as an upper-class urban expression of identity through high-end fashion, the sale of *landibe* as clothing *is* making its way to the less affluent countryside, where some of the population would argue that this material had indeed been worn tradi-

Figure 17
Purse from Vatosoa Boutique, Antananarivo, 2003. Photograph: Rebecca L. Green.

tionally in the distant past. For example, the northern Betsileo town of Ambositra is known as a traditional center of indigenous silk weaving and is surrounded by a number of well-known towns and hamlets that have made (e.g. Sandrandahy), or are making (e.g. Soatanana) names for themselves as important weaving centers.[22] Ambositra also touts itself as the "Art capital of Madagascar" and, being located along the central north–south highway, draws a substantial number of tourists. Most tourists are only in the town for a few hours of intensive shopping, focusing primarily on basketry, hats, embroidery, toy cars of recycled materials, knickknacks of cow horn, and wood carving made by the Zafimaniry peoples living in the nearby forests and who are famous for their geometrically incised wooden objects. Yet one of the many shops that line the streets is beginning to also recognize that these tourists also like silk textiles and more importantly, have the money to purchase them, and has begun to carry a few small items in the expensive indigenous silk (Figure 19). So far, the only buyers this store has had for the silk items have been foreign; locals have yet to purchase clothing or accessories in this material, although not for lack of interest. The issue of wearing indigenous silk is slowly gaining acceptance, even outside

Figure 18
Merina booth displaying indigenous and mulberry silk at the national festival on cloth, entitled *Dialogue des Cultures*, Antananarivo, 2003. Photograph: Rebecca L. Green.

of the fashion and global center of the capital city and within the more tradition-based rural communities, even if the actual practice of doing so has yet to become reality. Many people of this region have told me they would buy and wear the silk if they could afford it.

One rural community to embrace weaving shawls in indigenous *landibe* silk is the Betsileo town Soatanana, to the south of Ambositra. It is a small community but one that has established a reputation for its beautifully and subtly dyed large shawls that now regularly appear in the high-end fashion boutiques in the capital city. Their weavings have sparked interest on many levels. They have appeared in *Orchid*, Air Madagascar's onboard magazine (Grollier 2001: 42–52), Foreign non-government organizations (NGOs) are paying close attention to their work with one Italian-staffed organization periodically sending a representative to the town to discuss mulberry tree cultivation (the townswomen said that the Italians gave them seeds to plant trees) and to purchase textiles, and Peace Corps volunteers have informally worked with the weavers to help them land business connections to ensure viability. A number of the families have organized a cooperative and registered with CITE, the Centre d'Information Technique et Economique in Am-

Figure 19
Landibe scarf from Ambositra, 2004. The three-sided fringe is unusual. Photograph: Rebecca L. Green.

bositra, and a representative of the cooperative travels to the capital to deliver their goods biweekly if not weekly to various boutiques.

Some designer–artists have successfully taken traditional materials and methods to new heights. For example, Joël Andrianomearisoa, a young *haute-couture* designer based in Antananarivo and Paris, uses a variety of materials in his designs, including plastic, wood, metal, and stone. He has tried to launch a line using indigenous silk but has found, as have many others, that it is difficult to create fashion on a large scale due to the silk's relative rarity and to the resultant inconsistent preparation when one must rely on a variety of sources. He has therefore, at least for now, given up the idea of using indigenous silk. However, although seemingly far removed from traditional clothing, by wrapping his models in the variety of other materials listed above, he is using the new materials in a manner placed firmly within highland ancestral traditions. And he does so on a world stage, launching his collections from Paris to Dakar to Antananarivo.

Indigenous silk has also entered the contemporary art world through the work of fiber artist Zoarinivo Razakaratrimo, better known as Mme Zo. Zo, whose works were included in the 2002 exhibition of

Malagasy textiles at the Smithsonian's National Museum of African Art (see Kreamer and Fee 2002) and has been featured in the Senegalese contemporary art biennale exhibition *Dak'Art*, also creates art that involves wrapping. An unconventional weaver, Mme Zo introduces a great variety of materials into her work, such as *Progress.com* from 2003 (Figure 20). By incorporating various wrapped objects—from spices, pods, and various household objects to condoms, piano keys, walkman innards, and computer chips—the artist continues the highland Malagasy tradition of wrapping, enveloping, and touch that is so fundamental to ancestral traditions. Yet she does so in new and innovative ways, as when she wove indigenous *landibe* silk (the warp) with long strands of fragile uncooked spaghetti (the weft).

By manipulating powerful cultural symbols and designs, Malagasy art makers, vendors, and consumers are actively reading and negotiating identity through a process described by Steiner while discussing the art and tourist market as, "interpreting and capitalizing on the cultural values and desires from two different worlds" (1994: 14). By controlling the information upon which others base their thoughts, decisions, and judgments about the world and the players in it, individuals are empowered, in the sense that power, a multifaceted, multi-centered force that is grounded in one's sociocultural, communicative, and ideological environment, is a cohesive force that allows one to gain some control in one's life in order to transform one's world(s).

The visual vocabulary being used in Madagascar is not isolated. Rather, it is part of a global "public domain" that anyone may access and use to make any statement, whether or not one has any connections, understanding, or comprehension of the backgrounds, power, and complexity of the vocabulary involved. For example, American and European fashion houses, travel stores, and home decor shops, including "Pottery Barn" mail-order catalogs, incorporate materials or designs that exude exoticism—batik from Bali, *bogolanfini* from Mali, wooden headrests from across Africa, raffia and silk from Madagascar—to entice consumers to buy their goods and thereby experience first hand this mysterious and exotic "other." Television sitcoms such as *Frazier* encourage viewers to understand the "obvious" sophistication of the characters from their ownership, implicit understanding, and appreciation of some of the same "exotic" objects placed tastefully throughout the sets. "Fashion as a process ... [is] a useful mechanism for interrogating the subjective experience of modern life. Fashion is a process in two senses: it is a market-driven cycle of consumer desire and demand; and it is a modern mechanism for the fabrication of the self. It is in this respect that fashion operates as a fulcrum for negotiating the meeting of internal and external worlds" (Breward and Evans 2005: 2–3). What Mme Nanou, Suzanne Ramananatoandro, Joël Andrianomearisoa, Mme Zo, and others are doing, therefore, is to *knowledgeably* combine ethnic dress (Eicher and Sumberg 1995) with global fashion, in order to firmly grasp that "other-

Figure 20
Zoarinivo Razakaratrimo's mixed media fiber work titled *Progress.com*, 2003. Reproduced courtesy of the artist. Photograph: Rebecca L. Green.

ness," with an intimacy and understanding that outsiders profiting off of superficial impressions cannot have, and with a personal expressiveness born from taking the social, political, and economic risks necessary in such an undertaking, thereby owning it, promoting it, and expressing pride in their Malagasy identity through it. As noted by Jean-Aimé Rakotoarisoa, Director of the Institut de Civilisations of the Musée d'Art et d'Archéologie at the Université d'Antananarivo, "One thing that has remained fairly constant in Madagascar is the attachment people have to their cloth. Most of my countrymen, it is said, are born, live, and sleep for all eternity with a *lamba*, a versatile cloth, either hand-woven or factory made, that both men and women in many regions of Madagascar wear today. Though there are various reasons for wearing this cloth, one of the more compelling is a real will to promote an important aspect of Malagasy cultural heritage" (Rakotoarisoa 2002: 30).

Notes

1. Germaine Ravaoarisoa, Merina cloth vendor in Arivonimamo, February 2002. Translated by Tefinjanahary Tantelinirina.
2. "Un certain nombre de jeunes malgaches aspiraient par tous les moyens à devenir *vazaha*. Certains le devenaient effectivement et se mêlaient aux *vazaha*. Mais des années plus tard, ils redevenaient malgaches. Car les Malgaches devenus des 'étrangers' (*vazaha*) semblaient ne plus vivre entièrement les nombreuses dimensions de l'intégration qui'ils avaient vécues auparavant. Aussi leur *aina* s'affaiblissait-il de plus en plus. Après quelque temps, ils se sentaient 'isolés'. Ils ne supportaient plus cette situation, surtout lorsque survenait un grave malheur, ils redevenaient alors 'malgaches.'"
3. While all peoples in Madagascar speak Malagasy as their primary language, the specific dialects are not always mutually understood. Therefore, someone from the far south would have a very difficult, if not impossible, time understanding someone from the far north of the island.
4. I write here specifically in reference to families who own tombs. Highland peoples have been divided into royal/noble, free, and slave categories, and those individuals who are either recent immigrants into this region, or who are descendants of slaves have not always had the ability (or the desire) to purchase land and commission a tomb. Please see Graeber (1999) and Middleton (1999), among others.
5. Germaine Ravaoarisoa, Merina cloth vendor in Arivonimamo, February 2002. Translated by Tefinjanahary Tantelinirina.
6. The late Marie Rasoazanany, a Merina weaver from Arivonimamo. Personal communication, 1990.

7. While some form of cloth or shawl is used island-wide, customs of dress vary sometimes significantly. Therefore, non-highland Malagasy do not necessarily see the highland version of the cloth and of dress as particularly representative of themselves.
8. These items are now in the collection of the Smithsonian Institution's National Museum of Natural History.
9. Personal communication, Antananarivo, 2003.
10. Personal communication, Sandrandahy, 1993. Translated by Tefinjanahary Tantelinirina.
11. Personal communication, Arivonimamo, February 1993. Notes transcribed by Vero Raharijaona. The late Razafimahefa was a Merina shroud vendor.
12. Mr Rakotondramasy, Manankasina Arivonimamo. Personal communication, November 1992.
13. See also, for example, Eicher (1995), Hendrickson (1996), and Weiner and Schneider (1989). Although some authors, such as McCracken (1988), argue that visual culture is not directly analogous to speech or language due to its non-linear structure.
14. I have translated the five *lamba hoany* sayings that were current between 1990 and 2003: *Maharary ny manina* is "regret makes one sick," *Tsy misy manana ny amy fa sambatra izay mifanampy*, is "no one has enough in life so blessed are those who help others," *Azon'ny tanako tsy avelako* is "I will not lose what I have in my hand," *Tsy mora mora mahazo vola* is "it is not easy to find money," and *Mandry amin'ny raha tiana tsy marary* is "you will not get sick if you sleep with what/who you love."
15. Many shirts with risqué messages make their way to developing nations through shipments of clothing by the ton. Examples I have seen include images of kittens or "pussy," with reference to female genitalia, and images of roosters or "cocks," with accompanying text referencing male genitalia, along the line of, "There is nothing like waking up to a big cock in the morning."
16. Tarika's *Bibiango* cassette was published by Xenophile under Green Linnet Records (1994).
17. Personal communication, 1992.
18. Solange Razaka. Personal communication, 1990. Interestingly, the young woman did not seem to be concerned with repercussions from beyond the grave, even though she had previously discussed beliefs in ancestral wrath.
19. Miriam Razanadrabe, a weaver in Manankasina Arivonimamo. Personal communication, 1992.
20. Arivonimamo. Personal communication, February 1993. Translated by Vero Raharijaona. The late Razafimahefa was a Merina shroud vendor.
21. Antananarivo. Personal communication, October 2003.

22. The small and remote town of Soatanana is quickly becoming a center for weaving dyed indigenous silk for shawls/scarves, partially due to sponsorship by an Italian NGO, partially to intense interest on the part of a couple of recent Peace Corps volunteers, and partially due to the business acumen of a number of weavers who journey to the capital city to sell their wares to the larger and fashionable boutiques who are in a position to sell to wealthy tourists and Malagasy alike.

References

Anonymous. n.d. "Monographie Sur le Lamba en Imerina," Antananarivo: Musée d'Art et d'Archéologie, no. TH.726.

Arnoldi, Mary Jo. 2002. "Gifts from the Queen: Two Malagasy *Lamba Akotofahana* at the Smithsonian Institution." In Christine Mullen Kreamer and Sarah Fee (eds) *Objects as Envoys: Cloth, Imagery, and Diplomacy in Madagascar*, pp. 95–120. Washington, DC: Smithsonian Institution and the National Museum of African Art, and Seattle, WA, and London: University of Washington Press.

Boram-Hays, Carol. 2005. "Borders of Beads: Questions of Identity in the Beadwork of the Zulu-Speaking People." *African Arts* 38(2): 38–49, 92–3.

Breward, Christopher and Caroline Evans. 2005. "Introduction." In Christopher Breward and Carline Evans (eds) *Fashion and Modernity*, pp. 1–7. Oxford and New York: Berg.

Bloch, Maurice. 1971. *Placing the Dead: Tombs, Ancestral Villages, and Kinship Organization in Madagascar*. London, New York: Seminar Press. (Reissued with changes, Long Grove, IL: Waveland Press, 1994.)

Bogatyrev, Petr G. 1971[1937]. *The Function of Folk Costume in Moravian Slovakia*. Trans. Richard G. Crun. The Hague: Mouton Publishers.

Boulfroy, Nicole. 1976. "Vers l'Art Funéraire Mahafaly." *Objets et Modes* 16(3): 95–116.

Brown, Mervyn. 1978. *Madagascar Rediscovered: A History From Early Times to Independence*. London: Damien Tunnacliffe.

Camboué, Paul. 1928. "Aperçu sur les Malgache et leurs Conceptions d'Art Sculptural." *Anthropos* 23: 1–18.

Covell, Maureen. 1995. *Historical Dictionary of Madagascar*. African Historical Dictionaries, No. 50. Lanham, MD, London: The Scarecrow Press.

Decary, Raymond. 1951. *Moeurs et Coutumes des Malgaches*. Paris: Payot.

Dubois, Robert. 1999. *L'identité Malgache: La Tradition des Ancêtres*. Transcribed from Malagasy by Marie-Bernard Rakotorahalahy. Paris: Editions Karthala.

Edkvist, Ingela. 1997. *The Performance of Tradition: An Ethnography of Hira Gasy Popular Theatre in Madagascar* (Uppsala Studies in Cultural Anthropology 23). Uppsala: Uppsala Universitet.

Eicher, Joanne B. (ed.). 1995. *Dress and Ethnicity: Change across Space and Time.* Oxford: Berg Publishers.

Eicher, Joanne B. and B. Sumberg. 1995. "World Fashion, Ethnic, and National Dress." In J. B. Eicher (ed.). *Dress and Ethnicity: Change across Space and Time*, pp. 295–306. Oxford: Berg Publishers.

Gade, Daniel W. 1985. "Savanna Woodland, Fire, Protein and Silk in Highland Madagascar." *Journal of Ethnobiology* 5(2): 109–22.

Graeber, David. 1997. "Love Magic and Political Morality in Central Madagascar, 1875–1990." In Nancy Rose Hunt, Tessie P. Liu and Jean Quataert (eds) *Gendered Colonialisms in African History*, pp. 94–117. Oxford: Blackwell Publishers.

Graeber, David. 1999. "Painful Memories." In Karen Middleton (ed.) *Ancestors, Power and History in Madagascar*, pp. 319–48. Leiden: Koninklijke Brill NV.

Grollier, Bernard. 2001. "En Remontant la Route de la Soie." *Orchid: Le Magazine de la Compagnie Air Madagascar* 16: 24–52.

Hendrickson, Hildi (ed.). 1996. *Clothing and Difference: Embodied Identities in Colonial and Post-colonial Africa.* Durham, NC, and London: Duke University Press.

Khan, Natalie. 2000. "Catwalk Politics." In Stella Bruzzi and Pamela Church Gibson (eds) *Fashion Cultures: Theories, Explorations and Analysis*, pp. 114–127. London and New York: Routledge Press.

Kreamer, Christine Mullen. 2002. "Objects as Envoys: An Introduction." In Christine Mullen Kreamer and Sarah Fee (eds) *Objects as Envoys: Cloth, Imagery, and Diplomacy in Madagascar*, pp. 15–24. Washington, DC: Smithsonian Institution and the National Museum of African Art, and Seattle, WA, and London: University of Washington Press.

Kreamer, Christine Mullen and Sarah Fee (eds). 2002. *Objects as Envoys: Cloth, Imagery, and Diplomacy in Madagascar.* Washington, DC: Smithsonian Institution and the National Museum of African Art, and Seattle, WA, and London: University of Washington Press.

Larson, Pier. 2000. *History and Memory in the Age of Enslavement: Becoming Merina in Highland Madagascar, 1770–1822*, Social History of Africa Series. Portsmouth, NH: Heinemann.

McCracken, Grant. 1988. *Culture and Consumption: New Approaches to the Symbolic Character of Consumer Goods and Activities.* Bloomington, IN: Indiana University Press.

McGeorge, Susan. 1974. "Imerina Famadihana as a Secondary Burial." In SECMI (ed.) *Archipel* 7, pp. 21–39. Antananarivo: Musée d'Art et d'Archéologie, no. TH.26.

Middleton, Karen (ed.) 1999. "Introduction." In *Ancestors, Power and History in Madagascar*. Leiden: Koninklijke Brill NV.

Price, Arnold H. (ed.). 1989. *Missionary to Madagascar: The Madagascar Diary of the Reverend Charles T. Price, 1875–1877*. New York: Peter Lang Publishing Group.

Raherisoanjato, Daniel. 1986. "Quelques Aspects des Problemes Relatifs au Developpement de l'Industrie Textile a Madagascar: Exemple des Tissus de Soie ou Lamba Landy." Paper given at *Exigences Religieuses et Imperatifs de Developpement dans les Sociétés Malgaches*, December 15–19. Antananarivo: Musée d'Art et d'Archéologie, no. TH.867.

Rakotoarisoa, Jean-Aimé. 2002. "Madagascar: Background Notes." In Christine Mullen Kreamer and Sarah Fee (eds) *Objects as Envoys: Cloth, Imagery, and Diplomacy in Madagascar*, pp. 25–32. Washington, DC: Smithsonian Institution, National Museum of African Art, and Seattle, WA, and London: University of Washington Press.

Razi, G. M. 1977. *Sources d'Histoire Malgache aux Etats-Unis (1792–1882)*. Antananarivo: Centre Culturel Americain d'Antananarivo.

Roach, Mary Ellen and Joanne Bubolz Eicher. 1979. "The Language of Personal Adornment." In Justine M. Cordwell and Ronald A. Schwarz (eds) *The Fabrics of Culture: The Anthropology of Clothing and Adornment*, pp. 7–22. The Hague, New York, Paris: Mouton Publishers.

Schneider, Jane and Annette B. Weiner. 1989. "Introduction." *Cloth and Human Experience*, pp. 1–32. Washington, DC, and London: Smithsonian Institution Press.

Schwarz, Ronald A. 1979. "Uncovering the Secret Vice: Toward an Anthropology of Clothing and Adornment." In Justine M. Cordwell and Ronald A. Schwarz (eds) *The Fabrics of Culture: The Anthropology of Clothing and Adornment.*, p. 23. The Hague, Paris, New York: Mouton Publishers.

Steiner, Christopher B. 1994. *African Art in Transit*. Cambridge: Cambridge University Press.

Making Fashion in the City: A Case Study of Tailors and Designers in Dakar, Senegal

Joanna Grabski

Joanna Grabski is Associate Professor of Art History at Denison University. She has researched artists and art institutions in Dakar since 1998. She recently edited a special issue of *Africa Today* dedicated to Visual Experience in Urban Africa and is completing a book manuscript dealing with Dakar's art world city.
grabski@denison.edu

Abstract

This article examines the interface between fashion production and the visual experience associated with urban life in Dakar, Senegal. It focuses on tailors and fashion designers to explore how their relationship to the city informs their creative practices and the processes of making fashion. Both tailors and fashion designers locate their creative practice in Dakar by attributing their engagement with the city's visual and conceptual matrix as fundamental to fashion making. In addressing the interplay between fashion production and the urban environment, this discussion further considers the dynamics of artistic positioning and the

complex intersections between local and global inflections. This analysis underscores the imbrication of fashion in Dakar and the city's conceptual and visual landscape, the street and the mass media, and finally dialogues within and beyond Africa. Not only do fashion makers select visual and conceptual elements from the urban ocular field. By creating new propositions for visual consumption, fashion makers also ever-constitute visual experience in Dakar.

KEYWORDS: Dakar, Senegal, fashion, fashion designers, tailors, urban life, visual experience

Introduction

Important topics of everyday conversation and a substantial expenditure for many Dakarois, fashion and dressing well are central features of expressive, visual culture in Senegal's capital city. From custom-made attire to *haute couture* design and imported new clothing to second-hand clothing, Dakar's various platforms for fashion production encompass a broad spectrum of individuals and institutions.[1] As with other forms of creative expression, especially *beaux arts* production and collection, fashion making is a quintessentially urban phenomenon in that the city offers unparalleled creative and human resources (Grabski 2003).

The designers and tailors profiled in this article share a relationship to Dakar's urban space and its visual environment. Specifically, the work of fashion producers in Dakar is predicated on a relationship with the urban environment's visual and conceptual resources. My research in Dakar in 2001 and 2002 examined how fashion producers' location in the city informs their visual production and working methods. By considering the interplay between the work of fashion makers and the many other forms of visual traffic that animate Dakar, this analysis explicates the ways in which the city provides a globally inflected matrix for fashion production. Furthermore, in order to understand the complexity of their roles as fashion makers, this article discusses the resources instrumental to their visual production.

Interviews with two sets of Dakar-based fashion producers provide the foundation for this study. The first group includes tailors working in the neighborhood of Niayes Thioker, especially Maguette Sy and Cheikh Faye of Central Couture, Bira Diouf of Galerie Payenne, and Balla N'diaye, Ndiasse Thiam, and Ami Colle Sene who work independently on Rue Adja Madeline N'gom.[2] The second set of producers, whose work aligns most closely with an international notion of *haute couture* fashion are designers Claire Kane and Oumou Sy.[3] In addition to her recently opened Paris Boutique in the Forum des Halles, Kane has a downtown Dakar boutique located on Rue Mousse Diop, adjacent to

a main thoroughfare. Oumou Sy's studio is located in the heart of the Medina, just off Avenue Blaise Diagne. Although the neighborhoods discussed here are centrally located and contoured by porous boundaries, they epitomize what Pfaff describes as "the social and spatial dualism of African cities (Pfaff 2004: 103)." Medina and Niayes Thioker are crowded, popular neighborhoods with sprawling, seemingly makeshift residential and commercial structures. In contrast, downtown Dakar is recognizable by its relatively imposing colonial architecture as well as administrative and commercial buildings.

Dakar's Spectatorial Realm as Information Environment and Artistic Resource

The assertion that fashion exists within the visual circuitry of the everyday urban environment expands on recent scholarship in visual culture studies. The pioneering work of Mirzoeff, Rogoff, Shohat, and others posits vision and the everyday experience of the visual as analytical frames fundamental to our understanding of image making and meaning (see especially Mirzoeff 1998: 7).[4] My study of designers and tailors in Dakar builds on this foundation by examining how their work relates to their field of vision, the so-called spectatorial realm and the visual culture operating within it (Rogoff 1998: 14–16). Dakar's dynamic and dense visual realm is the primary field in which tailors and designers undertake the act of looking. Both public and private spaces figure into their daily visual experience. Glancing at the pages of a fashion magazine, watching a music video, or surfing the Internet offer fodder for the eye as much as the intense visual traffic of the city's streets. As Mirzoeff theorizes, the abundance of images as well as our ability to absorb and interpret them indicates that human experience is more visually oriented than ever before (Mirzoeff 1999: 1–5). Dakar is no exception, for in this city, visual experience is embedded in daily life to a striking degree (Figure 1).

It is widely recognized that Dakar is a copiously, and often unrelentingly, visual city.[5] This observation holds especially true for downtown Dakar, the Medina, and Niayes Thioker where the fashion makers discussed here work. It is virtually impossible to amble through these neighborhoods without submitting to a flurry of eye-catching encounters. Indeed, ocular overload kicks in soon after setting foot in these neighborhoods. The eye is pulled in every direction—the deteriorating surface of building facades plastered with nightclub flyers and advertisements for upcoming events, graffiti, and occasional wall murals. Vibrantly painted *car-rapides*[6] combine with yellow taxis and mopeds weaving through city streets. Glass painting displays, makeshift market stalls, and street vendors selling the latest mass-produced shirts from abroad vie for the attention of potential consumers.

Figure 1
The downtown streets of Niayes Thioker are alive with visual traffic. Individuals wearing billowing *boubous* or tailor-made ensembles of colorful wax-print cloth walk alongside individuals sporting blue jeans, jogging suits, and T-shirts. Photograph courtesy of Modou Dieng.

Many images populating the visual landscape are decidedly local in origin, such as the hand-painted signs advertising *dibiteries*[7] and the omnipresent iconic portraits of the Mouride Saint Amadou Bamba.[8] Others, including billboards plugging Nescafé, Michelin tires, and Coca-Cola, dot the horizon along the city's main roads, signaling the ubiquitous presence of international commodity culture. With its geographical location on the westernmost point of the African continent and its historical role as a crossroads, Senegal has been for centuries a site for the blending or *métissage* of ideas from near and far. Much as individuals in cities elsewhere in the world, there is little doubt that Dakar's populace participates in and negotiates the flows of a globally inflected environment for visual experience.

In addition to public spaces such as city streets, the mass media is a salient feature of Dakar's spectatorial realm. Media such as the local RTS (Radio Television Sénégal) and satellite television as well as national and international magazines offer significant conduits in

"the unceasing flow of images from the swirl of the global village" (Mirzoeff 1998: 4). For instance, the Mexican telenovela, *Marimar* and Brazilian *Sublime Mensonge* air weekly, much to the pleasure of their many devotees. Music videos by French and American rap musicians flash across television screens with as much regularity as videos by Senegalese superstar Youssou N'dour. It is common to see printed matter from abroad in Dakar, especially copies of fashion magazines, *Amina*[9] and *Elle*, whose pages offer a barometer of international trends. Indeed, the continuous influx of visual and conceptual propositions from within and beyond Dakar further insures the endless mutability of the city's cosmopolitan environment and visual traffic.

The vibrancy and dynamism of the city streets is dramatically illustrated by the sartorial concerns of its population. Style-conscious individuals elegantly dressed in billowing embroidered *boubous* or tailor-made ensembles in colorful wax-print cloth walk alongside individuals sporting blue jeans, jogging suits, and Sean Jean shirts. Dressing well adds another potent layer of vitality to ocular experience in Dakar. Tailoring is among the most common neighborhood businesses, and it is no exaggeration to say that a tailor's studio always seems to be just around the corner. In fact, tailor Bira Diouf, former President of the National Tailor's Association, estimated that more than 20,000 tailors practice their trade in Dakar, a city whose population is nearly 2.5 million (Bira Diouf, interview with author, Dakar, July 26, 2001).

The centrality of clothing, dressing well, and aesthetic evaluation to life in Dakar has been well established in an illuminating body of scholarship by Heath, McNee, Mustapha, Rabine, and Scheld. In her research on fashion, socioeconomics, and globalization, Mustapha establishes what she terms the "sartorial ecumene" of the Dakarois (Mustapha 1998: 15). She writes: "The spectacular garments and arresting individuals that populate Dakar's public spaces illustrate the vital importance of appearance, dress, and beauty there. Not only are the people, and especially the women, strikingly beautiful, but they are fashionable, and pay all the attention to conduct, style and detail that this entails" (Mustapha 1998: 19).

Dakar's spectatorial realm offers fashion producers a matrix of visual and conceptual propositions. Echoing Bourdieu's[10] theorization of "the field of cultural production," urban experience may be conceptualized as a terrain in which visual and conceptual propositions are enmeshed (Bourdieu 1993).[11] In this, fashion making is analogous to the creation of other art forms in that its production, circulation, and consumption are shaped by and linked to the urban environment. As the term matrix suggests, the elements constituting Dakar's spectatorial realm are multiple, intersecting, and of diverse origins. Both visual and conceptual, these propositions entangle with one another in an elaborate and dense circuitry, much as Appadurai discusses in his

conceptualization of the "flows" of images and ideas comprising an "ideoscape" (Appadurai 1996: 33–6). Whether global or local, whether deriving from the mass media or public life, the elements constituting visual experience in Dakar intersect as an inclusive and absorbent matrix of propositions.

The tailors and designers I interviewed commonly posited their interaction with the city's matrix of propositions as essential to their production. In this, the urban environment provides a central, defining frame out which their fashion production derives. Visual experience in Dakar and its various propositions provide an information environment and artistic resource for both designers and tailors. Their creative process involves an on-going dialogue with the city's spectatorial realm and its various propositions for fashion making, like other forms of creative expression, "is born *between* individuals and larger frameworks in a process of dialogic interaction" (Shohat and Stam 1998: 46). As is the case with other visual artists in Dakar, the fashion makers discussed here are catalyzed by the social and visual phenomena in which they live. Far from being passive consumers in their field of vision, fashion makers draw from it selectively and thoughtfully. In particular, they participate in a kind of visual sampling, culling the resources at their disposal. This process entails appropriation and invention, absorption and recombination. This process is described by tailor Bira Diouf, "I develop my designs in relation to the society in which I live and I also try to create even when I am walking in the street. Here I take my ideas and the ideas of others. I put them together and I create something else. That is always what I do, even if I am just looking, I am always working" (Bira Diouf, interview with author, Dakar, July 26, 2001).

Success as a tailor is based on more than technical expertise. It also requires knowing how to "plug into" the circuitry of Dakar's matrix of propositions. Sophie Ba, manager of Nabil Couture, summarizes the relation between the fashion enterprise and Dakar's visual environment: "to work in fashion, you need to be highly skilled, have a good imagination, and be an astute observer of all that is happening around you" (Sophie Ba, interview with author, Dakar, July 30, 2001). By referring to expertise, creativity, and observation as interdependent qualities for making fashion, Ba's statement echoes a central claim of visual culture studies as articulated by Rogoff who urges consideration of how visual producers interact with images in order to make images (Rogoff 1998: 16). Designers and tailors not only draw information and inspiration from urban visual experience, they are also important agents in shaping it. The dynamic sartorial forms they create are among the most significant elements giving form to the visual traffic of city streets. Central to the processes of information flow, these individuals shape hybrid visual culture in Dakar. Thus, fashion makers not only draw from Dakar's matrix of propositions, they also constitute it with their production.

Tailors in Niayes Thioker

Adjacent to Marché Sandaga, Dakar's largest and most central market, the neighborhood of Niayes Thioker represents a veritable crossroads for information flow. Objects, images, and ideas bustle in and out of this space with ease and regularity. Over the years, the market has grown beyond the confines of its main building, with vendors and stalls overflowing onto the nearby streets of Niayes Thioker. The visuals comprising this space encompass both locally grounded and globally connected images and products. The latest Sean Jean shirts, Air Nikes, and vibrant wax-print cloth combine with *fuug jaay* or second-hand clothing to offer an astonishing traffic of visual possibilities. Spatially, the neighborhood is also very much a nerve center of urban Dakar. It occupies the borderland between Medina's urban sprawl and upscale downtown, especially Dakar's main thoroughfare, Avenue Georges Pompidou, recognizable by its commercial edifices erected during the colonial and post-independence periods. Clients intent on commissioning the latest and trendiest garments visit tailors in Niayes Thioker, despite the availability of tailors in their home neighborhoods. Several tailors I interviewed recalled that their clients come to Niayes Thioker from as far away as Pikine, Parcelles Assanie, and Nord Foire, all neighborhoods located on Dakar's outskirts.[12] Tailors based in Niayes Thioker contend that being downtown affords them a greater proximity to the latest trends, making their work more desirable for a style conscious clientele. For instance, tailor Maguette Sy, co-owner of Central Couture, explained that his "studio's location on Avenue Adja Madeline N'gom makes it more connected to an urban pulse" (Maguette Sy, interview with author, Dakar, July 18, 2001; Figure 2).

As Mustapha has also observed, tailors read visual propositions from the streets and the mass media most astutely (Mustapha 2001b: 51). The tailors I interviewed emphasized that images from the media as well as the streets provide them with important sources of visual information. For instance, clothing designs derive from television, especially soap operas such as the Mexican *Marimar* and music videos by Senegalese and international hip-hop, rap, and popular musicians, among them Vivianne N'dour, Youssou N'dour, and Coumba Diallo Seck. As for the relationship between these resources and the tailors' creative process, several of them explained that when they watch television, especially soap operas and music videos, they do it with an eye towards fashion. Sy recounted, "clients come in here and ask me if I watched a recent episode of *Marimar* or *Sublime Mensonge* and describe what a certain actor was wearing" (Maguette Sy, interview with author, Dakar, July 18, 2001).

Music videos are also important sources of visual information. In recent years, favorite designs identified as "mayonnaise" and *dialgaty*[13] were popularized by Vivianne N'dour's music videos. In the case of

Figure 2
Tailor Maguette Sy of Central Couture outside his Niayes Thioker studio with two apprentice tailors. Sy describes "the act of looking" at the city's visual traffic as central to his creative process. Photograph: Joanna Grabski.

mayonnaise, the design consists of a ¾-length skirt with a V-shaped slit. Even when television does not introduce a new design, it can certainly increase its popularity. For example, Maguette Sy maintained that although he fashioned a garment in the mayonnaise style in 1999, it was N'dour's video the following year that sparked his clients' demand for this design. He explained, "we made this design a while ago, but the video made the dress and dance popular because of the people in it. The dress N'dour wore took the name of the dance" (Maguette Sy, interview with author, Dakar, August 10, 2001).

The connection between popular neighborhood life and fashion production is clearly demonstrated by the wide range of attire made in conjunction with Senegalese soccer victories in World Cup qualifying rounds in late May and early June 2002. The primary site for

public celebrations and the exhibition of solidarity was neighborhood streets. When Senegal defeated France, from whom they also gained independence in 1960, tailors enjoyed a boom in business due to fans commissioning tailor-made clothing celebrating the Senegalese victory. In response to market demand, tailors fashioned shirts, *boubous*, halter-tops, and dresses from cloth replicating the Senegalese flag (Figure 3).

Tailor-made garments were quickly made by many Niayes Thioker tailors and mass-produced T-shirts, bumper stickers, jewelry, and scarves were also available for purchase at Marché Sandaga. In addition to demonstrating the significance of fashion in urban public life, this example underscores the crucial role of tailors' visual production in forging collective identity and fostering solidarity. Their visual productions reflect national pride while reinforcing collective aspirations for global triumph in athletics, further highlighting the place of fashion in post-colonial reinvention. In situations of limited cultural capital,

Figure 3
Tailor-made garments from cloth replicating Senegal's flag in celebration of Senegalese soccer victory against France during the qualifying rounds of the World Cup. Photograph courtesy of Pap Ba.

the body offers a strategic site for the representation and contestation of power (Hendrickson 1996, Miessgang 2002, Mudimbe 1991). Positioned in dramatic public displays, the prominently visible "flag fashions" operate as performative opportunities to challenge and realign long-standing relations of power and domination between Senegal and France.

Another significant element in the creative process is dialogue between clients and tailors. Because tailors work by custom order and according to a client's specifications, conversation is essential to developing a particular design. Much as Fabian illustrates in his analysis of conversations with Congolese artist Tshibumba Kanda Matulu, the exchange of ideas and articulation of preferences catalyzes the creative process while offering a conduit for the circulation of information (Fabian 1996). Upon initiating a commission, clients bring in photographs, magazines, or garments in order to explain the design they intend to commission. At the tailor's studio, clients may consult additional clothing catalogs, photo albums of previously rendered designs, or posters showcasing a variety of garments.[14] Clients often select multiple design elements from different sources. For instance, one might choose a certain sleeve length to be combined with a flared cuff, a scalloped neckline, or pockets. Dialogue with tailors then adds new ideas to the mix. Tailors usually sketch out the designs and modify them as they work, as illustrated by the many tailor's drawings tacked to Central Couture's interior walls (Figure 4). Conversations between tailors and clients represent an opportunity to extend creative possibilities and expand the imaginations of both parties.

Figure 4
Interior wall of Central Couture plastered with sketches of various clothing designs resulting from conversations between tailors and their clients. Tailors often combine multiple design elements from different sources, sketching and modifying their design as they converse with the client. Photograph: Joanna Grabski.

While tailors acknowledge the importance of conversations with clients, they also emphasize that such discussions are mere points of departure for their creative, artistic expression. They contend that innovations rely on their artistry and imagination, rather than their clients' ideas. The emphasis on artistry is exemplified by a comment from Bira Diouf who stated concisely, "fashion, it is an art ... fabric and scissors are the tools of my expression" (Bira Diouf, interview with author, Dakar, July 26, 2001). Moreover, in discussing their productions, the tailors I interviewed invoked artistic concepts such as originality, invention, authorship, creativity, sensibility, self-expression, and personal style. With particular clothing designs gaining popularity at lightning speed and their replication both feasible and unavoidable, we must consider the significance of tailors locating their visual production within such discursive parameters. Tailors' discourse and its attendant premium on the concepts associated with artistry are powerful tactics for mediating the value of their visual production. Thus, it is with this narrative that tailors construct a professional persona and promote their expertise in order to attract clients. Although clients also promote tailors by word of mouth, and of course, their striking designs advertise themselves, tailors' narrative is an effective marketing strategy. In light of the intense competition resulting from many tailors working in close proximity, strategies of value inscription are essential to staking out a share of business.

Furthermore, concepts of originality and creativity are values that sustain the enterprise of tailoring for they underpin the very process of commissioning a garment. The premise of a commission implies that a garment will not be mass-produced but developed by way of the client's specifications and the tailor's imagination. The result will be a unique, custom-made garment. Indeed authoring an original design or inventing a style is a key aspect of the tailor's enterprise. Consequently, tailors have seemingly endless opportunities to innovate because they interact with a constantly changing array of clients, each of whom brings their own preferences and ideas to the commission. Maguette Sy explained that it would be unlikely to see the same tailor-made garment worn by more than one person on the street and, even if one observes the same fabric for a dress or *boubou*, it can be produced, depending on the tailor's expertise and creativity from an endless variety of combined elements (Maguette Sy, interview with author, Dakar, July 18, 2001). The tailor's expressive vocabulary is vast, encompassing a tremendous variety of cloth types and motifs, the cut, length, embroidery designs, and of course, the interpretation of the particular client's commission. Moreover, detail work—gathering, pleating, smocking, darts in strategic places, shoulder pads, ruffles, flounces, scalloped edges, and slits may be added to create visual interest and to define or highlight a client's particular body type (Figure 5). For instance, flattering detail work such as ruffles across the chest may be added to accentuate the client's upper body while highlighting a particular cloth's motif.

Figure 5
Interior of Central Couture with newly finished garments showing the range of creative expression making up tailors' extensive repertoires. Photograph: Joanna Grabski.

The importance of originality in a commissioned garment is demonstrated by the following anecdote. Maguette Sy recounted that one of his clients, after commissioning a dress from Central Couture, implored him to "forget the design" so as to ensure that she owned a one-of-a-kind garment and that others in her neighborhood could not have her design replicated (Maguette Sy, interview with author, Dakar, August 10, 2001). The emphasis on developing original designs also fosters intense competition among tailors, resulting in the need to "hide designs" before they make their inaugural public appearance by their owner. Sy explained, "when you create a design, clients can come to your studio and look at it and then leave to see another tailor to commission my design. Then, the tailor can come to greet me, look at my model and then leave. He can try to copy what he saw exactly but there is always a difference between an original idea and its copy" (Maguette Sy, interview with author, Dakar, August 10, 2001). As suggested above, perhaps the significance of such discourse is not whether a design is original, but

rather that tailors seek to inscribe their work with originality. To take credit for their creation and to provide a record of their originality, many tailors including Sy proudly stitch a label into their custom-made attire. As with *haute couture* design, the inclusion of a label indicates authorship, thus staking a claim to the ownership of a design.

The interactive component of the creative process has particularly extensive ramifications when it comes to tailors' international clientele. In this highly cosmopolitan city, tailors count a diverse group of expatriates and international visitors among their customers. International clients often place orders and transport clothing to other African metropolises like Lagos, Abidjan, Accra, or Bamako. Nabil Couture's Sophie Ba recounted that a sizable segment of her boutique's clientele include "Nigerians and Ivorians who order elaborately embroidered, custom-made Senegalese *boubous* from Nabil Couture and then carry them back to their home country in a large suitcase" (Sophie Ba, interview with author, Dakar, July 30, 2001).

Thus, the custom-made *boubou*, the undisputed hallmark of Senegalese fashion, is adapted to accommodate tastes and preferences from elsewhere. Several tailors were quick to point out distinct preferences including style, colors, and design motifs, among their international clients. Nabil Couture's Sophie Ba noted, "whereas Senegalese prefer champagne and beige *bazin* for *boubous*, clients from Lagos and Abidjan preferred less subtle motifs and vibrant colors" (Sophie Ba, interview with author, Dakar, July 30, 2001). Because tailors' creative output circulates into international networks via their clientele, their role extends beyond Dakar and contributes to the visual and sartorial experience of other urban spaces.

Clothing from Elsewhere

Much as Hansen illustrates in her seminal study on clothing networks and Zambia, clothing from elsewhere figures ubiquitously into Dakar's fashion scene (Hansen 2000). In addition to mass media, public life, and conversations with clients, the availability of imported clothing is a significant element in Dakar's visual and conceptual matrix. Like many cities in Africa, Dakar participates in the circulation of new and used clothing from other parts of the world, especially the United States, Asia, and South Africa. Boutiques and vendors selling imported new and second-hand clothing are widely accessible throughout downtown Dakar. New brand name attire such as mass-produced "Gap" jeans, "Levis" overalls, Air Nikes, and Sean Jean shirts[15] are available to many consumers just as is used clothing, called *fuug jaay*, meaning "shake and sell" in Wolof.[16] The interface of imported clothing with fashion production in Dakar is complex and multifaceted for the presence of imported garments poses both economic concerns and artistic possibilities.

My interviews with tailors, merchants, and consumers reveal diverse perspectives about the impact of imported clothing on fashion production in Dakar. Imported clothing is at once immediately distinguished as being from elsewhere and easily absorbed into Dakar's hybrid visual traffic.

Although new Western-style T-shirts, collared shirts, sports jerseys, jogging suits, and trousers are desired by some because of their availability, reasonable price, style, and relatively good quality, they have the disadvantage of being mass-produced and not made to measure. Conversations with friends in Dakar indicate that opinions about imported clothing vary greatly. For some, new imported clothing is desirable and stylish, while others argue that such items are worn only by youth or individuals of lesser financial means. As for second-hand clothing, it is less desirable because it is outdated by the time it is cast off and arrives in Dakar. As with new imported clothing, it is not cut to fit and so does not hang on the body perfectly as should tailor-made attire. For the most part, an individual with resources would ideally only wear custom-made attire. Indeed, the expense of custom-made garments is reflected in the fact that they are typically reserved for important familial ceremonies such as baptisms, called *xew* (Mustapha 1998: 38).

Imported clothing has a pervasive, though ambiguous impact on the economy of clothing production in Dakar. Tailors Bira Diouf and Balla N'diaye have commented that the availability of used clothing negatively affects the demand for their services. For example, N'diaye recalls making children's school attire until parents realized that they could obtain mass-produced garments more inexpensively and easily (Figure 6). Furthermore, in his former role as president of the National Tailor's Association, Bira Diouf even met with the Minister of Culture to call his attention to the fact that vendors selling imported clothing were diverting business from local tailors (Bira Diouf, interview with author, Dakar, July 26, 2001).

Despite the negative economic implications of imported clothing, these items do factor into local fashion production creatively. In an urban space where one-of-a-kind, custom-made clothing is highly desirable, the influx of new and used clothing offers a steady stream of ever-changing stylistic components. Imported clothing also provides a resource for tailors' production. For instance, clients might bring an article of new or used clothing to a tailor to have it replicated or to have certain features such as open cuffs or a particular neckline incorporated into a design. To Balla N'diaye, these items correspond to "potential ingredients in new recipes" (Balla N'diaye, interview with author, Dakar, August 4, 2001). Hansen also reminds us that clothing from elsewhere may mediate localized styles, appropriations and inventions (Hansen 2000: 248). The tailors I interviewed maintained that any article of used clothing can be altered, retouched, or reinvented completely.

Figure 6
Tailor Balla N'diaye, wearing Air Nike T-shirt, at work on custom-made dress from wax print. Photograph: Joanna Grabski.

Tailor Bira Diouf described this process: "if you buy a jacket with two buttons, the tailor can change it, re-cut it and so used clothes can be transformed … a good tailor could even buy a second-hand bed-sheet and make an expensive dress from it" (Bira Diouf, interview with author, Dakar, July 26, 2001).[17]

An additional perspective on the place of imported clothing in Dakar's fashion landscape was offered by Bobo Sylla, a 28-year-old fashion devotee, aspiring artist, and Niayes Thioker resident. Well-known in his neighborhood for sporting labeled attire, Sylla boasts of his wardrobe which includes Girbaud trousers, Ralph Lauren shirts, and a pair of Gucci loafers, much of which was acquired via second-hand clothing vendors in Dakar's Colobane market, the city's main used clothing market. As with tailor-made garments, the strategic acquisition of imported second-hand clothing also indicates good taste and aesthetic judgment. For Sylla, a self-proclaimed *esclave de la mode*, second-hand garments afford both a means of self-expression and a way

of staying connected to the world of style beyond Dakar. Sylla described the artistry of second-hand attire, "while wearing second-hand clothing can be interpreted as a strategy of making do, style-conscious individuals have made an aesthetic language out of wearing well-labeled, second-hand clothing" (Bobo Sylla, interview with author, Dakar, July 8, 2001). Counting himself among those who have elevated wearing cast-off garments to an aesthetic, Sylla was also quick to mention *haute couture* designer and former downtown Dakar resident Lamine Kouyaté whose label, Xuly Bët, has met with much international appreciation (Rovine 2005). Sylla described Bët's stylish designs as exhibiting an "aesthetic of *récuperation*," for they refer to used, second-hand materials by way of frayed seams and well-worn fabric held together with safety pins.[18] While Kouyaté represents the "street side" of *haute couture*, Claire Kane and Oumou Sy exemplify another nuance of urban African fashion production.

Haute Couture Designers in Dakar: Claire Kane and Oumou Sy

In contrast to tailors whose creative output is widely accessible and highly visible to Dakar's mainstream consuming audience, *haute couture* design is purchased by those with exceptional financial resources, including both Senegalese and expatriates. Although far fewer in number compared to tailors, *haute couture* designers also figure prominently in the city's fashion scene. Designers Claire Kane and Oumou Sy are dynamic creative forces in Dakar as well as the proprietors of their respective boutiques who oversee a sizable staff of employees. Like the Niayes Thioker tailors, the fashions of both Claire Kane and Oumou Sy grow out of their engagement with Dakar's spectatorial realm.

Born and raised in Paris, Kane is a Senegalese citizen by marriage who has lived in Dakar for more than twenty years. Her training was in neither fashion nor fine arts. Rather, she studied communication and business at the University of Montreal and attributes her understanding of design and aesthetics to her experience traveling in Morocco, Benin, Togo, Nigeria, and Senegal. She refers to herself as a *femme de communication* first and foremost who believes that "fashion embodies a form of communication and clothing represents a language in itself" (Claire Kane, interview with author, Dakar, July 31, 2001). Her goal in making fashion is not, as she stated, "to simply make clothes, but to make people more beautiful, to communicate, and to express myself" (Claire Kane, interview with author, Dakar, July 31, 2001).

Kane describes her artistic orientation as *mode conceptuelle* or conceptual fashion conceived in relation to the city. She elaborated, "it is the research I conduct on Dakar's environment that drives my

ideas, the forms and the materials" (Claire Kane, interview with author, Dakar, July 31, 2001). The notion that Dakar is a hybrid space is a cornerstone of Kane's work and indeed, her designs are frequently interpreted as epitomizing the hybrid aesthetic of urban Africa (Mensah 2000). Sold from her boutiques in Dakar and Paris, her designs articulate a fusion of local resources with cosmopolitan style.

Since launching her label in Dakar in 1988, Kane produces two seasonal lines per year.[19] Using locally woven cotton cloth, the designer creates several unisex designs, the elements of which are identified with both European and Senegalese fashion. For instance, she combines head-ties with long fitted dresses; boxy, tailored blazers with amply cut drawstring pants, and sporty hooded jackets with sleekly tailored trousers (Figure 7). By combining materials and styles from diverse sources, she creates what fashion writers appreciate as a style that is at once tailored and elegant yet urban and hip (Mensah 2000). At the same time, Kane considers her garments as formal

Figure 7
Ladies sun dress and parasol by Claire Kane. The dress features cloth that is part of Kane's series on Egyptian hieroglyphs. Photograph courtesy of Claire Kane.

solutions to design problems. Practicality and comfort are fundamental to her designs. As her press book informs us, her designs feature "pockets everywhere, collapsible collars, hooded collars ... clever accessories such as a cell-phone carrier to strap across the shoulders, belts with pockets, featherweight bags, and multipurpose scarves" (Kane 2000: 5).

Each seasonal collection departs from a conceptual premise or theme. Much like a graphic designer, Kane's approach centers on the creation of motifs or signs that visual consumers should be able to "read" in order to comprehend the collection's theme. After designing a motif signifying her conceptual premise, she uses seriography to imprint the motif on locally woven cotton cloth, which she then designs and cuts for the garments in each collection. The cloth for her designs is fabricated from locally grown cotton using a technique associated with Mandjak weavers in southern Senegal. Working in the inner courtyard of her boutique, two weavers prepare strips of cotton cloth. In order to adapt this woven cloth to her designs, Kane has modified its dimensions from the standard width of 30 centimeters to 90 centimeters. Mandjak cotton cloth is widely appreciated for its durability as well as attractive appearance.[20] While its surface is usually animated by brightly colored designs in relief against a white or black background, Kane omits the characteristic woven motifs in order to use the woven cloth as a support for her seriographed motifs.

Kane's imprinted cotton fabrics are both visually engaging and conceptually compelling. Though the cloth is conceived of as the medium for her designs, there is little doubt that it could stand alone as an artwork. In fact, two meters of her woven, seriographed cloth won the Prix de la Créativité in the 1998 edition of *Dak'art*, Senegal's Biennial Exhibition of Contemporary African Art. To highlight the contrast between the motif and the support, she often uses black or blue ink on the cloth support, which includes a range of shades such as deep gray, sky blue, ivory, violet, and sunset orange. The motifs must appear clearly and boldly delineated for they should be recognizable and, as she emphasizes, "readable and able to communicate information" (Claire Kane, interview with author, Dakar, July 31, 2001). Her inaugural collection, focusing on Egyptian hieroglyphs exemplifies her goal of creating recognizable motifs referring to broader issues and themes. Egyptian hieroglyphs point to the historical role of signs while alluding to her interest in pan-African history and identity.

A number of her collections have dealt with contemporary themes and issues relating to the urban environment, especially the increasing globalization of Dakar. Kane views globalization as the key force shaping city life, and she views fashion as the barometer of this globalization, stating, "urban fashion is where globalization is most evident in Africa" (Claire Kane, interview with author, Dakar, July 31, 2001). In two

recent collections, she focused on the city's ever-growing engagement with information technology and mass-consumption. She noted that, "in the past few years, an increasing number of internet cafes have sprung up in the city to give people access to email and the internet" (Claire Kane, interview with author, Dakar, July 31, 2001). To address these themes, Kane has designed fabrics featuring the @ symbol, associated with email addresses, and the barcode, the symbol of consumer culture. Other collections pivot around global personalities such as Ché Guevara, who the designer calls a "global icon of revolution," and musician Miles Davis, whose cool jazz and hip persona is much appreciated in Dakar (Figure 8). Comparing his melodies to "musical pictures," Kane explained that Davis's visually evocative music conjures up a multitude of images and locates Davis's jazz as growing out of African musical traditions (Claire Kane, interview with author, Dakar, July 31, 2001). A world music aficionado, Kane is especially interested in the musical connection between Africa and the African Diaspora.

Figure 8
Detail of blazer by Claire Kane composed of seriographed cloth with motifs honoring musician Miles Davis. Photograph courtesy of Claire Kane.

A second series dealing with this trans-Atlantic musical connection deploys characters from the Ethiopian alphabet as motifs. The Ethiopian alphabet was intended to allude to the inter-cultural heritage of reggae music and Rastafarian culture. For the designer, both "the rhythms and the lyrics extolling the virtues of freedom, hope, and peace refer to a musical genealogy between the Caribbean and the African continent" (Claire Kane, interview with author, Dakar, July 31, 2001). Her press book further explains that, "music was a means of survival and communication for the Africans uprooted by slavery" (Kane 2000: 5).

Some collections make reference to contemporary events affecting the lives of Dakar's populace while commenting on particular conditions of post-colonialism. The motifs for two collections in particular underscore the problematic relationship between France and its former colonies. In response to the devastating 1994 devaluation of the CFA to the French franc, she created a series dealing with the CFA, the unit of currency for Francophone West Africa. Similarly, the production of cloth depicting a visa stamp followed public uproar about an increase in the denial of Senegalese travel visas to France. This series may be interpreted on two levels. Not only does it allude to the contemporary predicament of border crossing for Senegalese and other African nationals, it also obliquely references Kane's identity as a former French national who has taken on Senegalese citizenship and has traveled extensively in Africa. With this motif, she suggests the ease with which French nationals can reside, let alone travel, to former colonies while highlighting the difficulty with which nationals of former colonies travel to France (Claire Kane, interview with author, Dakar, July 31, 2001). In light of her self-positioning as a "femme de communication" whose work also celebrates various dimensions of pan-African heritage, one might speculate that this series communicates a subtext about the inequity inherent in post-colonial reality.

It is no surprise that Kane refers to her fashion as "100% Dakar," for this slogan expresses the fact that every step in her fashion production, from conception to execution, occurs in this city. That her clothing is fabricated entirely on site is a source of great pride for the designer, for she views her initiative as a mode of economic empowerment for her thirty employees. Although the majority of her clientele in Dakar is composed of expatriates, international visitors, or celebrities such as Youssou N'dour, Peter Gabriel, and Senegal's President Abdoulaye Wade, she asserts that the appreciation and recognition of her work by a local audience is her greatest success.

Unlike Kane, Oumou Sy, another of Senegal's leading designers, is an autodidact whose experimentation with fashion dates to her childhood in Podor, northern Senegal. Sy began fabricating dresses for her dolls when she was eight years old. In addition to making dresses, she also

recalls crafting her dolls and her own scissors. By the age of ten, she made clothing for clients and by twelve, set up her own sewing studio. Sy often attributes her creativity to the freedom of being self-taught (Oumou Sy, interview with author, Dakar, August 10, 2001). She describes, "in my mind, my ideas and my creativity have no limits. I was never trained. Everything I know I learned independently and without rules. I am Peul, my people are nomads, we do not need papers and passports to traverse boundaries. It is what we do" (Oumou Sy, interview with author, Dakar, August 10, 2001). She has also asserted that her creativity is further bolstered by the fact that she is not literate, making fashion her most important vehicle for self-expression.

Although she offers *prêt-à-porter* garments, her unique, experimental *haute couture* designs are most celebrated (Figure 9). Her designs' originality and flamboyance underscore that she is indeed unconstrained by the conventions of fashion production. Inventive and resourceful, Sy combines a variety of seemingly incompatible materials such as

Figure 9
Haute couture dress by Oumou Sy. Inspired by the elegance of a bird in flight, this dress was featured at SIMOD (Semaine Internationale de la Mode de Dakar) 2001. Photograph courtesy of Pap Ba.

strip-woven cotton with raffia and organdy with calabash and computer disks. Whether she crafts sleeves from baskets, a bustier from calabashes, or a halter top from beads, her industrious use of materials suggests that she leaves no resource unexplored. Whereas Kane's garments may be appreciated for their hip style, design solutions, and wearability, Sy delights in creating extravagant designs which she refers to "as a spectacular event" and "*objets d'art*" in their own right (Sy 2002: 32). Her theatrical flair has made her a favorite costume designer for theater and cinema productions by the late Senegalese filmmakers Ousmane Sembène and Djibril Diop Mambety.

Like the other fashion makers described in this article, Sy ascribes her hybrid environment as central to her artistic creations. In contrast to the other fashion makers interviewed for this article, Sy views Senegal, and not only Dakar, as a source of inspiration. She invokes Senegal's history of *métissage*, the blending of cultures and peoples, in discussing both her work and her own biography. In particular, she views the mixing of European and African culture, modern technologies and traditional cultures, and urban with rural as the foundation for her fashion making. She elaborates, "if I see a European design for a dress, I can easily outfit it with some African accessories and so create something new. It is this very exchange that is so interesting" (Sy 2002: 32). Her work exemplifies that *métissage* is a point of departure by way of combining motifs from Senegalese folklore or artistic techniques such as batik, weaving, and embroidery with elements she associates with modernity or globalization such as bowler hats or compact disks. As writer Nicole Smith asks, "where else does Western chic meet Afro-avant-garde but in the creations of Oumou Sy" (Smith n.d.).

Sy is also the founder and host of SIMOD (Semaine Internationale de la Mode de Dakar), which had its fifth edition in June 2001 (Figure 10).[21] SIMOD exemplifies *haute couture* spectacle. As a platform for fashion designers from Africa and beyond, SIMOD is a relatively exclusive showcase attended primarily by participants in Senegal's culture industries, Dakar-based diplomats, and photographers from fashion magazines such as *Marie Claire*, *Elle*, and *Amina*. It is intended to serve as both a meeting place for designers and an arena for the exhibition of creativity in fashion. At the other end of the spectrum, Sy also organizes the *Carnaval de Dakar*, an open-air event held in the streets of the Medina. The event, which entails a procession of costumed characters moving through the streets, brings Sy's designs to Dakar's popular audience. Her motivation for hosting this event stems from her desire to share her production with the city's local population whose heritage of *métissage* and hybrid reality inspires her work. She states, "I just think that it is no good to organize a fashion show in a hall and to leave those who don't have the money to remain outside" (Sy 2002: 33). This event firmly positions her creative work at the intersection of urban visual culture, spectacle, and social space. Not only does her work grow out

Figure 10
Oumou Sy's designs on the runway at SIMOD (Semaine Internationale de la Mode de Dakar) 2001. Photograph courtesy of Pap Ba.

of Senegal's hybrid visual landscape, for with this event, she returns fashion to the streets of the Medina in particular and Dakar's ocular realm more broadly.

In another illustration of her commitment to popular accessibility, Sy played a principle role in founding Dakar's first Internet café, Metissacana in 1996. Moreover, she founded a fashion school, Atelier Leydi, where students learn indigenous techniques for making clothing as well as new technologies.[22] In part because of her entrepreneurial acumen and partly because of her masterful self-fashioning, Oumou Sy enjoys the status of legend in Dakar.

Conclusion

This study has examined fashion production in Dakar by focusing on the relationship between visual production and the urban environment. The point of departure for the production of fashion makers discussed in this article is their location in Dakar and their engagement with the city's visual realm. By addressing the relationship between fashion and the urban environment, this discussion examines the complexities of artistry as well as local and global intersections. It also illuminates how fashion making in Dakar draws upon the city's conceptual and visual matrix, the street and the mass media, and finally dialogues in Africa and beyond. In their production, fashion makers not only select from the city's visual and conceptual traffic, they also ever constitute it by creating new propositions for visual consumption.

Notes

1. While aspirant fashion designers can train at the École de Mode, Coupe, et Couture, part of the national art school, other forms of training such as an apprenticeship with a master tailor or matriculation at one of the city's many tailoring schools are more common paths to working in fashion.
2. Due to economic constraints, the majority of tailors in Dakar rent sewing machines and workspace, aspiring to someday own their own machine as well as studio. Other tailors with extensive experience and the right connections might accept employment at one of the city's upscale *boubou* boutiques such as Nabil Couture, Mandele Couture, and Plateau Broderie. At the high end of the market, these reputable boutiques cater largely to a clientele with the financial resources to purchase elaborately embroidered, custom-made *boubous* for holidays or special occasions.
3. Whereas *haute couture* designers usually showcase their collections in fashion shows, tailor's creations are given visibility on the city streets and other public or private arenas such as family gatherings and neighborhood events. While *haute couture* designers such as Claire Kane and Oumou Sy also offer off the rack attire available for purchase in their boutiques, they typically exhibit their work by collection, producing two to three seasonal collections annually. Unlike tailors, the work of *haute couture* designers is not produced, at least in the strict sense, in consultation with clients who place custom-made orders. Finally, *haute couture* designers enjoy greater high-profile visibility by way of their coverage in international fashion magazines such as *Amina* and *Elle* and their participation in international fashion shows.
4. Mirzoeff argues that more attention needs to be focused on the everyday experience of the visual as everyday public life is a central terrain for visual culture studies. He explains that visual culture studies "directs our attention away from structured, formal settings like the cinema and art gallery to the centrality of visual experience in everyday life. Most of our visual experience takes place aside from these formally structured moments of looking ... a painting may be noticed on a book jacket or in an advert; television is consumed as part of domestic life rather than as the sole activity of the viewer."
5. The density of images characterizing Dakar's public spaces has been recognized in both scholarship and popular writing such as tourist books. For instance, see Roberts and Roberts (2003: 21). This exhibition catalog opens with the statement that "Dakar is a boldy visual city, images abound."
6. These are the brightly painted minibuses that serve as Dakar's public transportation.

7. *Dibi* is a Wolof term for roasted meat, usually lamb, and *dibiterie* is the restaurant where this meat is sold.
8. For more on Amadou Bamba and Mouride visual culture, see Roberts and Roberts (2003).
9. Published in France, *Amina* calls itself the "magazine of Black women."
10. Bourdieu conceptualizes a field as a socially structured space within which a discursive formation, like visual art, can function. Bourdieu's cultural field situates artistic works in the social conditions of their production, circulation, and consumption which exist within a kind of cultural circuitry.
11. Because this article's focus on is the relationship between urban visual experience and fashion production, it does not intend to examine other variables informing production and shaping consumption, such as economic and social life in Dakar. For more on these themes, see Heath (1992), Mustapha (1998), Rabine (2002), and Scheld (2007). As Mustapha's work shows, socioeconomic crises associated with globalization in the 1990s also had significant consequences for Senegalese cultural production. Her research interrogates the seeming contradiction between financial instabilities and Dakar's thriving clothing culture to reveal how fashion consumption is a strategy of empowerment responding in part to wide-scale economic restructuring (Mustapha 1998).
12. Clients typically work with multiple tailors. They choose a tailor for a commission depending on their objectives and the tailor's particular strengths. That is, a client who would commission Maguette Sy for a trendy outfit, may go to another tailor to replicate a garment. A great deal of variety and specialization distinguishes the city's many tailors. Some are celebrated for their original designs while others are known for their meticulous replication of clothing models advertised in catalogs, often from the United States, or garments acquired in Dakar and abroad.
13. *Dialgaty* is a Wolof word meaning to trip a person up or knock them over. It also has a sexual connotation.
14. Tailors' studios occasionally display a "decorative" poster sold to them by itinerant vendors from Nigeria. Because Senegalese rarely identify with the styles depicted in the poster, tailors described the posters as decorative, offering little more than points of departure for discussion.
15. The origin of these garments is ambiguous. It is assumed that they are the "real thing" produced by American manufacturers. Several interviewees have said that no factories for producing imitation label clothing exist in Senegal. Rather, these items are exported from China or Nigeria.
16. The term shake and sell suggests that it is desirable to shake off the dust accumulated on the garments during their movement from their previous owner to the sales context.

17. Mustapha (1998) notes a similar example, but associates it with a subversion and defiance of Western forms (p. 31).
18. The term *récuperation* refers to a method of making art using found or salvaged materials. This term was widely used by fine arts artists in Dakar in the late 1990s when they responded to a dearth of new art materials at Dakar's École Nationale des Beaux Arts by salvaging used materials such as horse shoes, aluminum cans, driftwood, and metal reinforcement bars (or rebars) as their expressive media. Salvaged materials continue to afford important artistic resources for artists in Dakar and other parts of Africa. For more see Grabski (2008).
19. Kane noted that she occasionally creates a third collection for Muslim and Christian holidays.
20. Other Dakar-based designers, including Aissa Dione and Oumou Sy, have begun to fabricate shawls and handbags using cotton cloth made in the Mandjak weaving tradition.
21. At the time of this writing, the future of SIMOD is uncertain. Oumou Sy has not announced when or if she will continue to host this important event.
22. *Leydi* means earth in the Pular language and refers to teaching of traditional techniques at the foundation of student training.

References

Appadurai, Arjun. 1996. *Modernity at Large: Cultural Dimensions of Globalization.* Minneapolis, MN: University of Minnesota Press.

Bourdieu, Pierre. 1993. *The Field of Cultural Production: Essays on Art and Literature.* Trans. Richard Nice. New York: Columbia University Press.

Fabian, Johannes. *Remembering the Present; Painting and Popular History in Zaire.* Berkeley: University of California Press, 1996.

Grabski, Joanna. 2003. "Dakar's Urban Landscapes: Locating Modern Art and Artists in the City." *African Arts* 36(4): 28–39, 93.

Grabski, Joanna. 2008. "The *Dak'Art Biennale*: Exhibiting Contemporary Art and Geopolitics in Africa." *NKA: Journal of Contemporary African Art* (Special Issue on Exhibitions and Curating) 22/23: 104–13.

Hansen, Karen Tranberg. 2000. *Salaula: The World of Secondhand Clothing and Zambia.* Chicago, IL: University of Chicago Press.

Heath, Deborah. 1992. "Fashion, Anti-Fashion, and Heteroglossia in Urban Senegal." *American Ethnologist* 19(Fall): 19–33.

Hendrickson, Hildi. 1996. "Bodies and Flags: The Representation of Herero Identity in Colonial Namibia." In Hildi Hendrickson (ed.) *Clothing and Difference: Embodied Identities in Colonial and Post Colonial Africa*, pp. 213–44. Durham, NC: Duke University Press.

Kane Claire, 2000. *Dossier de Presse*. May 12, 2000.

McNee, Lisa. 2000. *Selfish Gifts: Senegalese Women's Autobiographical Discourses*. Albany, NY: State University of New York Press.

Mensah, Ayoko. 2000. "Cap sur le style Claire Kane." *Balafon* 152: 54–7.

Miessgang, Thomas. 2002. "Directors, Flaneurs, Bricoleurs: Studio Photographers in West Africa." In Gerald Matt and Thomas Miessgang (eds) *Flash Afrique: Photography from West Africa*, pp. 16–23. Vienna: Kunsthalle.

Mirzoeff, Nicholas (ed.). 1998. *The Visual Culture Reader*. London and New York: Routledge.

Mirzoeff, Nicholas. 1999. *An Introduction to Visual Culture*. London and New York: Routledge.

Mudimbe, V. Y. 1991. "'Reprendre:' Enunciations and Strategies in Contemporary African Arts." In Susan Vogel (ed.) *Africa Explores*, pp. 276–87. New York: Center for African Art.

Mustapha, Hudita Nura. 1998. "Sartorial Ecumenes: African Styles in a Social and Economic Context." In Els van der Plas and Marlous Willemsen (eds) *The Art of African Fashion*, pp. 13–45. Trenton, NJ: Africa World Press.

Mustapha, Hudita Nura. 2001a. "Oumou Sy: The African Place, Dakar, Senegal." *NKA* 15(Fall/Winter): 44–6.

Mustapha, Hudita Nura. 2001b. "Ruins and Spectacles: Fashion and City Life in Contemporary Senegal." *NKA* 15 (Fall/Winter): 47–53.

Pfaff, Francoise. 2004. "African Cities as Cinematic Texts." In Francoise Pfaff (ed.) *Focus on African Films*, pp. 89–106. Bloomington, IN: Indiana University Press.

Rabine, Leslie. 2002. *The Global Circulation of African Fashion*. Oxford: Berg.

Roberts, Allen 1996. "The Ironies of System D." In Charlene Cherny and Suzanne Seriff (eds) *Recycled, Re-seen: Folk Art from the Global Scrap Heap*, pp. 89–101. New York: Abrams in association with the Museum of International Folk Art, Santa Fe.

Roberts, Allen F. and Mary Nooter Roberts. 2003. *A Saint in the City: Sufi Arts of Urban Senegal*. Los Angeles, CA: UCLA Fowler Museum of Cultural History.

Rogoff, Irit. 1998. "Studying Visual Culture." In Nicholas Mirzoeff (ed.) *The Visual Culture Reader*, pp. 14–26. London and New York: Routledge.

Rovine, Victoria. 2005. "Working the Edge: Xuly Bët's Recycled Clothing." In Alexandra Palmer and Hazel Clark (eds) *Old Clothes, New Looks: Second-hand Fashion*, pp. 215–27. Oxford: Berg.

Scheld, Suzanne. 2007. "Youth Cosmopolitanism: Clothing, the City and Globalization in Dakar, Senegal." *City and Society* 19(2): 232–52.

Shohat, Ella and Robert Stam. 1998. "Narrativizing Visual Culture: Towards a Polycentric Aesthetics." In Nicholas Mirzoeff (ed.) *The Visual Culture Reader*, pp. 27–49. London and New York: Routledge.

Smith, Nicole. n.d. "Oumou Sy, Senegal's Queen of Couture," *Africa Travel Magazine*. www.africa-ata.org/fashion_senegal.htm, accessed January 12, 2009.

Sy, Oumou. 2002. "Ideas Have No Boundaries: Interview with Wolfgang Kos." In Gerald Matt and Thomas Miessgang (eds) *Flash Afrique: Photography from West Africa*, pp. 32–6. London: Steidl and Thames & Hudson.

The Idea of Africa in European High Fashion: Global Dialogues

Kristyne Loughran

Kristyne Loughran, an independent scholar in Florence, Italy, focuses on African jewelry and fashion in Africa and the Diaspora. Her recent publications include *Art of Being Tuareg*, 2006, with Tom Seligman; *Desert Jewels*, 2008, with Cynthia Becker; and *Contemporary African Fashion* (forthcoming), with Suzanne Gott. She is a consulting editor of *African Arts*.
tinabini@mac.com

Abstract

African form and design have stimulated the creativity of European fashion designers for centuries. They have been used as inspiration for clothing designs, fashion accessories, and jewelry. By looking at the lure of the exotic in a historical perspective, and the importance of Africa in scientific, sociopolitical, and artistic arenas; this article will analyze the dynamic presence of African aesthetic expressions and styles in European fashion arenas in the twentieth century. This phenomenon was prominent between the years 1991 and 2000, with 1997 displaying a sustained African presence throughout the year. The work of John Galliano

and Jean Paul Gaultier reveals African motifs and ideas have inspired their designs, and are also employed to communicate social and political messages. Conversely, African fashion designers such as Xuly Bët and Seidnaly Alphadi, who work in Europe and in Africa, use their own aesthetic to design their collections, to spur their home economies, and to place Africa in the global fashion circuit. In the twenty-first century, the era of globalization and instantaneous communication *par excellence*, such issues disclose the interrelationship between African and European fashions. Inspiration and creativity, fueled by the allure of exoticism may become a global dialogue, which goes both ways.

KEYWORDS: exoticism, European high fashion, John Galliano, Jean Paul Gaultier, Alphadi, Xuly Bët, globalization

Introduction

As an Africanist art historian who specializes in Tuareg jewelry,[1] I have long been struck by the recurrent role African forms and aesthetic expressions have played in the European fashion arena. Judging from the persistent coverage on African-style attire and adornment in the contemporary media one can also assume that these forms will continue to be a source of creative ideas and inspiration for years to come. This phenomenon is not new, but the communicative and aesthetic roles that the "idea" of Africa plays in contemporary fashion magazines and on the street are all issues that raise important questions in this era of globalization. As Eicher and Sumberg noted in 1995:

> ... Ethnic dress in the late twentieth century cannot be analyzed without acknowledging the phenomenon of world fashion for ethnic dress and world fashion are interrelated ... (1995: 300).[2]

I will begin by first looking at how exoticism and the allure of otherness have a long history in European fashion with a particular emphasis on the historical development of this "idea" of Africa in European fashions. Then by concentrating on one year, 1997, I will illustrate how African aesthetic expressions have proven to be adaptable to new markets (Rovine 2001: 131). A closer observation of two examples from the world of *haute couture*, John Galliano and Jean Paul Gaultier, provide incisive if extreme examples of this point. In parallel, this phenomenon has also had a relevant impact on talented African fashion designers who live and work in Europe, such as Xuly Bët, and in Africa, such as Seidnaly Alphadi, who lives and works in Niamey, Niger. Through his fashions, Alphadi renegotiates African traditions for a global audience in the postcolonial era.

In Search of the Exotic: Historical Perspectives

Designers in the West are in constant pursuit of new ideas outside the dominant cultural aesthetic system they are working in. In order to understand the appropriation of African motifs by European designers, we must see it in the context of their consistent method of renewing designs by borrowing from exotic places, artistic movements, scientific discoveries, and sociopolitical events.[3] Stylistic borrowing across cultures began at least as early as the late thirteenth century, "when Marco Polo brought the first Chinese artifacts into Europe" (de la Haye 2000: 62). The earliest cross-cultural influences on Western fashion drew their inspiration from the East. Chintz, calico, and khaki are all of Indian origin. The growing importation into Europe of these and other textiles—such as cashmere shawls—not only influenced the world of European fashion, but also fueled European manufactures of new textiles to imitate these imported goods (Figure 1).[4] Men's morning coats, or "banyan," a long, loose jacket worn by gentlemen in their homes in Europe and in England in the 1800s, are a hybrid of Japanese and Indian influences (Orzada 1998).

Figure 1
Portrait of Madame Leblanc, wearing a cashmere shawl. Jean-Auguste-Dominique Ingres (French, 1780–1867), *Madame Jacques-Louis Leblanc (née Françoise Poncelle, 1788–1839)*, 1823; oil on canvas, 47 × 36½ in. (119.4 × 92.7 cm). All rights reserved, The Metropolitan Museum of Art, Catharine Lorillard Wolfe Collection, Wolfe Fund, 1918 (19.17.2). Image © The Metropolitan Museum of Art.

Two European artistic movements made an important impact on fashion and their influence is still felt today. The eighteenth-century Chinoiserie movement and the Japonisme period, which occurred in the second half of the nineteenth century,[5] inspired clothing with straight seams, V-shaped necklines, and full sleeves.[6] Modernist art movements within Europe like cubism also offered fashion designers new ways of seeing. What Richard Martin calls "the culture of cubism" eradicated the Belle Époque's silhouette and introduced cylinders, planes, and flatness (1998: 16).[7] Madeleine Vionnet's 1932 evening dress constructed on the bias and Jacques Doucet's 1920–3 ensemble with asymmetrical shapes are both examples of this new visual perception. More obvious analogies appear later on with Yves Saint Laurent's 1965 Mondrian dress and his Braque-inspired cape in the Spring/Summer 1988 collection.[8]

Scientific discoveries also fueled fashion trends. When an entirely new "exotic" culture appeared in 1923, with Howard Carter's dramatic discovery of King Tutankhamun's burial chamber, the attention in the press was such that it set off a wave of Egyptomania or what is often referred to as Tutmania. In fashion, this was translated into popular colors such as Nile blue, and motifs including the scarab—often reproduced in jewelry designs. The French designer Paul Poiret used embroidered hieroglyphic designs on clothing, and his hats replicated Egyptian hairstyles, as did Jeanne Lanvin.[9] This fashion focus on ancient Egypt was repeated fifty-four years later when the phenomenally popular *Treasures of Tutankhamun* exhibition traveled to the United States.[10]

Sociopolitical events also sparked the creative imagination in amusing and surprising ways. For example, in 1827, Muhammad Ali, the Viceroy of Egypt, presented a giraffe named Zarafa to the King of France, as a political gesture to allay strained relationships between the two nations. This diplomatic gift sparked a fashion craze and "zarafamania" spread at lightning speed, with French women wearing necklaces and hairstyles "a la giraffe" (Allin 1998: 176–7). Like "zarafamania," today's style forecasters regularly relate a "look" to some political, social or economic event. For example, when trade between China and the West reopened in the 1970s, Chinese workers' suits became very fashionable in Paris. This phenomenon spills over into other areas as well. In August 1992, the winner of the Golden Lion Award at the Venice Film Festival was a Chinese film called *The Story of Qiu-Ju*. Only two months later many designers produced sumptuous clothes made of embroidered silks and stores displayed Chinese objects as fashionable household decor.

Professionals inside the fashion industry have often remarked that this fascination with one exotic look over another and its expression in other cultural arenas are the result of "something, which is in the air."[11]

That *je ne sais quoi* is what partly sparks designers' creativity and urges them to produce specific collections. As McDowell states:

> The exotic and the ethnic have, to varying degrees of intensity become a permanent element in the structure of fashion ... Sometimes they play a major part, more often their role is in accessories, patterns and color combinations rather than in line and shape (2000c: 327).

Contextualizing Africa in European Style

The presence of Africa was felt early on in European intellectual, artistic, and fashion circles, because of colonial interests, artistic movements, and scientific discoveries. In 1854, Louis Vuitton started producing sturdy and hermetic traveling cases, camp beds, and linens for trips to the colonies (Borge and Viasnoff 1995: 17). The French trade and colonial expansions in the eighteenth and nineteenth centuries gave rise to the Colonial and Universal expositions. These were huge shows—the precursors of contemporary trade shows. They presented the history and technological progress of participating and host countries. The colonial sections were instrumental in disseminating information about distant cultures. They were also used to promote French colonizing activities (Tolini Finamore 2003: 347). According to Tolini Finamore (2003: 345), the 1900 Paris International Exposition was symbolized by the orientalist-style monument Porte Binet, which was crowned by "La Parisienne," a figure symbolizing Paris and dressed in a blue dress inspired by the Parisian dressmaker Paquin. This was a direct reference to France's profitable luxury industry (Tolini Finamore 2003: 347). The 1925 *Exposition Internationale des Arts Decoratifs* presented finished products and its mission was "a celebration of modernity that was rooted in beauty in simplicity and luxury in the quality of the material used" (2003: 349). The colonies were seen as a source for aesthetic inspiration and for exotic raw materials like tropical woods and ivory for consumer goods. France always used these events to promote its fashion industry and included boutiques and pavilions devoted to luxury goods, fashion, accessories, and textiles. The 1931 *Exposition Coloniale Internationale* included couturier clothing from designers such as Worth, Lanvin, and Callot Soeurs. The media coverage was celebratory and noted the beauty of the colonial influence on clothing and textiles (Tolini Finamore 2003: 355). Both the 1925 and the 1931 Paris exhibitions celebrated what Tolini Finamore calls the "coloniale moderne,"[12] which she defined as a "harmonious fusion of foreign aesthetics and western fashion that diverged from nineteenth-century incarnations of the exotic imaginary ... This new style was a more encompassing cultural hegemony that inspired a spirit of unity rather than 'otherness'" (2003: 245–6).[13]

In the 1920s and 1930s, many African American artists, performers, and musicians lived in Paris, where they enjoyed more personal freedom than in the United States.[14] The look and presence of Josephine Baker, a dancer from St Louis, at the Revue Nègre at the Music Hall des Champs Elysees in 1925 left a mark on French fashion. Hailed as "la Venus Noire," Baker came to represent a new canon of beauty (Bachollet *et al*. 1987: 136). Art Deco furniture displays cultural borrowing from Africa in the use of materials such as ebony, ivory, horn, and leather. For example, stools designed by Pierre Emile Legrain, a founder of the Art Deco movement for the designer Jacques Doucet, draw on the purity of the line, and are adaptations of Asante prototypes.[15]

The influence of non-Western cultures on the fine arts has been well documented over the years. Vlaminck, Derain, and Matisse's interest in African sculptures, and Picasso's famous trip to the Trocadero in 1907 are part of the African "*je ne sais quoi*" in Europe (see Goldwater 1986: 86–7; Rhodes 1994: 116; Rubin 1984: 242). As followers of the intellectual and artistic avant-garde became interested in African aesthetic expressions, it is not surprising that the influence of and interest in Africa spread to fashion and fashion accessories (see Baudot 1999: 100).[16] Paul Poiret designed a cape made of homespun cotton inspired by North African prototypes, and in May 1924, the fashion magazine *Art Goût Beauté* illustrated his design for a "Nubian evening dress." Mariano Fortuny, the Spanish designer from Venice, created his trademark pleated fabrics by fusing ancient Greek techniques and models with the linear simplicity of Moroccan caftans, and used these simple forms to reflect new modern lifestyles.[17] Fashions in the 1940s were influenced by World War II and designers had to contend with restrictions and shortages of materials (Boucher 1987: 415).

One of the first European designers to create an African collection in the 1950s was Madame Carven. She used African textiles to manufacture dresses, bathing suits, and wraps. Mendy-Ongoundou reports the designer was impressed with the draping systems and the color combinations of the textiles she had seen during extensive travels to Cameroon, Senegal, Ghana, and other African countries (2002: 126).[18] The appeal of bright colors, ample draped forms, and comfortable clothes was to repeat itself in the following decades. In 1967, Yves Saint Laurent produced his landmark African collection, creating "Bambara" dresses. Some were shifts, made of ebony beads, and others were made of braided raffia and flax.[19] According to *Harper's Bazaar* the collection was "a fantasy of primitive genius" (in McDowell 2000c: 337), but fashion historians saw his success somewhat differently. According to McDowell:

> Saint Laurent's genius lay in his choice of new materials for an haute couture line. He had the gift of borrowing from one culture without being condescending to the other. His dresses had integrity (2000c: 337).

The next year Saint Laurent borrowed from men's tailoring and created the "Saharienne" safari jacket,[20] which designers are still reinterpreting today. In 1984, Kenzo designed flowing "*boubou*" dresses[21] and in 1990 and 1991 he designed jackets and shirts inspired by bogolan motifs[22] and colors. In 1990, Missoni's *Africa di Missoni* highlighted a collection of knitwear with bold colors and geometric shapes. According to Gilles Rosier, the style director for Kenzo, the influence of Africa is a modern one, and is especially visible in textiles, materials, graphic designs, volumes, and forms (Mendy-Ongoundou 2002: 130). In fact, the "*boubou*" dresses created by Paco Rabanne in the 1996 Spring/Summer collections only emphasize that these shapes and colors continue to be recurrent motifs in European fashion shows.

In the period between 1991 and 2000, many articles and photographs published in European fashion magazines emphasized styles inspired by African aesthetic forms and illustrated the continuous presence of the "idea of Africa" in European fashion arenas. African inspiration as represented in fashion magazines is myriad and it is used in different ways. For the purpose of this article, I am limiting myself to a single year, 1997, because it was a very prolific year for African-inspired fashions.

European Fashion in 1997

In the European fashion arena, 1997 can be thought of as the Year of Africa as evidenced by articles and advertisements in popular fashion magazines.

February
In February *L'Officiel* proposed "Ethno-Chic Jewelry" to get ready for summer (p. 48) and featured a spread "African Reminiscence" (p. 74) that presented a collage of African art, sculptures, and the review of the *African Mosaïque* show, a runway show that features work by African designers.[23] According to the Spring issue of *Fashion Almanac*, the African inspiration was congruent with themes of global exploration (p. 41).

March
In March, the *Marie Claire France* cover displayed a Dior design, with Masai necklaces worn over a net top.[24] *L'Officiel* featured Dior's Masai mini-dress covered with a beaded apron. "The Jewelry Tribe" article (pp. 180–3) included striking photographs of jewelry by Harry Winston, Bulgari, and others resting on African bronze bracelets, bowls, combs, and a figure (sold at a boutique with the suggestive name l'Ile du Démon or Devil's Island). The *Vogue Paris* cover presented Dior's "Kamata" dress decorated with a Dinka corset and Masai necklaces. Also featured was Hermès' year of Africa campaign entitled "Africa: Earth and Mother," illustrated with a model wearing a bright orange cashmere turban. Louis Féraud's advertisement was a close-up view of

a black and white bodice decorated with rectangular, cross-shaped, and round Baule[25] beads. *Vogue Italy* included an article entitled "Ethno-extravagances" on artists and other eccentrics (such as Edith Sitwell, Vaslav Nijinskij) wearing ethnic costumes, and a fashion spread featuring African models, such as Kadra and Kiara from Ethiopia and Alek Wek from the Sudan, wearing Dior dresses.

April
Vogue Paris's "Echoes of Africa" spread was a long dress made with a Cameroon postage stamp print by Junko Shimada (p. 125), and *Vogue Italy* touted the "Savannah style," by displaying Hermès scarves and jackets with African wildlife motifs, entitled "Tanzania," and reviewing a dance ensemble called I Mande.

May
An article in *Vogue UK* titled "Into Africa" included safari jackets, jungle prints, and the "African inspiration running wild" (p. 33). The collage of images included Dior's dress with a Dinka corset worn with a beaded hat, Lawrence Steel's top made of wooden beads, worn with a brown knit skirt (revisiting the 1967 beaded Saint Laurent dresses), Hermès' leopard-print beach towel, and Ralph Lauren's "Safari" eau de parfum. *L'Officiel* included an article by Laurence Benaim addressing street styles, Afro chic, and the melting-pot effect. Discussing the importance of cross-breeding, Benaim cites Isabelle Marant's show, a parade inspired by trans-Parisian Africa. The Italian newsweekly *Panorama* (May 22, p. 233) presented striped sandals as a "taste of Africa." In *Vogue Paris*, a fashion spread presented African-inspired clothes by Hermès and Yamamoto, paired with photographs by the Malian photographers Abderramane Sakaly, Yussuf Sogodogo, and Hamadou Bocoum.

June
In June *Vogue Italy*'s collage-style presentation of McQueen and Galliano's dresses referred to the body as a "multi cultural totem" and Jean Paul Gaultier's African hairstyles are entitled "anthropological logic."

July
Elle Italy (pp. 108–9) featured a two-page spread entitled "African Nostalgia, Why Get Better at a Time when the Black Continent is so Fashionable?"[26] A virtual tour of the continent, these pages included combs, hair picks, raffia bags, leopard bags, an Akan[27] headrest, leopard pareos, fringed sandals, Akan bracelets, *Madre Africa* CDs,[28] a zebra-skin Versace chair, an ostrich egg lamp, beaded bracelets, literary releases from African authors, and an Ibeji figure.[29] A brightly striped Ralph Lauren dress similar to Kenyan textiles, and a Christian Lacroix Africa couture dress display stripes and the mixture of bright colors, in the African

style. *Vogue Paris* included a review of the Bamako photo show[30] at the FNAC (Fédération Nationale d'Achat des Cadres), an article on the Malian fashion designer Lamine Kouyaté, reviews of Kerchache's book on African Art[31] and of the "Magies" exhibition at the Dapper Museum in Paris. *Elle UK* documented a photo shoot in Kenya, concentrating on the technical and artistic aspects of the trip, as well as safari style encampments and clothing, which were compared to the clothes worn in the film *The English Patient* (p. 52).

September
In September, *Vogue UK* featured a review of the photographer Dan Eldon's African journal entitled *The Journey is the Destination*, a rather sobering note (see Eldon *et al.* 1997).[32]

October
Fashion journalist Suzy Menkes wrote an enthusiastic review of the latest *African Mosaïque* show entitled "The Real Thing: Celebrating Africa's Design Heritage" (*Herald Tribune* October 28). She noted that whereas previous shows had illustrated Africa's influence on European designers, this particular show, organized by Anna Getaneh, an Ethiopian model, only presented African designers and their creations. *L'Espresso*, the Italian newsweekly magazine (October 30) predicted the latest trend: "We Will Dress à la Masai," though the article featured Tuareg bracelets and the colorful sweat pants worn by African models (p. 193) rather than Masai adornment. *L'Officiel* devoted half of its issue to Laurence Benaim's article entitled "Magie Noire" (or Black Magic). The author discussed the collections, the growing presence of African models, the marketing of black cultures, and the evolution African inspirations in the 1990s. The issue included photographs of Saint Laurent in 1971 with a black model, Lamine Kouyaté of the Xuly Bët line, Naomi Sims, Alphadi, Gaultier's 1997 all-black model collection, and African hairstyles.

December
In December *L'Officiel* took its readers to Botswana and the Kalahari for a visit to Hemingway's Africa.

Hermès, the leather goods store in Paris, dedicated 1997 as the "Year of Africa." Their biannual catalogs (*Le Monde d'Hermès* 1997, Vols I and II) abounded with field photographs, and texts by African authors such as Frédéric Bruly-Bouabré,[33] Amadou Hampate Ba.[34] The cover of *Le Monde d'Hermès* (1997, Vol. I) displayed a beautifully embroidered reproduction of the famous Kelly bag[35] made with blue, white, and red beads by a Cameroonian artist. This was not a first for Hermès. Since 1993, their catalogs have featured the travel diaries, comments, and notes made by Hermès designers and photographs of the artists and artisans they visited.

The realm of fashion models has reflected the growing presence of Africa as well. Like Josephine Baker, in the late 1980s–1990s, African fashion models such as Iman, Alek Wek, Kadra, Naomi, Kiara, and others came to stand as a new standard of modern beauty. In March 1994, Paquita Paquin, fashion correspondent, wrote a biographical article in *Vogue Paris* entitled "But What Do They Have That We Don't?" on the young models Aminata, Bintou, and Coumba (the former Senegalese and the latter two Malian; Paquin 1994). In February 1997, *Vogue Paris* introduced Kadra, the twenty-year-old Ethiopian model who had her fashion debut in the Spring/Summer collections (p. 163). Characterized as the "Queens of Africa" and described as "statuesque, striking, stunning and thoroughly modern" (*Elle UK*, June 1998, pp. 89–94), these women have secured their places on the European catwalks and continue to be popular with fashion photographers and designers.[36]

Throughout 1997, fashion correspondents frequently alluded to the "new metropolitan African styles" entering the fashion arena (*Panorama*, October 30, 1997) and expressions like "ethnic chic," were definitely mainstream (*Vogue UK* September 1997: n.p.). Advertising for perfume and cosmetics was no exception. Big corporations have often turned to images of Africa and Africans to coin that phrase which will sell a product.[37] For example, Benetton's silent images for the Tribu Perfume advertisement in 1993 relied on the strength and beauty of the image alone. Liberty of London's beauty department in *Vogue UK*, November 1993 added a catchy pitch to sell their products in November: "Experimenting with cosmetics can do wonders for your images as men of the Wodaabe tribe will tell you."

Some people might take exception to the snappy, flip, and frivolous language, the superficial headings, and the incessant, up-beat sales pitches one reads in fashion magazines. They are not intended as ethnographies, and much of the information is erroneous. Most are not intended to educate, but to titillate and to sell a product. They provide a window on actual trends and they define a certain moment and a mood in the annals of fashion. As we saw, this is how the system functions.[38]

The most dramatic or shocking is essentially what lures fashion photographers, journalists, and editors. In many instances, the most outrageous clothes are not purchased to wear (Menkes 1999; de la Haye 2000: 61). What has become increasingly important in the past years is the "noise" a collection can generate because it attracts attention. Media coverage and advertising are interrelated. Advertising costs (quoted at US$80,000 per page in some fashion magazines) are more than compensated when a runway show generates interest—be it positive or negative (Andrews 2004: 5).[39]

What most scholars agree upon, however, is that designers who successfully use ethnic sources are those who avoid theatricality and pastiche to create clothes one can actually wear in one's own culture (McDowell 2000c: 327–31). Fashion historian Amy de la Haye (2000: 64)

notes designers "could be criticized for indulging in parody," but I find this is a rather slippery area. Anything that grabs public attention risks a backlash, and the inspiration that leads to creativity is difficult to earmark let alone copyright. Cross-cultural borrowing is compounded in an era when everyone travels, and when the availability of information through the media and the Internet is immediate. Appropriation is a phenomenon that, in essence, cannot be stopped. In his discussion of the evolution of exoticism from 1880 to 1914, as it related to the arts and popular culture Laurent Gervereau concludes:

> Exoticism feeds on the baroque of customs and the sensuality of the imaginary … When … individuals understand that they are each an exotic partner for the other, projections onto the outside may acquire the allure of choice. In any case, images at our end of the millennium are striated with styles and offer confusion, which may be understood as beneficial one day. It is up to us to invent diversity (1993: 48).[40]

The confusion Gervereau alludes to certainly persists in the new millennium, and if anything cross-cultural borrowing gives one more freedom of choice. Discourses surrounding these systems are remarkably globalized today and are reaching an ever-increasing audience. Among the many designers who were inspired by African ideas in 1997, both John Galliano and Jean Paul Gaultier come to mind as I discuss below. This is not only because they are creative individuals and artists, but also because both, over the years, have made otherness part of their creative processes, in order to enrich their aesthetic statements. These two designers continue to surprise, to sometimes shock, and to amuse the public. Their clothing is dramatic in some instances, and their shows have become staged performances of the highest caliber. As design consultant Ian Griffiths says, "… fashion has become a spectacle its 'superstar' designers and models principal characters in the narratives of popular culture" (2000: 69).

John Galliano and Jean Paul Gaultier

John Galliano
John Galliano was born in Gibraltar in 1960 of a Spanish mother and an English father. When he was six years old, his family moved to South London, which Galliano describes as a cultural melting pot (Chenoune 2003: n.p.). After taking design classes at East London College, he started at St Martin's School of Design in 1979 (Cabasset 2000–1: 84). Galliano's early styles were inspired by the streets and by the London club scene. His early collections such as *Afghanistan Repudiates Western Ideals*, were political commentaries, as was, indirectly, his thesis show

Les Incroyables, based on post-Revolutionary France, when clothes were used as a political and social statement to show contempt for rules and for standards dictated by society (see McDowell 1997: 82–4).

In 1996, after a year at Givenchy, John Galliano was appointed the Design Director at Christian Dior. His 1997 Spring/Summer collection was to celebrate Christian Dior's 50th anniversary. Some of the evening gowns in this collection were decorated with exquisite Masai necklaces and Dinka corsets. "Kamata," a layered orange tulle gown was inspired by a 1948 Dior dress called "Eloise," and by photographs of the Masai taken by Mirella Ricciardi (McDowell 1997: 27, 33). Manolo Blahnik designed the shoes for this dress using Venetian beads and photographs of Masai headdresses as inspiration as well (McDowell 1997: 134).[41] The "Kamata" dress and other models in this collection were a homage to the creative spirit of Christian Dior (who created the New Look in 1947), with a modern edge. "Galliano … realized that without new elements, homage collections could slip dangerously towards the borderline between cultural atavism and pastiche" (McDowell 1997: 37). In this instance, it is interesting to note Galliano did not use the 1947 leopard-skin print dress from the Dior archives, which would have been a more obvious choice.

Galliano's success is in great part due to his creative energy and his capacity to make eclectic juxtapositions taken from a very wide spectrum. As McDowell (2002: 145) notes "he is always open to the new. He doesn't think in clichés."[42] His travel journals, which include photographs, memorabilia such as sugar bags etc. become evocative sources of ideas. Other sources of inspiration are urban street scenes, music, and London clubs. In an interview with Chenoune (2003: n.p.) and talking about inspiration, the designer recounts, "I travel to China, but the result is not a Chinese look, that would be too simple! Once I return to the studio, I start making a big notebook, my "bible," based on the travel journals, and on other things, books, drawings, textiles, color schemes … This is when I start mixing the elements, finding ideas through textiles …"

Galliano has not always received positive media coverage. His 2000 collection, drawing from the poverty seen in the street was severely criticized for exploitation. Galliano retorted: "Look at Saint Laurent creating looks inspired by the extreme rich. Why not then be inspired by the poor? These images have become part of fashion vocabulary. Take a look around. There are so many frayed edges on the catwalk. When it was all going on, it moved off the fashion pages and onto the political pages …" (Webb 2001: 95). Galliano's work is imbedded in an aesthetic exercise. He uses the familiar notion of beauty and juxtaposes it with the unfamiliar to create a visual tension in order to shock and garner attention. He is certainly aware of the tensions of French politics and society; however, he makes no claims that his fashions are intended to spark political debates. Yet they do.[43]

Jean Paul Gaultier

Designers use African adornment to enrich their creations, and some also use it to make social statements. Jean Paul Gaultier, once nicknamed "*L'Enfant Terrible*" or the "King of Bad Taste," strongly believes in "the intermixing of ethnic strands to make a complete whole" (McDowell 2000b: 50). Born in a suburb of Paris called Arcueil, in 1952, Jean Paul Gaultier spent many afternoons in his childhood with his maternal grandmother (who was running a home beauty parlor) where he drew women wearing evening gowns (McDowell 2000b: 11). In 1970, at the age of eighteen, Pierre Cardin hired him. Though the early years of his career were difficult, he received media attention because of his capacity to mix textiles and color, and his continued use of ethnic elements (McDowell 2000b: 11–64). He was also constantly battling the *status quo*, using shock tactics and eclectic inspirations to get his message across. By the late 1980s, he was already an established figure in the fashion world, and opened boutiques in Paris, London, Milan, Brussels, and in New York. He has designed clothes for Boy George and Madonna, and costumes for Pedro Almovadar's film *Kika*, and Luc Besson's *Le Cinquième Elément*. In the 1990s, he hosted the English television show *Eurotrash*. In 1997, he presented his first *haute couture* collection (*L'Officiel* 1999).

Fashion systems rely on the relationships between the foreign and the familiar to create "looks" which are effective and profoundly different (Craik 1994: 17). Gaultier, who is said to believe in preserving the integrity of the cultures and countries that inspire his creations, also seeks to eradicate social prejudice (McDowell 2000c: 347). Deeply influenced by his travels, by movies, music (ska, funk, rap, etc.), and the shock value of street culture, he uses bright colors to create his fashion affect (*L'Officiel* 1999: 10). Gaultier is one of the first Parisian couturiers to have fought to use black models in the 1980s, and as Suzy Menkes noted in March, 1998:

> Gaultier is one of the rare French designers to draw on ethnic Paris, from the African inspiration in Barbes through the Indian quarter for his tattoo collection.

His Fall/Winter 1997/8 collection was dedicated to Black culture as a tribute to Nina Simone and Miriam Makeba, and to be shown only by black models. For this collection, his turbans were a reinterpretation of Vermeer's *Young Woman with the Turban*, and his Spring collection included a different take on the Tuareg veil (*Vogue Paris*, September 1997: n.p.). Concurrently, the French Government passed a law to limit immigration. This turned Gaultier's tribute into a political statement (McDowell 2000b: 124). Gaultier is quoted as saying: "Our everyday life is the fruit of politics and the only way to make it work is by getting together and fighting" (McDowell 2000b: 124). According to McDowell

(2000b: 95–6), Gaultier has had occasional run-ins with the media because of his strong beliefs about fairness and lack of prejudice. Talking about a show in which most of the models were black men, he is quoted as saying:

> ... A particular French journalist, using the slogan for a washing powder wrote "Omo Le Plus Blanc." I thought it was insulting to me, outrageously insulting to many models and a classic example of petit-bourgeois French anti-homosexual fascism.

Gaultier has an uneasy relationship with the fashion press and said: "I have no difficulty if they don't like what I do. But fashion commentary is very political and, in some cases, I suspect the criticism has a hidden agenda with nothing to do with the clothes. If one talent rises, another sinks. I know that. I expect it. But I don't always accept it" (McDowell 2000b: 96). While Galliano uses "otherness" for affect, Gaultier's choices have a certain political intentionality. By using fashion, he brings it into another realm that responds to new fields of interest. He is already "ahead of the wave" (Mary-Jo Arnoldi, personal communication, February 2005).

African Designers in Paris

Some African fashion designers (such as Ly Dumas, Xuly Bët, Mike Sylla, Katoucha, and others) and jewelers have settled in Paris, where they are enjoying a certain recognition and notoriety. For example, the jeweler Mickaël Kra moved to Paris in 1993. He created his own line called Reine Pokou, and has produced accessories and jewelry for Louis Féraud, Jean Louis Scherrer, and Paco Rabanne. He is now enjoying a growing recognition in European fashion circles (*Vogue Italy* May, 1997).

Xuly Bët

In the same way, street fashions and popular culture are an intrinsic part of Gaultier's oeuvre, other designers use the same inspirations to create a radically different "look." Xuly Bët (aka Lamine Kouyaté) is probably one of the most well known and successful African designers working in Paris and he works very hard to produce new styles. He has also sought the continued approval of youth by creating recycled fashions that are, to use a fashion cliché both cheap and chic. Lamine Kouyaté was born in Mali in 1962 to a Senegalese mother and a Malian father. He trained in architecture in Strasbourg, before moving to Paris. In 1989 he launched his own label, Xuly Bët (which means, "do you want to take my picture?" in Wolof), which is manufactured in the Funkin'Fashion Factory. His presence in French department stores in the "Young Designers" stands, and continued coverage in the press[44] soon earned him a secure place in the Parisian fashion scene. In 1996, he

was voted best stylist of the year in Paris (*Revue Noire* 1998b: 75). Now he has a boutique in the shopping mall called the Forum des Halles in Paris.[45]

Kouyaté's approach is eclectic. His garments are inspired by items found in thrift shops, at flea markets, and street fashions, which are then reworked into an urban pluri-ethnic style. He considers himself a militant modernist (Fall 1995: 29), and eschews conventional textiles such as raffia. His trademark: a red thread, visible seams, and visible label has become the favorite among rappers such as Neneh Cherry and other members of the music world such as Janet Jackson, Ophelie Winter, and Rossy de Palma. In 1994, his clothing was used in Robert Altman's film *Ready to Wear* (*Prêt-à-Porter*), representing Cy Bianco's collection (www.imdb.com/title/tt0110907). In March 1996, he was awarded the Trophée de la Mode by French fashion designer Sonya Rykiel.

In November 1998 Kouyaté showed the Xuly Bët collection in New York City, and returned there again in 1999 (Hastreiter 1999). While some reporters argue that his success is due to the fact street styles became the "in thing," it is important to note Kouyaté also understands the workings of the fashion system and his sales are high. Despite the fickleness of fashion trends from one year to another, the Xuly Bët label continues to flourish, and can be found in boutiques in Paris, London, Scandinavia, and Japan. His "look" has a noticeable appeal across cultural boundaries and for several years he promoted the look on a website.[46] His website was a satirical take on society and the fashion world, and his messages, often play on words, were loud and clear such as: "x-tra trash, x-tra strass, stress and paillettes." The site included sections on fashion, the press, news, factory mail, the boutique, and Africa. The African section promoted literature, music, textiles, and other up-to-date trends. In his own words, Lamine Kouyaté seeks to "transpose all the experience acquired in France to Africa. "To help a continent one needs to know it" (Vellard 2001).

Alphadi

The impact the fashion system has on global markets and the important role that the industry plays in the financial sector of the global economy makes it relevant to address the role that fashion assumes in African countries. The growing amount of African fashion and accessories boutiques in European capitals also indicates new market trends and demands.

Chris Seydou, the Malian designer who died in 1994, was considered the doyen of African fashion. He paved the way for a global recognition of what people have come to call "African style"—in Africa, or as a European interpretation. The new generation designers such as Pathé-O, Xuly Bët, Ly Dumas, and Oumou Sy have all successfully connected

their cultural heritage with modernity in an urban landscape in Africa and abroad. These individuals have all made names for themselves on international platforms by participating in fashion events such as the Johannesburg Fashion week, the SIMOD (or La Semaine Internationale de la Mode de Dakar, also known as International Fashion Week) in Dakar, the Manja (or Festival de la Mode d'Antananarivo) in Antananarivo (Manservisi 2003: 132–6), the New York Fashion Week, and the Paris collections and the *African Mosaïque* shows.[47]

The Nigerien fashion designer Seidnaly Sidahmed Alphadi wears two hats. He inherited Chris Seydou's mantle in the world of African fashion (*Revue Noire* 1995: 68–70), and is the President of the Festival International de la Mode Africaine (FIMA or the African International Fashion Festival). Alphadi lives and works in Niamey, Niger, and has a boutique in Paris. In his fashions, he renegotiates African traditions to create new identities for a global audience.

Alphadi: The Couturier

Alphadi was born in Timbuktu, Mali, on June 1, 1957. He grew up in Niger, and he is the eldest of eight children. Popularly known as the "Magician or the Prince of the desert," his interest in fashion began at an early age. He recalls that he always made-up his sisters and mother, he loved to create ensembles for them, and was fascinated with Indian films and oriental "costumes." He designed his first collection at the age of eleven. His father, however, expected him to take over his business or to become a doctor. When he passed his Baccalaureate in the early 1980s, he went to Paris to study tourism, and took design classes in the evenings at the Atelier Chardon Savard (Mendy-Ongoundou 2002: 92). After a stint as the Minister of Tourism in Niger, he turned to fashion design in 1983. He created his first *haute couture* line in 1985.[48]

Alphadi designs range from formal evening attire to daywear to casual outfits. His mixing of classical African materials (hand-woven cotton textiles, damask, raffia, linen, and accessories made of leather, bronze silver, and gold) with textiles such as lycra and with Chinese silks, etc., produce a multi-layered effect which is very modern. The couture line dresses are characterized by long flowing skirts and are sometimes made with Vlisco wax prints.[49] The bodices are often heavily embroidered with Wodaabe and Hausa designs, and adorned with glass beads. His sportswear line, Alphadi bis, created in 1999, accentuates a young urban style and the Alphadi Jeans line is aimed at a younger clientele. Alphadi puts great emphasis on accessories and detail. He also makes a prolific use of modern African jewelry forms, which he commissions from Tuareg smiths in Niamey, or from African jewelry designers in Paris such as Mickaël Kra.

Like his counterparts the world over, Alphadi is constantly searching for new ideas and inspiration. According to Manservisi, Alphadi

sees the Sahara desert region and its people as a continued source of inspiration (2003: 161). His palette progresses from indigo hues to the yellow of the sand and the ochre of clay. His style is varied and can be characterized as a mix of retro-classical—which follows his cultural identity, and modernism—which represents his persistent search for inspiration. His conceptual approach and his designs reflect the cultural diversity of his African heritage and his rigorous training. He is also mature and not given to short-lived trendiness. Yet his desire for originality, refinement, and the unique are part and parcel of Alphadi's fashion aesthetic. In 2000, he created the first perfume to be marketed by an African couturier: l'Aïr d'Alphadi.[50]

Among his many awards, Alphadi received the best African Stylist award from the French Haute Couture Federation in 1987. In 1989, he was awarded the Golden Scissors award in Niger and in 1990 he received the Golden Palm in Togo (Manservisi 2003: 144). In 1998, he received the Prince Claus Foundation Prize and the Platinum Scissors in Abidjan. In 2000, he received the Kora Fashion Award in Sun City, South Africa. Finally, in June 2001 he received the prestigious Chevalier de l'Ordre du Mérite de la France, which was bestowed upon him by French President Jacques Chirac. Today Alphadi has boutiques in Niamey, Bamako, Abidjan, and Paris.

Alphadi: President of FIMA

Over time, many African fashion designers have voiced concerns about the European fashion industry's "appropriation" of their traditional designs, textiles, and adornment (Cadasse 2001). As we have seen, the mechanism of fashion pushes fashion designers to turn their gaze to all sources and to reinterpret it for use in their own culture. One of the more positive responses to this problem has been that of Alphadi, whose primary goal has been to give visibility and credibility to African designers. He notes:

> I have always wished to see Africa presented through its beauty, its cultural prestige and its innate dignity … If African creativity is still unknown, if the international press is not interested enough, and if for decades European fashion designers have been creating African trends undisturbed, it is because we have not believed in our own organizational, managerial and professional abilities (in Manservisi 2003: 144, 161).

Faced with the lack of continuity between creativity and productivity and the economy, Alphadi decided to remedy the problem using a Western approach and marketing techniques.[51] He conceived of the Festival International de la Mode Africaine (FIMA), also designated as "Culture–Peace–Development," to develop a positive image of African fashion. The underlying purpose of FIMA is to instigate new and

varied marketing systems to effectively create infrastructures and jobs and to support local entrepreneurship in the textile and fashion industries, and in the accessories business in African countries (Alphadi in Anais 1996: n.p.). During these festivals there are conferences and workshops where participants address issues on marketing outlets and the creation of professional design schools.

FIMA is endorsed by African heads of state, and is underwritten by UNESCO, the Coopération Française, and the European Union and UNDP, among others. To date, the FIMA has held several successful, high-profile events. The first one was held in 1998, near Agadez in Niger (Figure 2). The second FIMA was held in Niamey, Niger, in 2000 and the third edition was held in the island of Boubon, near Niamey. The fourth festival was held in 2005, 16 kilometers from Niamey in the dunes of Karey Gorou, followed by a fifth edition in Niamey, Niger, in 2007. FIMA festivals now organize a young designer competition as well as a Top Model competition.

These festivals are media events, complete with the usual entourage of reporters, local and foreign VIPs, and people watchers. They attract

Figure 2
Commemorative stamp sheet showing the designer Alphadi and fashion models, issued at the occasion of the First Festival of African Fashion, Republic of Niger, 1998. Courtesy of the author.

buyers from major European and American department stores including the Galleries Lafayette, Harrods, Macys, and Bloomingdales (UNDP News Front 2000). European fashion designers such as Saint Laurent, Kenzo, Jean Paul Gaultier, Miyake, and Rabanne have made appearances, as have African fashion designers such as Katouchka, Mickaël Kra, Oumou Sy, and Ly Dumas. The settings are dramatic and chosen for visual impact, and happenings include fashion shows and concerts—usually performed by leading African performers of the day.

Alphadi's success, born from his commitment to put Africa on the map of international fashion, is in part due to the fact that he understands the role of hype, and the importance of being noticed. The fact that many high-profile international designers were present and showed their own designs turned these events into international occasions rather than local small-scale festivals. These successful ventures are also a tribute to Alphadi's power of persuasion and his innate understanding of a "global fashion system."[52]

Alphadi also invented the "Caravans"—a series of collections in transit, created to act as a bridge between each FIMA event, and to promote young African fashion designers through cultural venues. These caravans have occurred in African countries such as Benin, the Ivory Coast, Mali, Niger, Togo, Congo, Chad, Gabon, and Burkina Faso. They have also taken place at the Festival of Cannes, at the Carrousel du Louvre and at the Galleries Lafayette in Paris, in Quebec and in the Ifa Gallery in Stuttgart in 2001 (Figure 3). As with FIMA events, the Caravans aim to show that fashion is an intrinsic factor in economic development.

www.alphadi.com

In the past decade, the Internet has become indispensable to fashion designers worldwide. Alphadi believes in the syncretic hypertext (Cantoni 2003: 34), and has created a website www.alphadi.com (see Anais 1996). Alphadi's images are stunning, coherent, and offer multisensory (music underground) aspects. The site does a good job of presenting his clothing styles, his politico-cultural messages, and actually generates a healthy amount of curiosity. Its primary purpose is informative and promotional. Its accent is on FIMA and related events. www.alphadi.com has all the proper contact data, and you can send e-mails for precise information. Alphadi does not sell his products on line.[53]

Despite the problems inherent in virtualizing fashion on the Web, Alphadi remains committed to this enterprise. He believes that the power of the Internet will allow African fashion designers to be in direct contact with a global public, with each other, and even with prospective clients. He also plans to create the first fashion cyber cafe in Africa to help local businesses and development.

In the past ten years, Alphadi the designer has evolved. He creates beautiful fashions for both an African and international audience. His insights into the fashion system have shaped his relentless goal to give

Figure 3
Alphadi display, Galleries Lafayette, Paris, 1993. Photograph: Victoria Rovine, 1993.

the African fashion industry the push it needs to become a productive element in the financial sectors of the continent. Alphadi might not have the fresh quirky appeal of a Xuly Bët or the profoundly striking style of Oumou Sy, whose work in the theater has greatly influenced her oeuvre (Mustafa 2005: 255–8). But Alphadi, much like his staunch supporter Yves Saint Laurent is here to stay, and is a reality new generations of African designers have to measure themselves with in the post-modern era of globalization.

Conclusion

The structure of fashion has clearly changed in the last fifty years, both in Europe and in Africa. The fashion system is multi-vocal and its inspiration is multicultural. While some designers, such as Gaultier, voice concern that clothes do not count anymore saying, "it's the show that counts" (McDowell 2000b: 127–8), others move forward, espousing hard-core marketing strategies to sell their products. This paradigm will

evolve far into the future. The idea of Africa reentered the podiums for the Spring/Summer 2005 collections. Considering 2005 was the Year of Africa for the European Union, that the Group of Seven (G7) nations are pledging debt relief for Africa (Desai and Dawson 2005) and that in their Group of Eight (G8) Presidency, Britain and the European Union have made Africa a priority for 2005 (Nature Editorial, 16 February, 2005) this should come as no surprise. From the opposite end of the spectrum, *L'Officiel*'s February 2005 cover title was "African Style," and its "Styles et Tendances" insert included two fashion spreads, one entitled "Africa," and the other "Safari." Saharienne jackets have made a comeback, and Jean Paul Gaultier's collection certainly celebrated his African inspiration—giving the dresses names such as Fétiche, Baule, and Haoussa to name a few. The African presence, then, has laid a valuable foundation for the future.

As both the European and African fashion systems begin to converge on some levels, a universal fashion system may become a reality. Though paradoxical, the allure of exoticism will continue to entice because it always survives itself.[54] The work of fashion designers the world over will always display foreign aesthetic forms. It is the result of immense creativity and a tireless search for innovative marketing strategies, which are both the backbone of the fashion system. This mixing of the familiar with the "other" is paving the way for a global aesthetic and will surely prompt questions on cultural biases that go both ways.[55] What remains important is that the different concepts of beauty and intention that create these aesthetic forms—in this case fashion, be respected and recognized simply for what they are.

Acknowledgments

This article is based on an article delivered at the Cultured Body African Fashion and Body Arts Symposium held at the University of Iowa in October 2002. I would like to express thanks to the University of Iowa for the travel funds, which enabled me to participate in this conference.

I would like to thank Mary Jo Arnoldi, Suzanne Gott, and Leslie Rabine for taking the time to read this article, and for their incisive and helpful comments. I would also like to thank Victoria Rovine and Joanne Eicher for their valuable editorial comments.

Translator's Note

Many of the headlines listed in this article were originally in French or Italian; the translations are my own.

Notes

1. The Tuareg are a semi-nomadic pastoralist people who inhabit the Sahara desert and neighboring regions.
2. Many studies on fashion are careful to define the words clothing dress and fashion, especially when used in relation to ethnic dress. Eicher and Sumberg (1995: 300) define ethnic dress as "those items, ensembles and modifications of the body that capture the past of the members of a group, the items of tradition that are worn and displayed to signify cultural heritage … Frequently the word fashion, when referring to dress implies styles emanating from an acknowledged fashion center such as Paris … In contrast, daily dress can easily be distinguished from high fashion or *haute couture*, we refer to ordinary dress as world fashion or cosmopolitan fashion."
3. Gervereau's "L'éxotisme" (1993), Mendy-Ondougou's *Élégances Africaines* (2002), and Manservisi's *African Style* (2003) all address this fascination with exoticism and "the other."
4. The paisley motif gets its name from Paisley in Scotland, which is where the shawls were produced for a Western clientele. The original name of the motif is "boteh" (Orzada 1998). The fashion historian Colin McDowell (2000c: 327) also notes that the cashmere shawl from India was very popular in eighteenth-century Europe, and was considered a Western fashion accessory as opposed to costume.
5. Both influenced the arts, music, and literature. Japonisme was brought on by the war between Japan and Russia.
6. See Palais Galliera (1996: 32) for Renoir's portrait of Madame Eliot wearing a Japanese-inspired dress, and the illustration of a Kimono dressing gown from 1906 (1996: 66).
7. See Martin (1998) for the Vionnet dress (p. 51) and the Doucet dress (p. 56).
8. See de Givry (1998), pp. 157–8 for the Mondrian dress, and pp. 165–6 for the Aria de Bach cape. The cape pays tribute to Braque's Aria de Bach.
9. See Baudot (1999: 66–7) for and illustration of Lanvin's cape. The Paul Poiret dress is in the Philadelphia Museum of Art.
10. The exhibition was one of the first blockbuster shows: complete with endless ticket lines, glossy catalogs, and the obligatory gift shop at the exit.
11. Personal communication, Alexander Vreeland, 1992. At the time, Vreeland was the Executive Vice President of Giorgio Armani Corp. North America. Debora Silverman in *Selling Culture* (1986) discusses the link between the Metropolitan Costume Institute's exhibition entitled: *The Manchu Dragon: Costumes of Chine, the Ch'ing Dynasty, 1644–1912* and Bloomingdales' sales of Chinese fashions. More recently, Lisa Immordino (personal communication, August 2002)

remarked "things are in the air" is a general fusion between the arts, culture, and political events.

12. The author is using Robert Rydell's term, as he describes it in his book *World of Fairs: Century of Progress Exhibitions* (1993).
13. Tolini Finamore (2003) also reports that left-wing thinkers and artists such as André Breton and Louis Aragon organized a counter-exposition called *l'Exposition Anti-Impérialiste* at this occasion.
14. Powell (1997: 56–7) notes that the importance of jazz in Paris at this time inspired Archibald J. Motley to paint images of the Jockey Club (1929), and Jean Renoir, whose message was "that black creativity was modern society's only salvation and hope for human perpetuity," was inspired by performance and he produced a film entitled *Sur Un Air de Charleston* (1926).
15. See www.nmafa.si.edu/exhibitions for an example of "tabouret" *c*. 1923, lacquered wood, horn, and gilding.
16. Nancy Cunard, the shipping heiress-poet was a collector of African art. She was immortalized in Man Ray's photograph wearing ivory bracelets (presumably African) from her wrist to her elbow.
17. See Martin and Koda (1994: 50) for an example of Fortuny's dressing gown. In the 1930s, Morocco became the intellectual Mecca of many literary figures, such as Paul Bowles.
18. See Mendy-Ongoundou (2002: 124) for an illustration of Madame Carven's dresses.
19. See McDowell (2000c: 336, 337, 338) for illustrations of these Yves Saint Laurent dresses.
20. A Saharienne is a khaki jacket, which resembles those worn by British officials in the colonies. They have pockets and are popular in warm climates because they are lightweight. Khaki is also a practical and useful color.
21. See Mendy-Ongoundou (2002: 129) for Kenzo's "*boubou*" dresses. "*Boubous*" designate ample gowns with long sleeves worn by both women and men in many West African nations.
22. See Rovine (2001, 2005: 451–2) for a thorough analysis of Bogolan. Bogolan refers to a woven cotton cloth decorated with geometric motifs, which is manufactured in Mali.
23. The *African Mosaïque* fashion show was founded in 1996 by the Ethiopian model Anna Getaneh. The purpose of the 1997 show was to benefit Ethiopian children.
24. The Masai are a group of African pastoralists who live in Kenya and Tanzania.
25. The Baule people live in the Ivory Coast and are renowned for their refined gold jewelry.
26. *Mal d'Africa* means African nostalgia. This Italian expression usually refers to those people who, once they have lived in Africa, can no longer adapt in their country of origin.
27. The Akan people come from Ghana.

28. *Madre Africa* was a compilation of African music including artists such as Youssou N'dour, Kanda Bongo Man, Khaled, Mory Kante, Angélique Kidjo, and others. PolyGram released it in 1997.
29. Ibeji figures represent twins are made by the Yoruba people in Nigeria.
30. The *Rencontres de Bamako* is a recurrent exhibition of African photographers. The FNAC show included artists from the *Rencontres de Bamako* exhibitions.
31. Jacques Kerchache is the author (with Jean Louis Paudrat and Lucien Stephan) of *L'Art Africain* (1988).
32. Dan Eldon was a young Anglo-American photographer who lived in Nairobi. While in Mogadishu in 1993, he was killed covering a story on the bombing of the home of the Somali General Mahammed Aideed. He was twenty-two.
33. *Le Monde d'Hermès*, Vol. I (1997: 8). Excerpt from *La Légende de Domin and Zézê*.
34. *Le Monde d'Hermes*, Vol. II (1997: 61–9).
35. In 1956, Hermès created the Kelly bag, which was named after Grace Kelly, who was shown holding the bag on the cover of *Life* magazine, hence its fame and popularity.
36. *Vogue Paris*, *Vogue UK*, *US Vogue*, *Frank*, *Marie Claire*, *Elle Italy* and *Elle UK*, *L'Espresso*, and *Panorama* have all included either an article or a feature on African models during the 1997–9 period. Alek Wek has been photographed for an UNICEF campaign under a heading that reads: "I was born with a shirt, they were not!"
37. The Italian textile manufacturer Rubelli produced a stunning image of a group of men and women standing outside the mosque in Mopti, Mali, and wearing "*boubous*" made of their textiles.
38. In fact, some articles now include background information on the locus of fashion shoots, or, as *Elle France* did in July 1998, they publish an accompanying article on the history of certain textiles—in this case, raffia. The Hermès catalogs and travel diaries stand out as a departure from the norm. They are intended to present and to sell collections, and their inclusion of more substantive information (field photographs, names of artists, literary excerpts, etc.) are closer to a form of truth, and are in standing with the political correctness which exists today. I personally wonder if this new "political correctness" is in reaction to Gaultier's 1993 *Hasidic Chic* collection, which caused a very negative public reaction, or if it is done to avoid accusations of economic imperialism.
39. The author states based on a New York consultancy, that a twenty-minute runway show that costs US$500,000 can generate US$7m in American fashion magazines alone (Andrews 2004: 5).
40. The original text is in French. This is my translation.
41. Herbert Blumer (1968: 341–5) addressed the impact of social change on fashion and its social functions and collective taste and

fads. Following these lines, McDowell (1997: 119), posits that a designer's inspiration results from a process of research (in art museums, clubs, in libraries, and on the streets) and layering. This collage of various influences ends up in a source book. As the images and ideas evolve, Galliano formulates a storyline, which becomes the skeleton for the collection.

42. I already mention this to some degree in Loughran (2003: 57).
43. I wish to thank Mary Jo Arnoldi for the very enlightening conversations we have had on the issue of the language used in fashion magazines, as well as the creative versus political aspects of Galliano's and Gaultier's work.
44. Articles on, and mentions of, Xuly Bët abound, such as: *Vogue Paris*, December 1997–January 1998 (publicizing his workspace, n.p.); *Elle* January 26, 1998: n.p.; *Elle* May 24, 1999: 183 (in an article on the singer Amina); *L'Officiel* March 1999: 38 (in "Repères"); and *Vogue Paris* November 1999: n.p. (in "Brisons la Glace").
45. See Rovine (2005: 215–27) for an in-depth and thoughtful analysis of Xuly Bët's recycled clothing.
46. At this writing, the Xuly Bët Funkin'Fashion website (www.xuly-bet.com) is no longer online.
47. The SIMOD was created by the Senegalese fashion designer Oumou Sy, and has had events since 1997. Anna Getanneh, an Ethiopian designer, created the *African Mosaïque* shows in order to help the Ethiopian Children's fund. The designer Elia Ravelomanantsoa created MANJA in 1986 in Antananarivo.
48. Tailors in Africa often use the term *haute couture* on their signboards to attract clients. While it might insinuate assimilation with aesthetic canons imposed by the Western fashion industry, it has been translated into a viable and economically positive source of income in many African countries. *Haute couture* is a diffused term, and should not be taken literally in the French sense. In this case, *haute couture* describes clothing that is commissioned, hand-made, and is beautiful and elegant. According to informants, it is a step up from the *tout cousu* (ready-to-wear) and ironically, it is less expensive. Personal communication, Alia Traore Kande, March 2004.
49. Vlisko is a Dutch company, which has been manufacturing wax-print cloth for export to Africa since 1846. For many years, waxes or imitation waxes have been produced in West Africa. There are companies such as Sotiba in Senegal, Uniwax in the Ivory Coast, Sonitextil in Niger, and others (Mendy-Ongoundou 2002: 63). The irony here is that both the Vlisco wax prints, and damask, are produced in Europe for the African market, but have subsumed an African identity.
50. L'Aïr refers to the Aïr region, near Agadez, in Niger.
51. In November 1997, the organizers of the K'Palezo festival in Abidjan, stressed the fact that international visibility and the development of

Western marketing techniques within the African fashion milieu are of primary importance to African designers and to the African fashion system today (*La Voie*, November 8–9, 1997).

52. I should note that reactions have not always been positive. When the second FIMA festival was held in Niamey in 2000, it generated riots and the outrage of Islamic fundamentalists who tried to stop the event, calling it both decadent and satanical (*Absolu Féminin* 2002a, b, and *BBC News* 2002). The government of Niger backed the festival nonetheless and the protest made it all the more noticeable.
53. The technological aspects of Alphadi's site are fairly straightforward. The site loads quickly and the internal pages open instantly. The site's structure is simple and easy to navigate. Thanks to a very sober and clean layout, it is very functional. The choices are clear and direct, there are no complex operations, nor are there too many pop-up windows. The accessibility is excellent and the site shows up on the first pages of most search engines.
54. The idea of exoticism which always survives itself is inspired by Legrand (1998: 187).
55. Although I have mentioned this in passing when discussing Gaultier, Galliano, and Alphadi, a longer discussion of cultural biases is not in the purview of this article.

References

Absolu Féminin. 2002a. "Carte Noire à la Mode (1)." www.absolufeminin.com, accessed September 26, 2002.

Absolu Féminin. 2002b. "Carte Noire à la Mode (2)." www.absolufeminin.com, accessed September 26, 2002.

Allin, Michael. 1998. *Zarafa: A Giraffe's True Story, from Deep in Africa to the Heart of Paris*. New York: Walker and Co.

Anais. 1996. "Être Vu et Être Compris: Les Espoirs des Créateurs de Mode Africains." Conference on Africa and New Information Technologies, Geneva, October 18, 1996. www.anais.org, accessed September 28, 2002.

Andrews, John. 2004. "Rags and Riches. A Survey of Fashion." *The Economist* (Special Survey) 370(8365): March 6.

BBC News. "Islamic Groups Banned in Fashion Row." http://news.bbc.uk, accessed September 28, 2002.

Bachollet, Raymond, Jean-Barthelemi DeBost, Anne-Claude Lelieur, Marie-Christine Peyriere and Kofi Yamgane. 1987. *Negripub. L'Image des Noirs dans la Publicité*. Paris: Somogy.

Bancel, Nicolas, Pascal Blanchard and Laurent Gervereau (eds). 1993. *Images et Colonies. Iconographie et Propagande Coloniale sur l'Afrique Française de 1880 à 1962*. Paris: BDIC-ACHAC.

Baudot, Francois. 1999. *A Century of Fashion*. London: Thames & Hudson.
Blumer, Herbert G. 1968. "Fashion." In David L. Sills (ed.) *International Encyclopedia of the Social Sciences*, Vol. 5, pp. 341–45. New York: The Macmillan Company and The Free Press.
Borge, Jacques and Nicolas Viasnoff. 1995. *Archives de l'Afrique Noire*. Paris: Éditions Michèle Trinckvel.
Boucher, Francois. 1987. *A History of Costume in the West*. London: Thames & Hudson.
Cabasset, Patrick. 2000–1. "Dans le Labo de John Galliano." *L'Officiel* December 2000-January 2001: 84–91.
Cadasse, David. 2001. "La Mode Africaine Existe." www.afrik.com/journal/decouverte/dec-328, accessed August 17, 2002.
Cantoni, Lamberto (ed.). 2003. *Fashion on Line. Come Utilizzare il Web per Dare Valore Aggiunto Alle Aziende Della Moda*. Milan: Franco Angeli Srl.
Chenoune, Farid. 2003. "Les Trésors de John." *Vogue Paris* March: n.p.
Craik, Jennifer. 1994. *The Face of Fashion: Cultural Studies in Fashion*. New York: Routledge.
de la Haye, Amy. 2000. "Ethnic Minimalism: A Strand of 1990's British Fashion Identity Explored via a Contextual Analysis of Designs by Shirin Guild." In Nicola White and Ian Griffiths (eds) *The Fashion Business: Theory, Practice, Image*, pp. 55–68. Oxford, New York: Berg.
Desai, Sumeet and Stella Dawson, 2005. "Euro versus Dollar Currency War Monitor." www.beearly.com/opinion, accessed February 8, 2005.
Duart, Florence. 1998. "Dans le Sahara, le Paris-Dakar de la Mode." www.webdo.ch/hebdo, accessed September 26, 2002.
Eicher, Joanne and Barbara Sumberg. 1995. "World Fashion, Ethnic and National Dress." In Joanne B. Eicher (ed.) *Dress and Ethnicity*, pp. 295–306. Oxford: Berg.
Eldon, Kathleen, Dan Eldon and Kathy Eldon. 1997. *The Journey is the Destination: The Journals of Dan Eldon*. San Francisco, CA: Chronicle Books.
Fall, Ngone. 1995. "Xuly Bët." *Revue Noire* 17: 28–9.
Gervereau, Laurent. 1993. "L'éxotisme." In N. Bancel, P. Blanchard and L. Gervereau (eds) *Images et Colonies. Iconographie et Propagande Coloniale sur l'Afrique Française de 1880 à 1962*, pp. 26–48. Paris: BDIC-ACHAC.
de Givry, Valérie. 1998. *Art et Mode. L'Inspiration Artistique des Créateurs de Mode*. Paris: Éditions du Regard.
Goldwater, Robert. 1986. *Primitivism in Modern Art*. Cambridge, MA, and London: Belknap and Harvard University Press.
Griffiths, Ian. 2000. "The Invisible Man." In Nicola White and Ian Griffiths (eds) *The Fashion Business: Theory, Practice, Image*, pp. 69–91. Oxford, New York: Berg.

Hastreiter, Kim. 1999. "New York Fall Collections: Xuly Bët." www.papermag.com/stylin/fashion/shows/99fall/xuly_bet, accessed September 24, 2002.

Kerchache, Jacques, Jean Louis Paudrat, and Lucien Stephan. 1988. *L'Art Africain* Mazenod: Paris.

Le Monde d'Hermès. 1997. *Le Monde d'Hermès*, Vols I and II. Paris: Éditions Hermès.

Legrand, Frédérique. 1998. *Touches d'Exotisme XIVe–Xxe Siecles*. Paris: Musée de la Mode et du Textile.

Loughran, Kristyne. 2003. "Jewelry, Fashion and Identity—The Tuareg Example." *African Arts* XXXVI(1): 52–65, 93.

L'Officiel. 1999. "Notre Jean Paul." *L'Officiel* (Special Insert) February: n.p.

Martin, Richard. 1998. *Cubism and Fashion*. New York: Metropolitan Museum of Art.

Martin, Richard and Harold Koda. 1994. *Orientalism. Visions of the East in Western Dress*. New York: Metropolitan Museum of Art.

Manservisi, Michela. 2003. *African Style. Stilisti, Moda e Design nel Continente Nero*. Rome: Cooper Srl.

McDowell, Colin. 1997. *Galliano*. London: Weidenfeld & Nicolson.

McDowell, Colin. 2000a. "Fashion Starts Here." *Elle UK* February: 132–4.

McDowell, Colin. 2000b. *Jean Paul Gaultier*. London: Cassell & Co.

McDowell, Colin. 2000c. *Fashion Today*. London: Phaidon Press.

McDowell, Colin. 2002. "King Pin." *Vogue UK* January: 142–5.

Menkes, Suzy. 1996a. "Ralph Lauren's African Beat." *International Herald Tribune* November 1.

Menkes, Suzy. 1996b. "Caftan Makes Its Return in a Marrakech Moment." *International Herald Tribune* May 14.

Menkes, Suzy. 1997. "The Real Thing: Celebrating Africa's Design Heritage." *International Herald Tribune* October 28.

Menkes, Suzy. 1998. "Paris Turns to the East for Ethnic Mix and Youthful Hip." *International Herald Tribune* March 13.

Menkes, Suzy. 1999. "Wild and Unwearable. But Couture Outfits Grab Public's Attention." *International Herald Tribune* July 21.

Mendy-Ongoundou, Renée. 2002. *Élégances Africaines. Tissus Traditionnels et Mode Contemporaine*. Paris: Éditions Alternatives.

Mustafa, Hudita. 2005. "Oumou Sy." In Valerie Steele (ed.) *The Encyclopedia of Clothing and Fashion,* Vol. B1), pp. 255–8. New York: Scribner.

Orzada, Belinda T. 1998. "Twentieth Century Design: Ethnic Influences Course" http://udel.edu/~orzada/toc.htm, March 15, 2004.

Palais Galliera. 1996. *Japonisme et Mode*. Paris: Musées de la Ville de Paris.

Paquin, Paquita. 1994. "Mais Qu'est-ce-Qu'Elles Ont de Plus Que Nous?" *Vogue Paris* March: n.p.

Revue Noire. 1995. "Alphadi le Magnifique." *Revue Noire* 17: 68–71.
Revue Noire. 1998a. "Alphadi." *Revue Noire* 27: 20–5.
Revue Noire. 1998b "Xuly Bët France." *Revue Noire* 27: 70–5.
Rhodes, Colin. 1994. *Primitivism and Modern Art*. London: Thames & Hudson.
Rovine, Victoria L. 2001. *Bogolan. Shaping Culture through Cloth in Contemporary Mali*. Washington, DC: Smithsonian Institution Press.
Rovine, Victoria L. 2005. "Bogolan" In Valerie Steele (ed.) *The Encyclopedia of Clothing and Fashion*, Vol. 3, pp. 451–2. New York: Scribner.
Rubin, William (ed.). 1984. *Primitivism in 20th Century Art. Affinity of the Tribal and the Modern*. New York: The Museum of Modern Art.
Rydells, Robert. 1993. *World of Fairs: Century of Progress Exhibitions*. Chicago, IL: University of Chicago Press.
Silverman, Debora. 1986. *Selling Culture: Bloomingdales, Diana Vreeland, and the New Aristocracy of Taste in Reagan's America*. New York: Pantheon Books.
Steele, Valerie. 1997. *Fifty Years of Fashion. New Look to Now*. New Haven, CT, and London: Yale University Press.
Steele, Valerie and John Major. 2000. "Fashion: Yesterday, Today and Tomorrow." In Nicola White and Ian Griffiths (eds) *The Fashion Business: Theory, Practice, Image*, pp. 7–22. Oxford, New York: Berg.
Tolini Finamore, Michelle. 2003. "Fashioning the Colonial at the Paris Expositions 1925 and 1931." *Fashion Theory* 7(3/4): 345–60.
UNDP News Front. 2000. "High Fashion Helps Fight Poverty and Promote Peace in Niger. www.undp.org, accessed November 10, 2000.
Vellard, Véronique. 2001. "Xuly Bët, An African on the Paris Fashion Show." http//www.nepalnews.com.np/contents/englishweekly/telegraph/2001/Oct 10, accessed September 24, 2002.
Vormese, Francine. 1997. "L'Afrique Flamboyante." *Elle France* May: 138–43.
Webb, Ian R. 2001. "My World." in *Elle UK* April: 92–6.
White, Nicola and Ian Griffiths (eds). 2000. *The Fashion Business: Theory, Practice, Image*. Oxford and New York: Berg.

FASHION & MATERIALITY

What is the role of the *object* within fashion theory? How does fashion *materialise* an idea? How might *artefacts* be re-interpreted within contemporary cultural theory? How does *materiality* relate to new consumption and media practices?

Symposium at Stockholm University, 2-3 October 2009.
Further information available at www.fashion.su.se
Forthcoming symposia themes: *Fashion in Translation* and *Fashion and Time*.

Centre for Fashion Studies

Stockholms universitet